Pure SEA GLASS

Discovering Nature's Vanishing Gems

By Richard LaMotte

Edited by Sally LaMotte Crane

Featuring photography by Celia Pearson

First Edition

Published by Sea Glass Publishing
PO Box 156 - Chestertown, Maryland 21620 U.S.A.
www.pureseaglass.com
www.seaglasspublishing.com

Pure Sea Glass - Discovering Nature's Vanishing Gems

Printed in China

Library of Congress Control Number 2004092546

ISBN-10: 0-9753246-0-8
ISBN-13: 978-0-9753246-0-8

Note: This compilation represents opinions of the author, his consultants, and editors, as well as references to historical events provided by authors noted in the bibliography in the back of this book. Every effort has been made to validate dates and events, however conflicting information was at times discovered. References to dates when bottles and glassware were manufactured represent periods of primary production or use. This book is intended solely to provide helpful direction for those interested in the collection and identification of sea glass.

Dedication

To my wife, Nancy, thank you for introducing me to the world of glass, and especially for your continued patience, support, and collaboration along this enlightening journey.

To my parents, thank you for your perpetual kindness. No one gift could ever repay all the years of generous care and support.

To my children, Shelley and Greg, who teach me everyday the joys of discovery through their young eyes, and, who with Nancy, are my favorite companions on any beach.

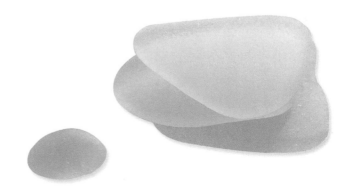

Table of Contents

Photo Credits

Featured photographer
Celia Pearson, Annapolis, Maryland

www.pearsonphotography.com

All photographs copyright ©2004 by Celia Pearson, or by others as attributed.
Unless noted by credit below, all photographs are by Celia Pearson.

Digital microphotography
Marta Flohr – Advanced Imaging and Analysis, Fairfax Station, Virginia.
 (sea glass on pages: 31, 39, 40, 41, 168, 205)

Additional bottle photography
Robert Dodge – Artemis Gallery, Ancient World Arts, Louisville, Colorado.
 (Egyptian glass on pages: 46 and 51)

Ed and Kathy Gray – Greatantiquebottles.com
 (barber bottles, inks and Quaker bitters on pages: 110, 114, 115, 121, 134, 135)

Jim Hagenbuch – Glass Works Auction, East Greenville, Pennsylvania. (215) 679-5849
 (bitters bottles, Owl drug bottle, case gin, patent medicines, whiskey bottles, bladder wine bottle
 on pages: 79, 82, 106, 110, 120, 121, 124, 126, 127, 132, 140, 142, 143)

Nancy LaMotte – Chesapeake Seaglass
 (iron pontil mark and snuff bottles on pages: 112, 144)

Robin Myers
 (Mason jar lip on page 111)

Al and Ginny Way – in-glass.com
 (fire grenade advertisement on page 126)

Additional tableware photography
George Chapogas – private collection, Eugene, Oregon
 (Burmese, Cameo, Peachblow on pages: 156, 157, 176)

Nezka Pfeifer – Curator, Sandwich Glass Museum, Sandwich, Massachusetts.
 (Sandwich Glass on page 174)

Sea turtle photograph
Courtesy of Caribbean Conservation Corporation, Daniel R. Evans, Coordinator
 (sea turtle on page 188)

Jacket photography
Photo of Celia Pearson by Jessica Earle

Acknowledgements

It is with sincere gratitude that we recognize the contributions by photographer Celia Pearson toward the development of this book. Our first glance at her artistic talent inspired us to venture immediately forward, taking a whispered concept to a forthright endeavor—compiling a comprehensive book on sea glass. She obviously shared the passion and vision that my wife and I have for this subject, and in the course of a year, became a close friend to our entire family.

We greatly appreciate the dedicated efforts of Sally LaMotte Crane in lending her extraordinary expertise to every inch of my text. Her attention to demanding detail was as educational to me as my text was to her. I also wish to personally thank a pair of fine designers—Robin Myers and my wife, Nancy LaMotte—who spent countless hours putting together the many elements of this incredible puzzle.

Lastly, my sincere thanks go to all the members of the Federation of Historical Bottle Collectors who assisted in this project. Their unwavering cooperation never ceased to amaze me. Special thanks go to Dr. Richard Baldwin, Dr. Cecil Munsey, and Mark Newsome.

Editor
Sally LaMotte Crane

Cover Design
Nancy LaMotte

Design and Layout
Robin Myers

Design Contributors
Carla Massoni - Owner, Carla Massoni Gallery, Chestertown, Maryland
Shelley Robzen - Sculptor, "seascape #1 and #2," Carrara white marble, courtesy of Carla Massoni Gallery

Creative Contributor
Stephanie Strasser

Technical Editors
Dr. Richard Baldwin - NASA research chemist and Midwest Region Director of the Federation of Historical Bottle Collectors
Dr. Cecil Munsey - Bottle and glass historian and writer

Sea Glass Collectors/Consultants
Christa Abram - Sea glass collector, Maryland and Delaware
April Grunsky - Sea glass collector, Florida
Joanne Howard - Sea glass collector, Maryland
Dick Keephart - Sea glass collector, Maryland
Nancy LaMotte - Sea glass collector, Maryland
David Mansell - Sea glass collector, Ohio
Sherry McCormick - Sea glass collector, Virginia and Spain

Bottle And Glassware Collectors/Dealers/Consultants
Marty Anderson - Cross the Street Antiquities, Chestertown, Maryland
Dick Keephart - Bottle collector
Holly Kehler - Glassics, Etc., Galena, Maryland
Veolo Hutt - A-Z Antiques, bottles and glassware, Tappahannock, Virginia
Mark Newsome - Bottle collector/consultant
Kathy Hopson Sathe - Editor, *Bottles & Extras,* (Federation of Historical Bottle Collectors)

Technical Contributors
Ralph Finch - Target ball collector and writer, Farmington Hills, Michigan
Dr. Donny L. Hamilton - President, Institute of Nautical Archaeology, Professor of Nautical Archaeology Program, Texas A&M University
Nezka Pfeifer - Curator (former), Sandwich Glass Museum, Sandwich, Massachusetts.
Dr. Jeffrey M. Reutter, Ph.D. - Director, Ohio Sea Grant College Program, Center for Lake Erie Area Research, The Ohio State University
Jan Rutland - Director of the National Bottle Museum in Ballston Spa, New York
Elizabeth Seidel - Director, Washington College Archaeology Laboratory, Chestertown, Maryland
Dr. John L. Seidel, Ph.D. - Assistant Professor, Washington College Department of Sociology and Anthropology, Chestertown, Maryland
Dianne Wood - Assistant Curator, Wheaton Museum of American Glass, Millville, New Jersey. www.wheatonvillage.org

Foreword

By Stephanie Strasser

Tucked within the pages of this book is the author's desire to take the reader on a colorful and informative journey. It is a passage to further inspire those who are already captivated by sea glass and to offer insight to those who are being introduced to it for the first time.

Nationally known photographer Celia Pearson elegantly captures the extraordinary sea-glass collection of Richard and Nancy LaMotte. Each glass color is presented in order of rarity based on the LaMottes' extensive study of close to 30,000 samples of sea glass. Bottles and tableware photographed with Celia's keen eye create a unique reference guide for sea-glass collectors to use in identifying the origin of their glass shards. Her seascapes throughout the book are a reminder of the alluring promise of the shore.

Pure Sea Glass begins with reflections on the lure of sea glass and suggests advantageous times and techniques for hunting these treasures. Subsequent chapters reveal facts regarding the science, history, and the finite existence of this dwindling resource. Vital support is given to the claim that sea glass shares some qualities with gems. The surface of aged sea glass can display crystalline-like structures uncharacteristic of glass itself. This process of glass hydration results in the familiar frosted patina of pure sea glass.

The text also includes knowledge of glass lineage that can help indicate the overall rarity and age of each glass shard. Introductions to specific glassware forms provide a key to identifying features of premium pieces. Although an attempt to reach high levels of expertise in identifying the vast array of all sea glass would undoubtedly be beyond the scope of this text, developing an increased familiarity with historic glassware can be beneficial to any collector. For those who find themselves irresistibly drawn to explore glassware forms (when they thought they were only sea-glass collectors), recommended sources for glass museums are provided in the back of the book.

Because we live in a culture that embraces disposability, there is little doubt that sea glass is becoming an obsolete resource around the globe. Collectors today are actually preserving fragile traces of our past. The hunt for pure sea glass will only get more challenging with each passing tide.

Preface

The impetus for this book began when my wife decided to resurrect her background in jewelry design by creating pieces using authentic sea glass. It became quite clear that her success would ride heavily on locating the most attractive sea-glass colors in dramatically conditioned forms. After speaking with others in her craft and numerous general sea-glass collectors, it was obvious that time has been running out on the ability to find good supplies of weathered sea glass. The influx of man-made sea glass is beginning to dominate what was once considered an abundant resource. In addition, natural beaches that were once prime for collecting sea glass are continuously compromised each year by rising sea levels, erosion, and coastal armoring—a process designed to reflect the energy of waves but which in many cases ultimately starves beaches of their sand. For these reasons, it seems prudent to research and archive the unique subject of genuine sea glass while supplies are still available to collectors.

My wife and I have found close to 30,000 pieces of sea glass that have provided us with an impressive collection in a wide array of colors. While only a small percentage of these shards are in adequate condition and size for use in jewelry, we have found ourselves graced with a growing supply of extraordinary pieces of sea glass. During exhibitions, numerous people have gravitated to these and shared stories of childhood beach walks and general reflections on the past. Most have asked questions about the origins of sea glass, prompting us to explore the topic in greater depth. It is these repeated questions from observers and fellow collectors, as well as our corresponding explanations, which make up the core of this book.

Among the questions that most commonly arise are: *What glass object might this piece of sea glass have come from and how old might it be? How would it have reached this location over time? Where are the best places to hunt sea glass and when is the most opportune time? Why are some colors so hard to find? How did something so sharp and jagged get so smooth and round? What causes the white patina on the surface of a piece of sea glass?*

Readers will learn that for the purposes of this book, a distinction is made regarding the differences between a piece of genuine sea glass—found with a smooth surface in a natural beach setting—and a piece of antique sea glass that has developed a distinctive white crystalline patina. It is the latter of these two that will be referred to as "*pure* sea glass" since it refers to the crystalline-like residue built up on the surface of old shards after being exposed extensively to natural shoreline elements. Most of the photographs in this book depict *pure* sea glass.

It is our hope that we have left the reader with a reference source that is worth returning to often, long after the initial visual pleasures of the stunning photographs in this book have been enjoyed.

Richard LaMotte

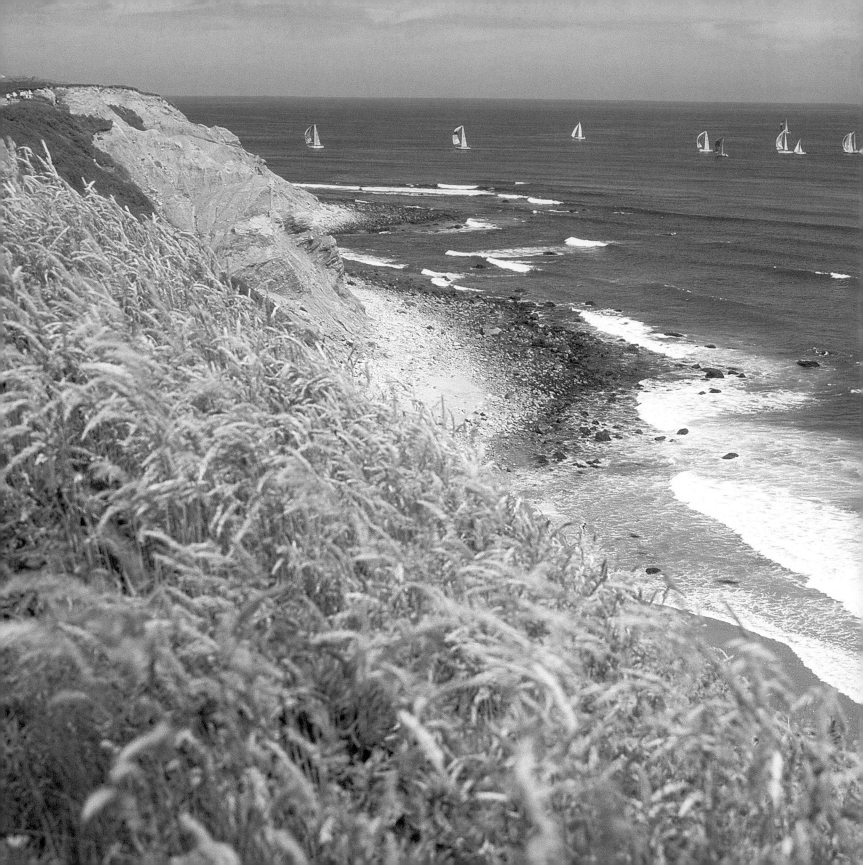

One

HISTORY IN THE SAND

*In every outthrust
headland, in every
curving beach,
in every grain of
sand there is the
story of the earth.*

Rachel Carson

History in the Sand

There is splendid irony in collecting sea glass, since this alluring trophy sought after in the shifting sand was once merely sand itself. Batches of molten sand, along with several conditioners, are heated to a near liquid state and then crafted into glass objects. Their gem-like colors are derived from carefully selected elements also found in the earth's crust.

For several thousand years, civilizations have used the same natural ingredients–sand, soda, and lime–to create glass. Leave it to Mother Nature to improve upon something manipulated by man and returned to her care after it has served our temporary needs. The forces of nature not only shape sea glass by abrasive physical conditioning, but contact with aquatic environments creates unique textures that are only poorly imitated by man. In some cases, exposure to the sun creates graceful colors out of glass forms once intended to remain colorless.

Discovering the origin of a glass shard is not an easy task. The educational process that allows the observer to make the most of subtle clues adds to the reward of identifying sea glass. One can quickly learn how to separate newfound treasures into respective groupings and, in time, become familiar enough with glassware identification to successfully confirm the source and age of shards greatly altered from their original form.

Sea glass is becoming more scarce with every passing day. Quite fortunate are the collectors who still find sea glass in a broad array of colors, since glass vessels produced today are in a far more limited color palette. For those who will follow in our footsteps, the kaleidoscope of glass remnants derived from fragile objects once used by our ancestors will only be thinly scattered along the shore.

Previous page: Block Island, Rhode Island

Opposite: Sea glass found near Cadiz, Spain

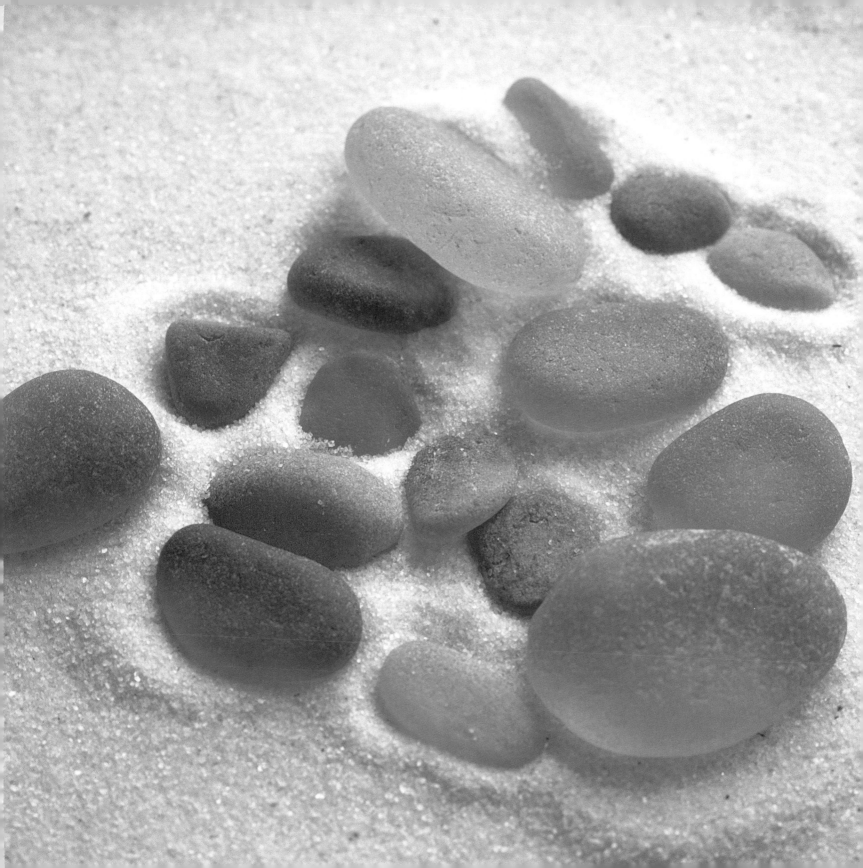

Shapes & Styles

Nearly as important as the color of sea glass to a collector is the amount of total wear or rounding of its surface. A specific cause for the degree of wear will be discussed later, but the amount is directly related to the length of exposure and the level of harsh conditions that the sea glass has withstood. A surprising reality is that while no two pieces of pure sea glass are identical, there is one most common shape—a triangle.

Many collectors are excited to discover the identity of the original glass. The majority of glass picked up from beaches is from bottles. So when a shard is found from tableware or an ornamental object such as Milk glass, Slag glass, or even Vaseline glass, it is particularly rewarding. When the type of glass is known, it can lead to an estimate of its age, especially if it was produced only during a specific time period. Calculating the length of time that the piece of glass has been exposed to the elements is a much greater challenge. This brings up a rather unique dilemma in that ideal pieces of sea glass are substantially etched and worn, which also makes them increasingly difficult to identify.

To increase the probability of properly identifying glass shards, the study of antique bottles and the many detailed references produced by bottle collecting experts is invaluable. Bottle collecting is an immensely popular hobby and remains easily accessible to anyone with interest to learn. For those who appreciate color and form, the lure of bottle collecting may become as irresistible as collecting sea glass. Visiting glass museums, local antique bottle shows, and web sites will also provide the sea-glass enthusiast with a wealth of knowledge.

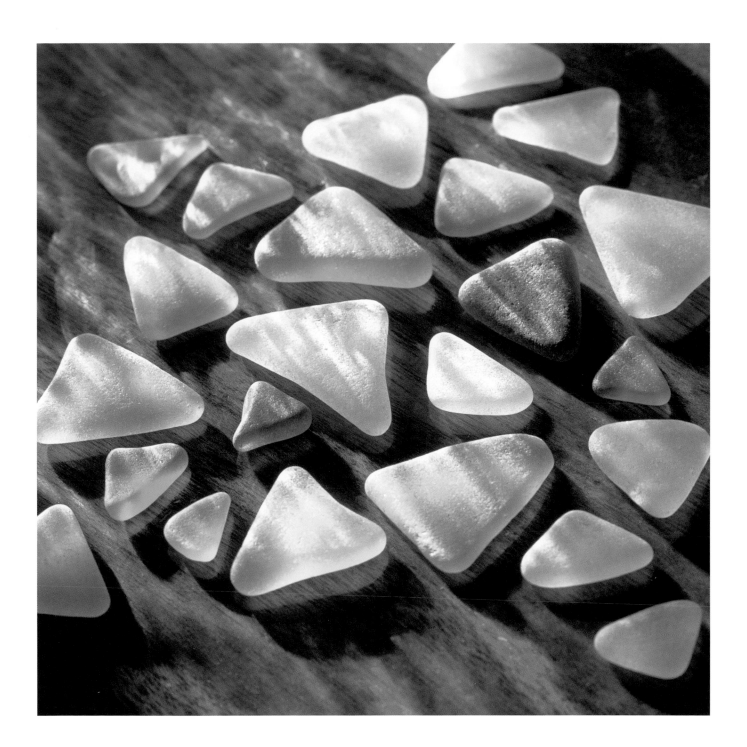

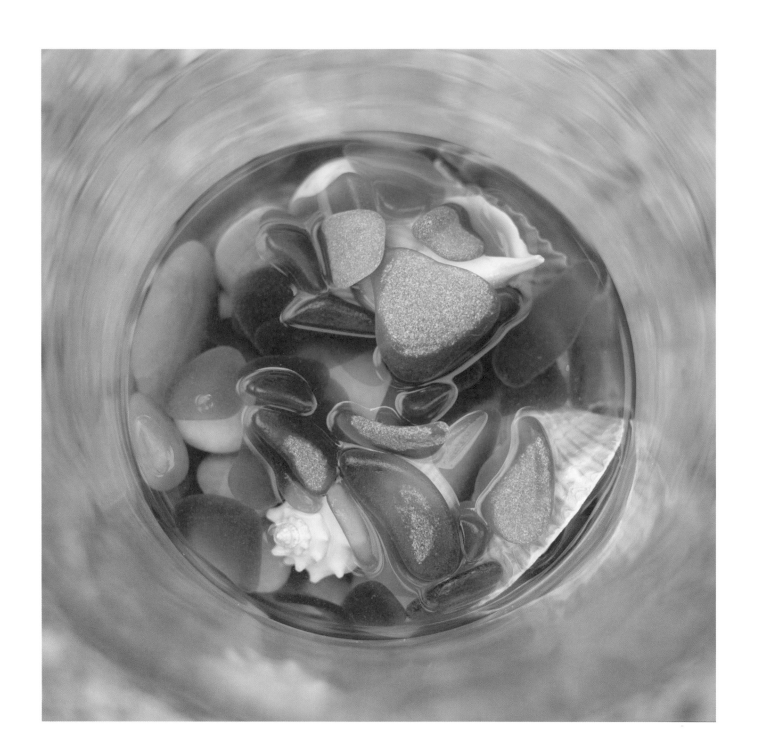

The Value of the Hunt

Many sea-glass collectors simply choose to keep their treasure in jars or bowls, while others enjoy giving pieces to friends and visitors. Some collect for a specific purpose such as jewelry or craft designs. The use of sea glass in jewelry has increased since more people are aware of its diminishing supply. Whatever the reason for collecting, most share the common goal of finding a new piece more exquisite than the last.

There are scores of collectors who simply enjoy the pleasure of spending time along the shore and absorbing the natural benefits from being outdoors. There is a great healing power found where water meets the shore. The rhythmic surf can soften our rough edges as well.

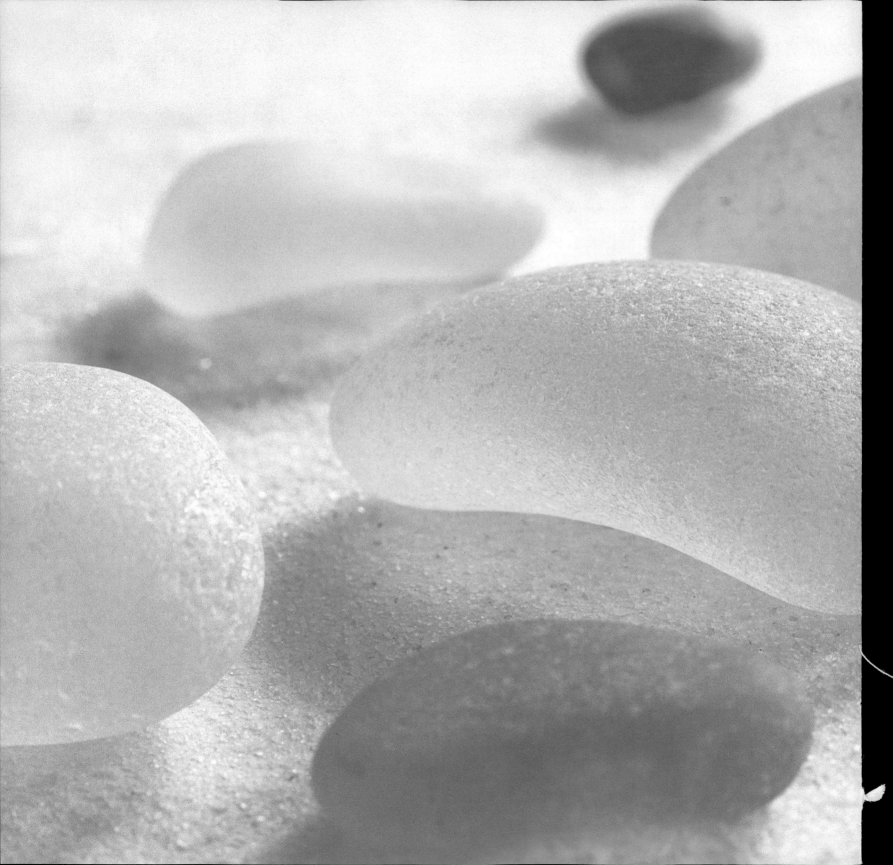

Two
LOCATING SEA GLASS

*Time will bring to
light whatever is
hidden; it will cover
up and conceal
what is now shining
in splendor.*

Horace

Locating Sea Glass

The goal of every collector is to find as rare a treasure as possible. In sea glass, the prize is a highly sought-after color in a softly rounded form. The value of an extraordinary piece of sea glass is unlikely to compare to that of a flawless diamond, but the relative beauty of each justly remains in the eye of the beholder. A diamond is created by nature and arduously refined by man, while sea glass is what man creates and nature refines for us.

An inherent reward for sea-glass hunters is that their quest to locate superior gems leads them to the best venues nature has to offer. Avid sea-glass collectors may be reluctant to relinquish specific directions to their favorite spots in order to protect their future treasures. For many people, searching a favorite beach at a convenient time is more than enough to satisfy and relax the soul. However, for those who wish to increase their chances for greater collecting success, there are several keys to finding the best sea-glass locations and optimal times to look. When collectors know that the conditions are ideal for a hunt, their level of enthusiasm can grow along with the reward.

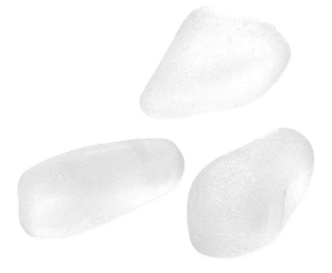

Finding an Ideal Site

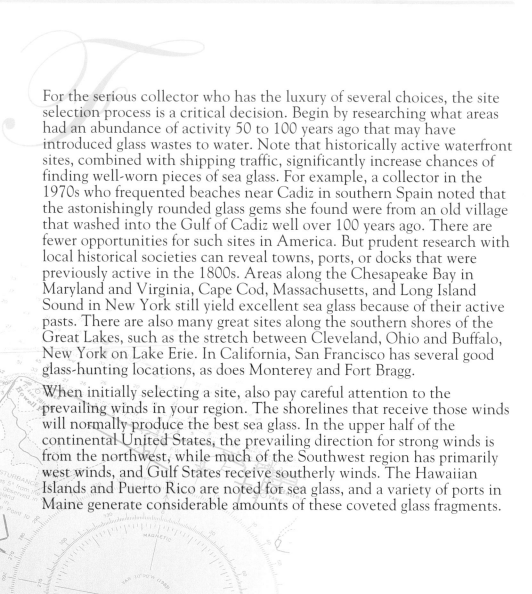

For the serious collector who has the luxury of several choices, the site selection process is a critical decision. Begin by researching what areas had an abundance of activity 50 to 100 years ago that may have introduced glass wastes to water. Note that historically active waterfront sites, combined with shipping traffic, significantly increase chances of finding well-worn pieces of sea glass. For example, a collector in the 1970s who frequented beaches near Cadiz in southern Spain noted that the astonishingly rounded glass gems she found were from an old village that washed into the Gulf of Cadiz well over 100 years ago. There are fewer opportunities for such sites in America. But prudent research with local historical societies can reveal towns, ports, or docks that were previously active in the 1800s. Areas along the Chesapeake Bay in Maryland and Virginia, Cape Cod, Massachusetts, and Long Island Sound in New York still yield excellent sea glass because of their active pasts. There are also many great sites along the southern shores of the Great Lakes, such as the stretch between Cleveland, Ohio and Buffalo, New York on Lake Erie. In California, San Francisco has several good glass-hunting locations, as does Monterey and Fort Bragg.

When initially selecting a site, also pay careful attention to the prevailing winds in your region. The shorelines that receive those winds will normally produce the best sea glass. In the upper half of the continental United States, the prevailing direction for strong winds is from the northwest, while much of the Southwest region has primarily west winds, and Gulf States receive southerly winds. The Hawaiian Islands and Puerto Rico are noted for sea glass, and a variety of ports in Maine generate considerable amounts of these coveted glass fragments.

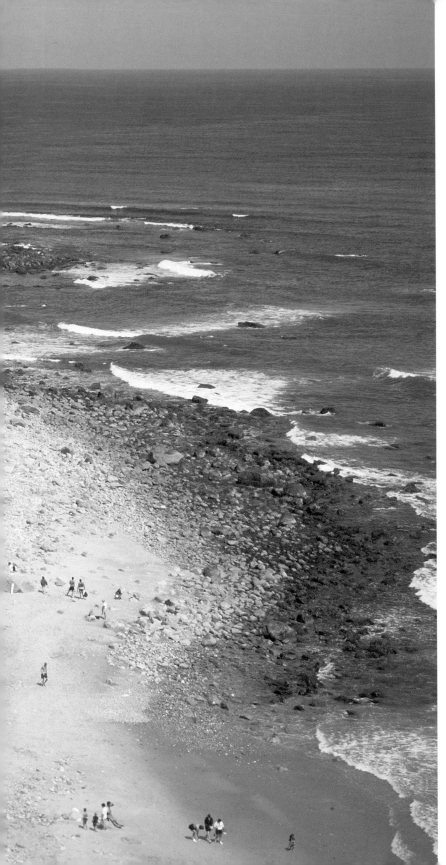

The classic beaches of the Atlantic, such as the Outer Banks of North Carolina, can occasionally provide prized bounty following a strong northeasterly storm. There the pieces of glass and other debris are often spread far and wide, so it could take extra time to get a handful of sea glass. Some beaches prone to erosion have been given generous beach replenishments of sand that contain little or no glass at all. This reduces opportunities for sea-glass collectors but protects valuable property. The long-term effects of rising water levels along the shoreline will be covered in more detail in the last chapter.

Wherever shipping channels come close to the shore, or even where small boat traffic is active, there are sites that are normally more productive for sea glass. The use of nautical charts to determine the points where vessels pass near the shoreline or approach local ports is quite effective. Though times have changed, careless boaters were once frequent contributors of glass items to aquatic environments. Discover a place along the shore where locals discarded household items years ago, and chances are very good of finding a broad array of sea glass. If that spot is often buffeted by strong onshore winds and has an abrasive surface at the water's edge, it is an ideal place to find well-worn shards.

Predicting Wind & Its Direction

In addition to the advantages of a broadly washed beach, strong winds can clear dry sand away from stones and glass, sometimes leaving them perched on a shallow pedestal. One method to predict wind and its direction is to look at a current weather map that shows "isobar" lines. Isobar lines are displayed as thin white rings around either a low- or high-pressure system, symbolized by an (L) or (H). These rings represent changes in pressure gradients, and wherever these lines are tightly packed together, the strongest winds will blow. This often occurs where a strong low-pressure system is running into a high-pressure system, and vice versa. Since the counterclockwise winds that rotate around the low (L) combine with clockwise winds rotating around the high (H), the areas where the two systems merge can create strong winds in a very predictable direction.

Take note of the wind directions predicted for the day by the local weather reporter. Also look for abrupt temperature changes of 15 to 20 degrees as these usually indicate a changing weather pattern often accompanied by strong wind. If strong on-shore winds are forecasted, the low tide may be much higher than normal. If the beach is small, the hunt may be cut short.

Sun, Shade, and Color

Bright sunlight can illuminate some glass pieces on the sand, but under dark hazy skies, a different visual opportunity exists. According to Nathan Cabot Cole in his book, *Abstraction in Art and Nature,* shades of blue, green, and purple will intensify in shadows. Thus, intensely sunny days have a minor drawback. Softly colored purple or pastel blue pieces may appear as less desirable white sea glass and can be ignored by a selective collector.

Sunglasses can also diminish your ability to find pieces since they can often mute colors. In the early morning or late evening hours, the strong shadows that fall on stone-laden beaches can sometimes hide glass shards. Also, try to avoid looking into your own shadow during these times since it will obscure much-needed light.

It can be amazing to realize how much sea glass one person can miss when searching a beach without assistance. Some may prefer searching for sea glass alone, in almost a meditative state, as the approach to one's hobby is a matter of personal preference. Over the years, we have observed that some individuals tend to locate certain colors more readily than others. For example, women are more likely to spot light pink or lavender pieces than men. Adult men appear more prone to pass by soft pastel colors and focus on bolder colors with greater contrast to the surrounding environment. However, with practice, almost anyone can develop a keen eye for spotting sea glass. This becomes a source of amazement to novices who tend to look curiously at the seasoned collector and comment that they never seem to find as much.

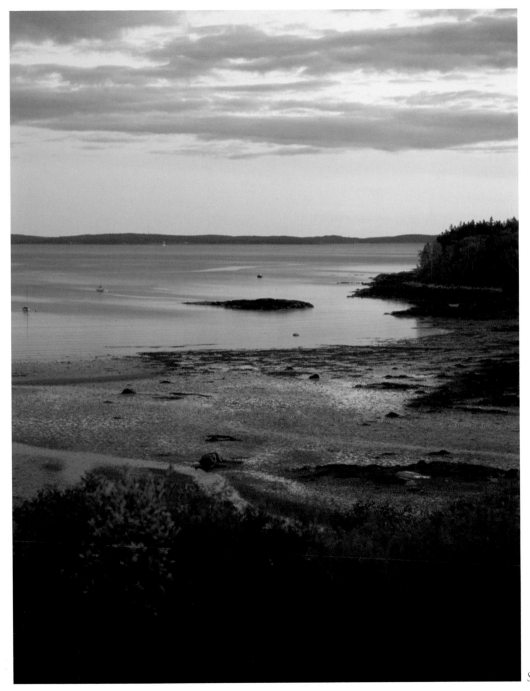

*The tide rises,
the tide falls,
The twilight
darkens, the
curlew calls;
....
The little waves,
with their soft,
white hands,
Efface the
footprints in the
sands, And the
tide rises, the
tide falls.*

Henry Wadsworth
Longfellow

Seal Cove, Maine

Searching Specific Areas of the Shoreline

When the water level shifts from a high to low tide, small to mid-sized pieces of sea glass can be found along distinct tidal lines. Petite glass shards are not particularly heavy and are carried to a lower point on the shore where the gentlest of waves have left them exposed. Though not a rule, it appears that larger pieces of sea glass often can be found further up the beach, away from the shoreline. This is likely a result of being exposed from their embedded residence.

Block Island, Rhode Island

Sea glass from deep beneath the surface of the sand is an essential contributor to a collector's bounty. Uncovered by a receding tide, some of these glass pieces may have spent a century in hiding. While some presume sea glass was only found after being washed ashore by the waves of recent days, it is evident that glass embedded in the sand and stone accounts for a vast amount of sea glass uncovered for the first time. On beaches laden with heavy stones, this unearthing process is, of course, far less likely. Rain is another contributor to exposed sea glass. Fossil collectors are well aware of the benefits of rain for revealing lost artifacts. Heavy rain showers can leave pieces of sea glass perched on small plateaus as the sand is washed away around it.

Small stones and sea glass are transients. When a deposit of small stones is found gathered in a specific area of a sandy beach, take a close look and consider sifting through the debris. If a jetty or some other protruding structure is on the beach, look nearby as waves often deposit abundant debris along such formations. Because sea glass can be swiftly washed across the sand, it is more likely to be found in a secure resting place between stones that have been compiled by receding waves.

The contributing elements that transform a piece of glass to a gemlike treasure with significantly frosted surfaces and softly ground edges are related to its environment and the structure of the glass itself. Water in frequent motion along with rough terrain create ideal conditions for producing well-worn sea glass. The glass and stones are initially worn smooth from traveling in zigzag patterns across the shore by lapping waves. This process is affected by daily changes in wind direction. The more frequent and aggressive the wave action, the more trips some pieces make across the abrasive terrain. Thus, calm waters will simply not produce rounded sea glass.

A collector is less likely to find premium pieces of sea glass on small freshwater lakes or rivers if silt and mud predominate the shore and if winds are rarely strong. Specific water conditions and the type of glass left in the aqueous environment also contribute to the level of surface corrosion.

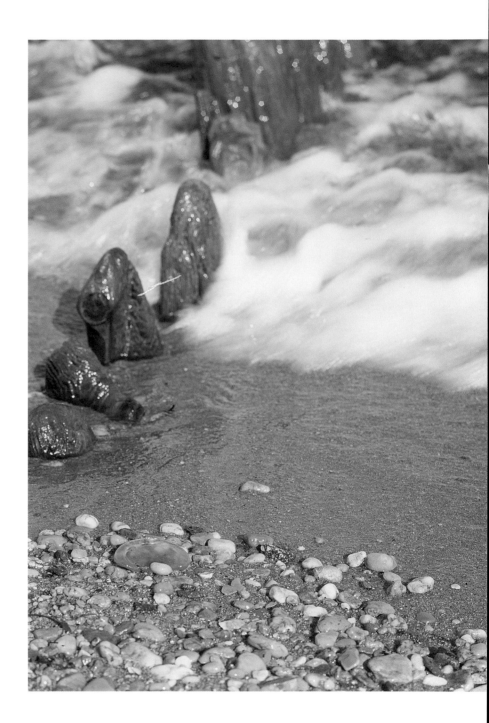

Three
CONDITIONING
& WEATHERING

Things perfected by nature are better than those finished by art.

Marcus Tullius Cicero

Conditioning & Weathering

Rough water washing against sand and stone contributes greatly to the formation of sea-glass fragments. When glass endures prolonged exposure to water, its surface becomes hydrated and subject to aggressive corrosion. Specific types of water chemistries will cause different forms of corrosion. Frosted pieces of premium sea glass are quite often the result of extended exposure to an abrasive environment with high pH saltwater.

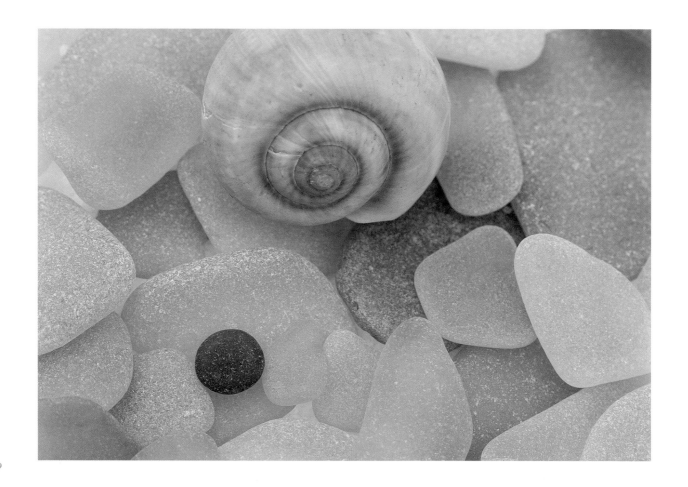

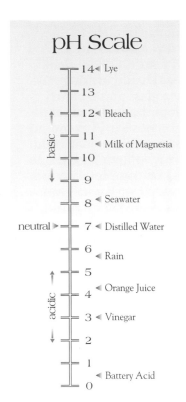

pH Scale

14 ◄ Lye

13

12 ◄ Bleach

11
 ◄ Milk of Magnesia

10

9

8 ◄ Seawater

7 ◄ Distilled Water

6
 ◄ Rain

5

4 ◄ Orange Juice

3 ◄ Vinegar

2

1
 ◄ Battery Acid

0

basic

neutral ►

acidic

Water is measured on a pH scale from 0 to 14, which relates to its acidic or basic composition, with 7 being the neutral value in the middle. Solutions below a pH of 7 are called "acidic" (examples include battery acid and lemon juice). Solutions above pH 7 are called "basic" (examples are seawater and bleach). The reason one body of water is different from another is due to the dissolved solids and gasses in the water. Seawater contains calcium and carbon dioxide giving it a pH of at least 8.

Many have questioned if there is a difference between sea glass and beach glass. Both terms refer to glass shards worn smooth by their aqueous surroundings. The specific type of environment—seawater or freshwater—is a logical separator since they normally have different water chemistries. Seawater, or even brackish water, has a slightly higher natural pH level that is far more conducive to leaving glass with a frosted surface. Freshwater usually has a more neutral to slightly high pH level, making it less aggressive.

While it could be argued that freshwater shards should be called beach glass because they are less weathered, there are notable exceptions. For example, the freshwater of Lake Erie is normally at a pH level of 8 to 9 and yields great frosted sea glass along its south shore.

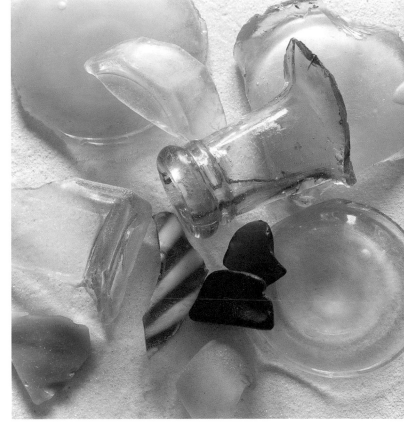

Antique glass shards found on a non-abrasive shore

Glass Composition

Glass is a very enigmatic substance. It appears to be a solid material, but deep within, there is the random molecular structure of a liquid, not the geometrically aligned molecules found in crystalline solids. Its components are heated to nearly a liquid form and then cooled just shy of a crystalline state by using a precisely controlled annealing process (slow cooling) to avoid shattering.

The three essential ingredients in commonly made glass are silica (sand) as the base component, soda (sodium bicarbonate) used to promote melting at around 2,400 degrees Fahrenheit, and lime (calcium oxide) to make the molten glass less soluble and easier to form. These are the primary components of what is known as "soda-lime-silica glass," customarily referred to as "soda-lime glass." This is the least expensive to make and the easiest to work with, so it has remained a primary glass recipe for thousands of years. Though many forms of more durable glass are made today, as much as 90 percent of the glass being produced is still the economical, soda-lime form. This is good news for sea-glass collectors since it is also the type of glass most prone to degradation. Unfortunately, small amounts of stabilizers, such as aluminum and magnesium, are now added to help protect glass from moisture deterioration.

Recipe for traditional soda-lime glass:

75% silica sand

15% soda (sodium bicarbonate)

10% lime (calcium oxide)

Broken glass called "cullet" is often added to aid the melting process and add color.

While the common element in glass is silica, numerous other materials are used to produce different forms of glass. One popular variety was "leaded glass," composed of 30 percent lead oxide, which was added to produce an ultra clear and sturdy form of glass tableware commonly known as lead crystal. England's George Ravenscroft first discovered lead crystal back in 1674 and spent several years perfecting his formula. It rapidly became an international favorite for fine cut-glass tableware.

In cookware, "borosilicate glass" is extensively used, which is primarily silica but with 13 percent boric acid and a small amount of aluminum added. Corning's Pyrex brand and Kimble's Kimax brand of consumer cookware are well-known forms of this shatterproof glass. According to Corning, one of the original reasons behind the development of borosilicate glass was to increase the heat resistance for railroad lanterns used for signaling trains to stop. Prior to this invention, the glass in the lantern could shatter when exposed to cold and wet weather.

A more recent form of glass is called "fused silica." It is made from raw quartz and is extremely heat-resistant and clear. Italians on the remote Venetian island of Murano first used crushed quartz back in the 1460s to create an exceptionally clear glass they called *cristallo*, but it was considered too expensive for high volume production. Today, halogen lamps are made of fused silica. The remarkable quality of this advanced form of glass makes it less attractive to sea-glass collectors because of its strong resistance to weathering.

The Conditioning Process

Tidal shifts, currents, and wave movement along rough shorelines mutually assist the physical conditioning of sea glass. Many have assumed that the pounding surf alone creates the soft, rounded edges of glass shards. However, significant abrasions also come from aggressive lateral movement of the glass within the littoral zone, just offshore. Strong currents, along with wave action, increase the overall etching of sea glass. It is a simple matter of physics that glass shards in shallow water will be moving at a much greater velocity across abrasive terrain than shards resting in deep water. In narrow channels, where the swift tide routinely moves water in a forceful manner, the opportunities for advanced conditioning are outstanding. Seashore undertows can be quite hazardous to swimmers, but the strong lateral flow they create helps the tumbling of potential sea glass.

It is not merely the time in the water that creates great sea glass. Much of it remains embedded in the sand and shifts from its resting place several times. This process can be observed by watching beds of small stones migrate several yards in just days. In general, stones often travel in a zigzag pattern along the edges of the shoreline as they are slowly eroded into additional grains of sand. This entire process can take hundreds to thousands of years.

Having a new appreciation for the length of time that rounded pebbles spend on the shore, one mystery is why sea glass is so rarely found in bulbous forms. Since most sea glass comes from bottles, and bottles are normally tapered and bulb-shaped, it stands to reason that pieces of sea glass would develop in curved forms. Yet the disorganized molecular structure within glass and the unpredictability of abrupt damage produce sea glass in all shapes. The most common form is actually a triangle.

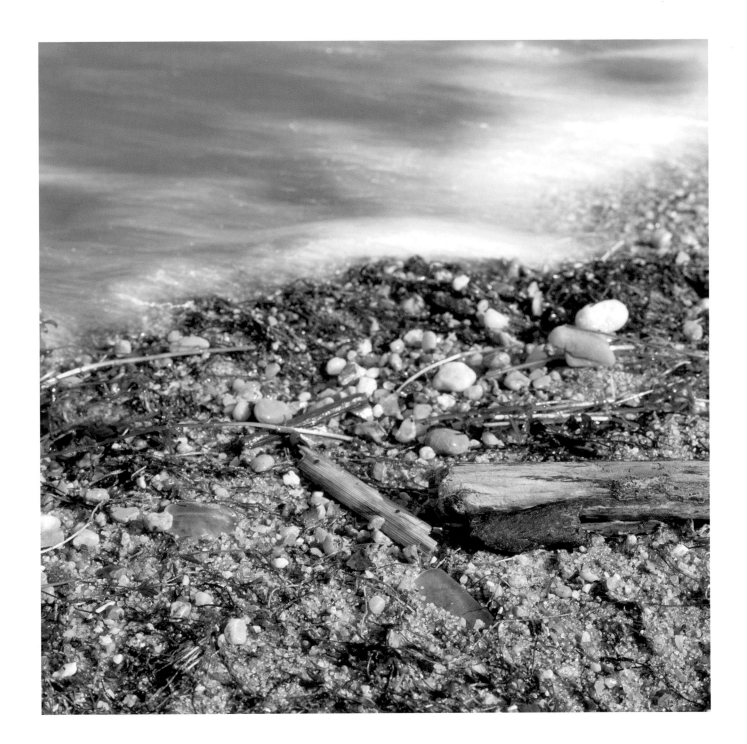

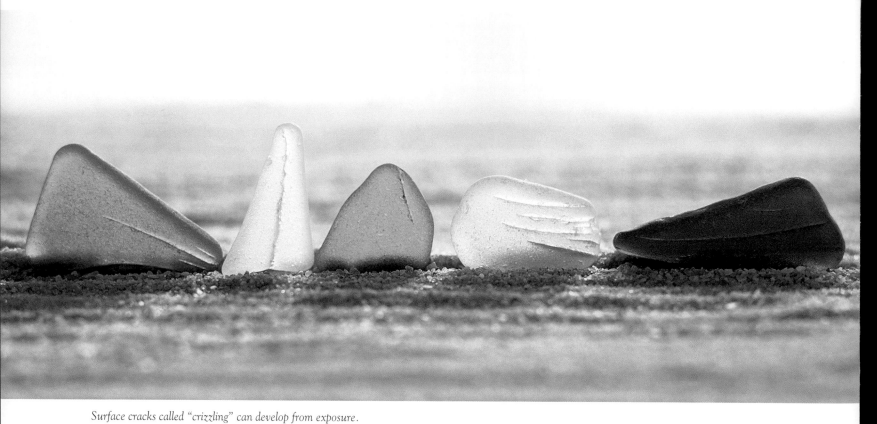

Surface cracks called "crizzling" can develop from exposure.

One explanation for numerous triangular shapes may be the effects of weathering. When the wet, saturated surface of a glass shard is exposed to freezing conditions, surface cracks can appear that are referred to as "crizzling." Advanced stages of weathering can even cause breakage. Since most bottle glass is relatively thin, pieces will then lie on their side and tumble for years into triangular shapes.

Stress lines that look like cracks can also appear on the surface of sea-glass shards. These could be from a manufacturing defect called "crazing," which is common to hand-blown historic bottles. Diagonal stretch marks occurred when the bottle's lip was being hand-tooled and the neck of the bottle was twisted slightly in the process.

The rare bulb-shaped forms of sea glass are usually from thick shards of historic bottle glass. It is possible to discover a nearly round piece from what is known as a "kick up" in the center of a bottle bottom. Often made of much thicker glass, these can be found in colors such as dark brown or dark green. They range in size from a penny to a quarter and were regularly part of wine bottles. These are considered a coveted prize for the avid sea-glass hunter.

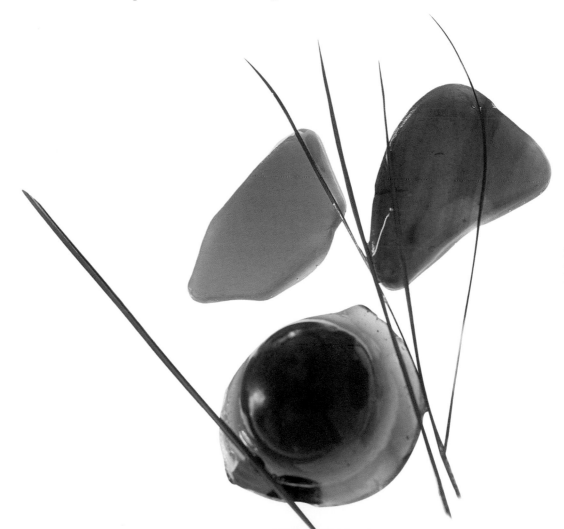

The Weathering Process

Glass is often thought to be highly resistant to chemical attack. Glass is, however, subject to slow corrosion by water. Over a long period of time moisture will leach out the soda and lime in glass and leave behind a silicate skeleton.

Dr. Cecil Munsey,
The Illustrated Guide
to Collecting Bottles

Writers commonly refer to sea glass as exquisitely "frosted shards." However, most people have little understanding of what actually creates this phenomenon. What has long been a mystery to sea-glass collectors has been familiar to glass scientists and archaeologists for years. Earlier in this chapter, the ingredients of glass were discussed in detail. As noted by Dr. Cecil Munsey, two of the primary components within glass are actually extracted from its surface through a process known as "hydration."

The basic form of soda-lime glass contains sodium bicarbonate. In the process of hydration, the hydrogen ions in water replace the sodium ions (soda) in glass, creating sodium hydroxide. The sodium hydroxide is then leached from the surface of the glass. The water actually binds with (hydrates) the glass, thus beginning a slow corrosion or pitting process. This weathering process is greatly assisted at higher pH levels, such as those found in saltwater oceans and estuaries, by actually dissolving the silica structure. High levels of carbon dioxide in seawater add to the destruction of the glass, thus increasing the weathering process. This procedure enables the glass surface to slowly become altered in almost a sponge-like manner. Upon removal from water, the dried surface of the glass can display powdery crystal formations from the glass corrosion process. This crystalline forming process is referred to in this text as "devitrification." It can take decades of aquatic exposure for this condition to be obvious to the naked eye.

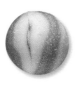
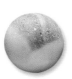

Crystalline formations develop as sodium and lime are leached from the surface of glass. Olive oil added on the right side conceals the frosted patina, restoring color. Actual size ½ inch square.

Initially, sea glass becomes cloudy primarily due to light being scattered across its scratched and pitted surface. But in time, small white deposits can develop on the glass surface and begin to crystallize to a point where they cannot be removed. The only methods for removal are to melt the glass again or to use special coatings that cover up the powdery surfaces to restore the initial color. However, the original clarity and gloss become lost.

Most glass chemists, archaeologists, and restoration experts are familiar with this form of devitrification in which the white hazy surfaces of glass appear covered in crystalline material. However, geologists who study obsidian (a dark natural glass formed by the cooling of molten lava) and other prehistoric rocks identify devitrification differently—as the white, snowflake-like crystals that take thousands of years to develop within the surface of volcanic rock.

While it is unlikely sea-glass hunters have been familiar with the chemistry of glass corrosion, the processes are essential to the making of pure sea glass. As mentioned previously, most collectors assume that the gently frosted surfaces of glass are smoothed only by the constant pounding of its surface against abrasive sand and stone. While this practice does account for much of the initial conditioning, it is the constant hydration and corrosion of glass that creates the crystalline patina characteristic of sea glass. It also contributes to the amount of pitting and flaking away of the soda-lime glass surface. The severity of the pitted glass surface resulting from the dissolution of the silica and other components depends also on the amount of these constituents used in the original batch of glass. A little too much soda and lime in the batch will make the glass more prone to pitting.

In some cases, the hydration process will also extract small circular flakes. These flakes can be seen with the human eye as recognizable "C" shaped patterns. This becomes a great telltale for old glass, as well as a means to verify pure sea glass from imitations.

Small "C" shaped patterns on genuine sea glass result from hydrated glass in an abrasive environment. Actual size ½ inch square.

Most of the imitation sea glass made today has a noticeable silky texture with very little surface pitting other than a uniform haze. Suppliers will often provide warnings regarding handling and use of this glass if it was etched with a strong (hydrofluoric) acid. These sometimes come in bags for flower displays or decorative uses but are not well suited for aquarium tanks with pH-sensitive fish. The hard edges and fracture marks of imitation sea glass can be easily spotted, as well as a general lack of the variable textures characteristic of pure sea glass.

Collectors that walk the beaches of oceans and estuaries are privileged since their higher pH environments will produce far more frosted gems. This desirable sea-glass trait is not from the exposure to salt in the water, as many have thought. It is the decomposition from contact with high pH water that creates this desirable look. Exposure to radiant heat aids the weathering process, so occasional sunbathing is another one of Mother Nature's contributions to the physical breakdown of hydrated glass.

Antique glass buttons found near a 1900 resort. Actual size ⅓ inch diameter.

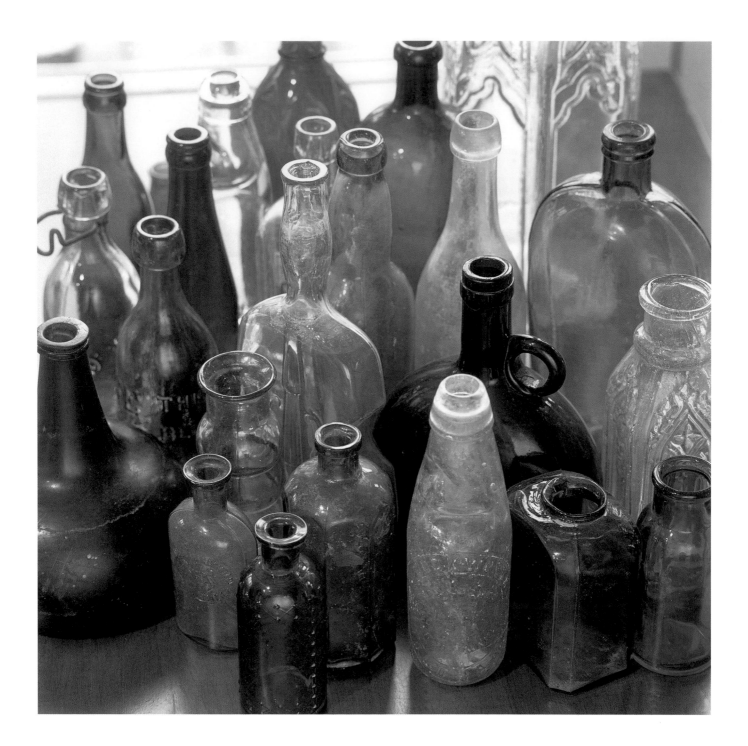

Glass History

The essential ingredients in common glass have remained virtually the same for over 4,000 years. It has been argued that the first glass was actually used to decorate pottery or to make beads. Most researchers agree that the earliest glass creations came from an area of the Middle East near Iraq.

The following time line shows major events in the history of glass. Of special interest is the date when glassblowing first started around roughly 250 BC. This date is widely debated, but most concur it was the blowpipe that began the rapid proliferation of glass vessels through all levels of society. The first significant event on U.S. soil was at the settlement of Jamestown, Virginia in 1608. The English were desperate to resolve their problems with deforestation at home due to the amount of wood needed to run both the country's glass and iron furnaces. Consequently, glass was America's first manufactured and exported industrial good. Fragments of "Crown glass" used for windows were excavated at Jamestown showing marks of on-site manufacturing. Unfortunately, the colony and its glass-making venture were short-lived.

It took more than 100 years before the glass industry had its first successful factory in America. Located in southern New Jersey, it was founded by Caspar Wistar in 1739 and operated for 40 years.

For several thousand years, glass containers were hand blown into simple, one cavity, base molds (used to form the bottom half of containers). Molds to form container walls began to evolve in the early 19th century. By the mid-1800s, bottles were being hand blown into molds shaping all but the upper neck and lip. At the same time, plunger-style presses were developed to create decorative tableware. In the late 1800s, hinged, three-part molds were in prevalent use for bottle manufacturing.

By the early 1900s, the birth of the automated glass bottle machine altered everything. Bottles were soon being produced in the millions in many U.S. glass houses. Then in the 1960s, the broad success of unbreakable metal and plastic containers severely impacted what was one of the nation's largest industries, thus turning the tide on the future development of sea glass.

2500 BC	Mesopotamia (now Iraq), Syria and Egypt have evidence of early glass beads.
1500 BC	Egyptians make glass vessels using a sand-core mold.
900 BC	Syria and Greece produce glass.
650 BC	The first known glass-making handbook is carved on stone tablets (Assyrian Assurbanipal's library).
500 BC	Venetian glass artists begin to develop their glass expertise.
250 BC	Babylonians discover glassblowing.
100 BC	Glassblowing begins to revolutionize glass containers throughout the Near East. Prior to this, glass was sometimes as highly valued as gold and silver. Glass making in Cologne, Germany also begins.
50 BC	Syro-Palestine glassblowing develops. Phoenicians begin to work with glass.

AD (anno Domini)

400	Egyptians and Syrians bring glass to China.
1200	Venice becomes the glass-making center of the world and develops a strong monopoly on glass by the 1400s.
1284	Eyeglasses are invented by Salvino D'Armate in Italy.
1291	Venetian government moves all glassmakers and their production to the nearby island of Murano.*
1300	English develop sheet glass for windows called "Crown glass."
1450	Clear, soda-lime glass called "cristallo" is developed by Venetians on Murano.
1500	Despite government laws and death threats designed to protect the nation's glass-making secrets, Venetians began spreading into France, Germany, and England to start glass houses.
1590	First glass telescope and microscope lenses are produced in the Netherlands.
1600	Germans in Bohemia develop a reputation for making colorful and decoratively engraved glass.

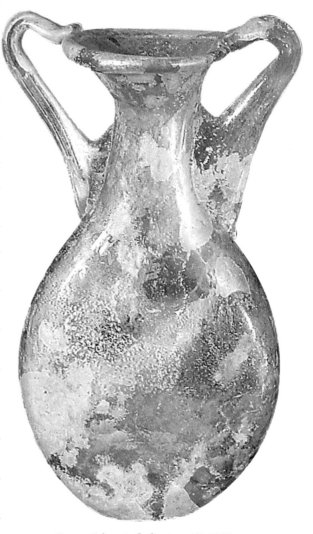

Roman Pilgrim's flask, circa AD 1000

1608	Jamestown, Virginia, after being settled in 1607, becomes the first glass-making site in America.
1665	French develop the plate-glass industry using a special polishing technique.
1674	England's George Ravenscroft develops "Lead glass" with exceptional clarity.
1739	Alloway, New Jersey, Caspar Wistar starts the first successful American glass factory.
1752	First sunglasses made by James Ayscough of London, England.
1765	Manheim, Pennsylvania, Henry William Stiegel starts one of several successful glass-manufacturing houses.
1784	Frederick, Maryland, John Frederick Amelung opens the New Bremen "Glass-House."
1814	First mold-made bottles are produced by Henry Ricketts and Company of Bristol, England.
1821	Hand-operated split mold is designed and greatly increases bottle production.
1825	John P. Bakewell of Bakewell, Page and Bakewell in Pittsburgh, Pennsylvania patents the first mechanical hot-glass press beginning the "Pressed glass" era.
1850	Elias Greiner of Germany develops commercially produced toy marbles.
1857	Friedrich Siemens of Germany invents the regenerative furnace that redirected heat back into the furnace and conserved tremendous energy.
1858	Mason home-food canning jar is introduced. Patent is granted for a zinc screw lid.
1883	Pittsburgh Plate Glass is the first successful U.S. manufacturer of plate glass.
1892	William Painter of Baltimore creates the "Crown Cork" seal that replaced the Hutchinson stopper by 1912 and remains today as an industry standard.
1903	Michael Owens invents a bottle-blowing machine, changing the industry by 1905. Patent granted on August 2, 1904 for his innovative "glass-shaping machine."
1915	The fluted, "hobble-skirt" soda bottle design is developed by Coca-Cola.
1919	Corning Glass Works patents Pyrex using borosilicate glass.
1920	Prohibition in the United States helps create a demand surge for bitters bottles and soda bottles.
1926	Corning's "ribbon" glass process produces 1,000 light bulbs per minute.
1933	Prohibition ends. Bottles for beer and other alcohol must be embossed with text noting "Federal law prohibits resale and re-use of bottles" until 1964.
1959	Sir Alistair Pilkington (England) patents the "Float glass" technique revolutionizing the making of flat glass over a bath of molten tin.

*In 1291, the Venetian government forced glassmakers onto the small island of Murano to protect Venice from potential fires. The Venetian government knew their glass-making enterprise was a tremendous resource. In a short time, their glassmakers became known as the world's finest. It has long been speculated that the island was almost a prison since anyone thinking of leaving knew that it might cost him his life. In time, the occupation provided one benefit as the daughters of Murano craftsmen were permitted to wed into Venice's high society. Murano remains a great destination for art-glass enthusiasts today.

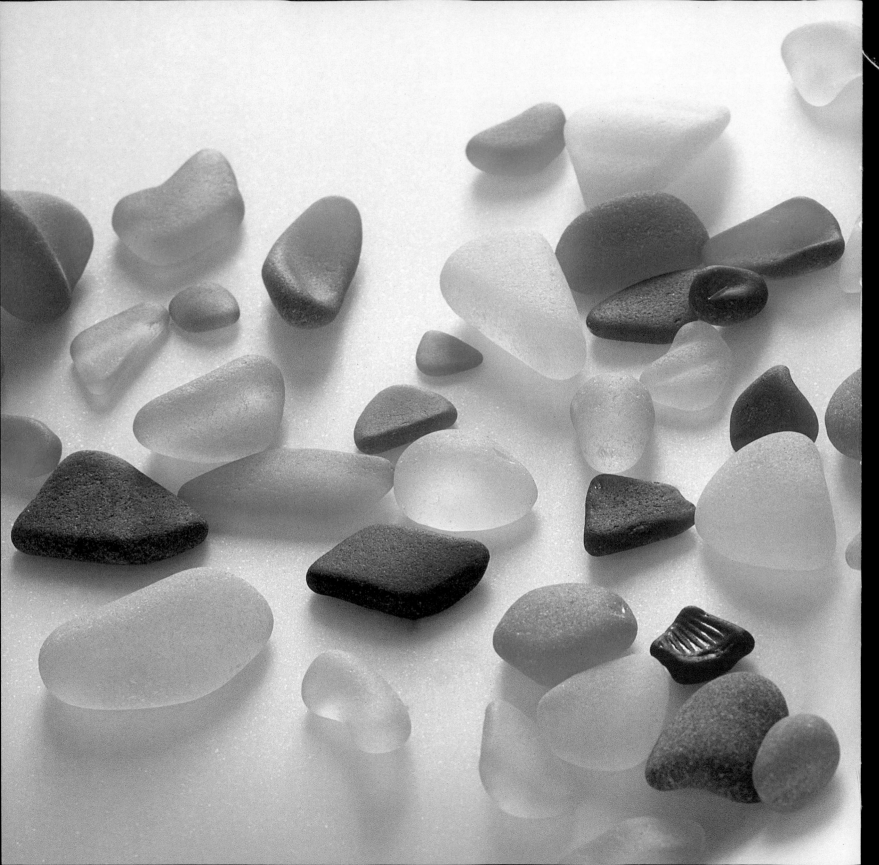

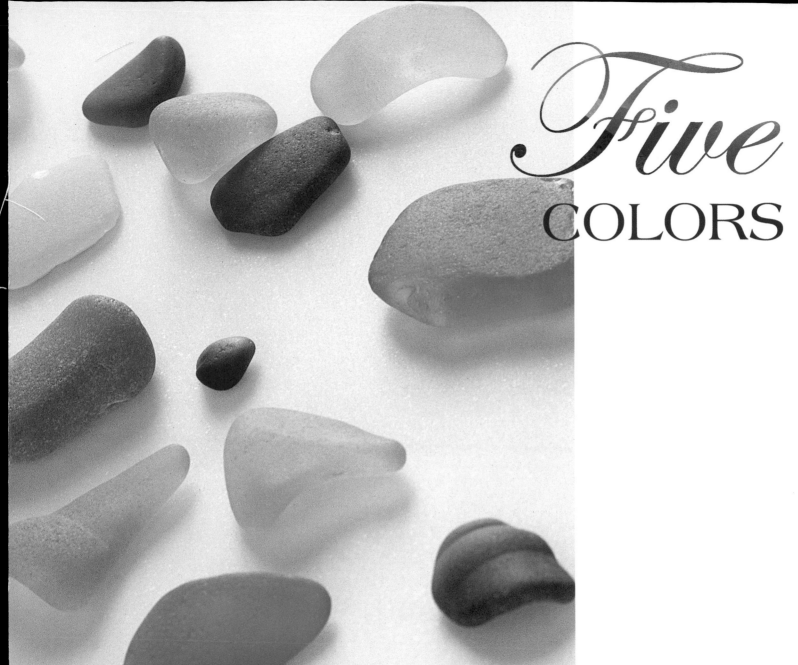

Five
COLORS

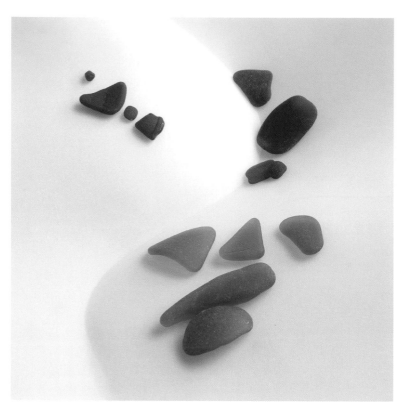

Male Colors

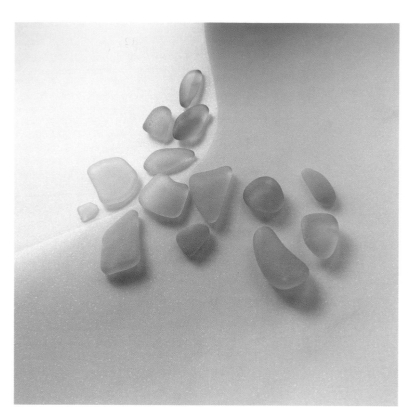

Female Colors

Colors

At the dawn of each new day, sunlight illuminates everything that surrounds us. Without light there is no color. We are trained at an early age how to distinguish one color from another as they activate one of our most acute senses by sending signals to our brain. The way in which color affects emotion is assimilated over time and varies greatly from one individual to the next. It is our highly valued sense of sight that allows us to fully appreciate the complete spectrum of colors created by light. Author Henry David Thoreau once called the eye "the jewel of the body," and Leonardo DaVinci pointed out that the first move of a suddenly threatened man is to protect his eyes.

Experts who study color preferences have found that a person's gender and age will frequently influence what they consider as their favorite colors. They agree that men prefer bright, rich colors such as cobalt blue, jade green, orange, and red while women normally prefer the softer tones of aqua, pale green, pink, and lavender.

By carefully exploring the range of colors found in glass, it becomes easier to date certain shards and begin to understand why some colors are significantly more rare than others. Several thousand years ago, glassmakers made incredible accomplishments in the area of color development. Many of the substances used then are still in use today. The ancient Egyptians and Romans made frequent use of the element cobalt to create glass beads and other glassware in deep blue. They also produced glass in several other colors by using specific chemical elements that were often mined for other purposes. Manganese, copper, and iron are several examples.

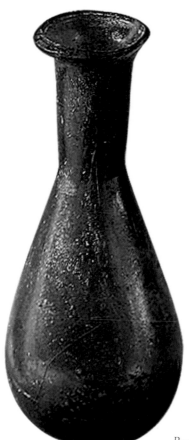

Roman flask, circa 100 BC to AD 100

Czechoslovakian art glass

By the year 1666, Sir Isaac Newton had designed the first "color wheel" after directing a beam of white light from a covered window through a glass prism. His wheel displayed what is now known as the three primary colors of red, yellow, and blue along with secondary colors of orange, green, indigo, and violet. Although scientists no longer recognize indigo as a color in the spectrum of light, much of his initial work has stood the test of time. It appears quite by coincidence, though, that the three primary colors are also three of the more difficult sea-glass colors to find. Newton's "color wheel" also introduced the concept of "complementary pairs" of colors. These are colors that are opposite each other on the color wheel, and when they are placed together, as in a batch of glass, the resulting product is colorless.

Most sea-glass hunters will readily admit that they have a favorite color and will often note their desire to find more of it. Their luck is directly proportional to their site selection, level of persistence, and above all, the amount of glass originally manufactured in the color they prefer. Serious collectors will often concur that in order of rarity, true red and yellow stand out as two of the most challenging colors to find. Orange, however, is consistently overlooked and is undoubtedly the most rare sea-glass color of all. This is principally due to the fact that orange was almost never used in bottle glass, rather it was used in tableware items, mostly during the glory days of Depression glass in the 1930s.

Bottles are by far the most common source of sea glass. This is due to the decades of enormous bottle production in the late 19th and early 20th centuries. The greatest variety of colored bottle shards comes from the late 1800s, before clear glass bottles became popular. The other principal forms of sea glass include tableware and flat glass. While limited amounts of glass tableware were discarded, what can be found offers the collector an extraordinary assortment of colors. Flat glass from windows, picture frames, or windshields is much more limited in overall color diversity unless someone is fortunate enough to find stained glass or rare panes of Pattern glass.

Making Colored Glass

The physics and chemistry involved in the creation of a specific glass color can be extremely complex. As formulas have evolved over thousands of years, so have the raw materials used to make glass. Thus, a particular element that produces a color in soda-lime glass may impart an entirely different color in potassium-based glass. The amount of a colorant used can also affect the outcome of one glass color, while another influence is the amount of impurities within the raw sand. The temperature of the batch of glass prior to and during its manufacture will affect the atomic structure within the glass melt and therefore its color. For example, glass containing an element such as iron could transform from green to brown simply due to its batch temperature.

The challenge of maintaining consistent colors from one batch to the next was at times easier with some colors than with others. For instance, one of the more resilient colorants is cobalt for making deep blue. But glassmakers would still guard specific color recipes they developed with great care. To maintain reliable colors, these craftsmen would carefully supervise raw materials, the stability of batch temperatures, and even the post-production cooling process in the annealing oven.

Obviously, the difficulty in controlling a color contributed to its rarity, but additional reasons for some colors being more scarce than others include consumer demand and the high costs of certain metal oxides used as colorants. There was also a great challenge to removing undesired color from a batch of glass. That process required the addition of an element that produces a counterbalancing color effect, or adding chemically oxidizing or reducing agents within the glass melt. Clear soda-lime glass was seldom made prior to the late 1800s.

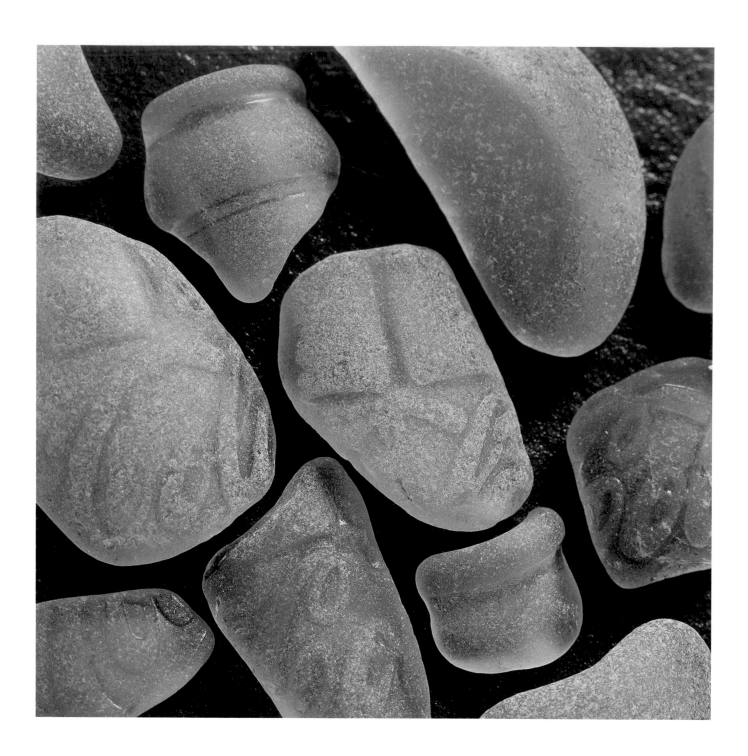

Dating Glass By Color

By 1970, the recycling movement had gathered momentum and the once common habit of throwing away bottles began to shift rapidly. The bounty of bottle glass from the first half of the 20th century currently yields the majority of sea glass still being found today. During that era, most bottles were produced in brown, green, or clear glass as they are now. These colors were less expensive to produce, and brown was frequently used to protect its contents from sunlight. It is the less common colors primarily made before the 20th century such as red, yellow, turquoise, teal, black, and citron that are most treasured by collectors of historic bottles and sea glass.

Color usually is the most significant emotional factor to excite the sea-glass enthusiast. It also provides collectors with valuable information for determining the age and source of glass. Most rugged looking "black glass" dates prior to the mid-1800s, while smoother forms could be remnants of latter-day Depression glass. Yellow-green "Vaseline glass" could date prior to 1930, and ribbed, soft green pieces common to Coca-Cola bottles hail from 1915 to roughly 1970. Meanwhile, a familiar cornflower-blue shard could likely come from a Milk of Magnesia bottle dating to the early to mid-1900s.

Making Unique Colors

When discussing which colors are the most challenging to find, many consider red their most sought after sea-glass color. The reason red is so rare is that gold was normally used as the key colorant to produce ruby-red glass. While copper oxide could have been used to produce red glass under controlled conditions, the guaranteed way to produce a vibrant red was to add a small amount of gold to the batch.

Silver and selenium were colorants for creating a true yellow, but another special ingredient for producing yellow that rivaled gold in scarcity was uranium dioxide. Understanding that the elements used to make red and yellow were both costly and scarce makes it easier to comprehend why so little red, yellow, and orange glass was ever made.

A royal blue was created by using cobalt oxide, and of the three primary colors (red, blue and yellow), is a distant third in rarity. Most sea-glass hunters can find cobalt from time to time, while the elusive red can take some collectors years to find. Three other challenging colors to locate are turquoise, black, and teal. What often appears to be "black glass" is normally an extremely dark green, dark amber, or dark purple color when held against a bright light. If desirable colors are not found on a selected beach, other sites might be more fruitful. It would not be unusual to find entirely different types of glass and colors within a mile of another location.

Note that a piece of soft-colored aqua can be from the same bottle as a piece with a much deeper hue of aqua, since the darker shade might have come from the bottle bottom or rim where the glass is much thicker than on the side wall. A good example is the classic Ball Mason jar where the neck rim is substantially thicker than its thinner side wall.

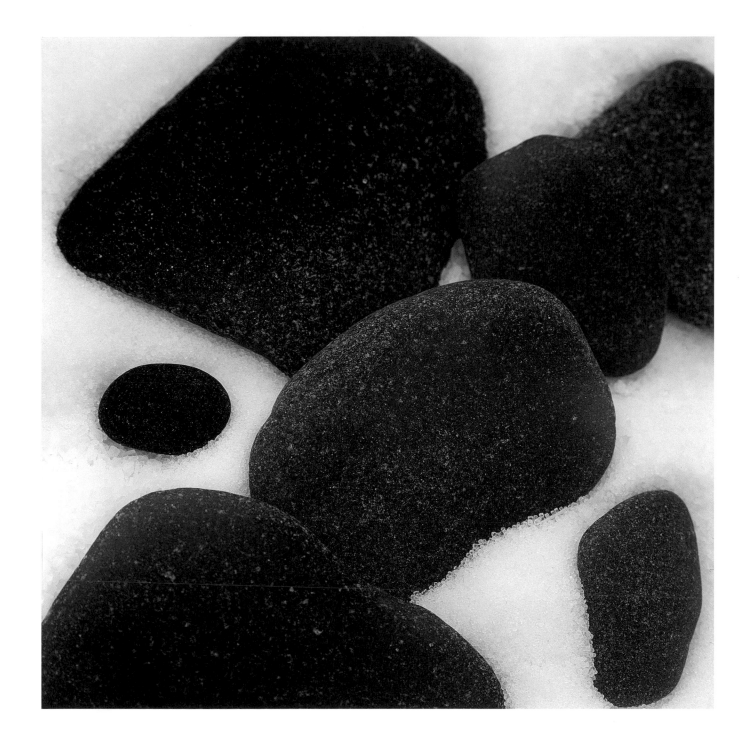

Sorting Sea Glass Colors By Rarity

The following chart is divided into four categories with colors listed within each that are based on years of collecting and sorting close to 30,000 personal pieces of sea glass. Also, interviews with collectors and extensive studies of historical glass have been important to the development of this list. The specific order of extremely rare to common can vary from one collecting location to another.

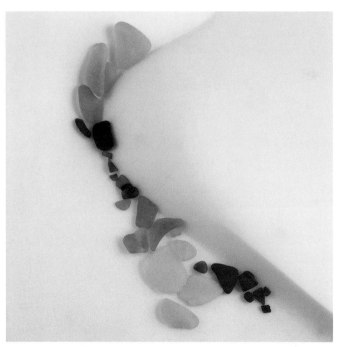

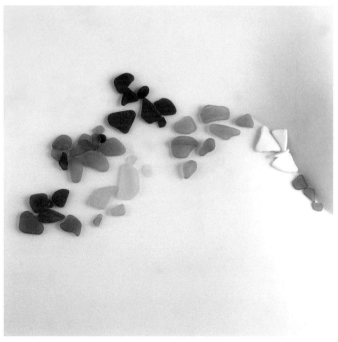

Extremely Rare

Orange	Black
Red	Teal
Turquoise	Gray
Yellow	

Rare

Pink	Opaque White
Aqua	Citron
Cornflower Blue	Purple/Amethyst
Cobalt Blue	

A brief background accompanies each color indicating how it was made, some examples of objects produced, and estimates on how frequently it might be found. Note that less than 1 percent of the 30,000 shards studied would be considered in the ideal refined condition of pure sea glass, and these are shown on the following pages. Those who have accumulated several pieces of the "extremely rare" colors can consider themselves advanced collectors, since it can take years for an ardent hunter to find just one.

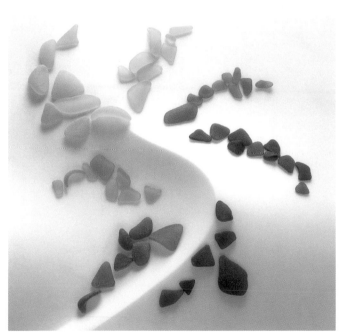

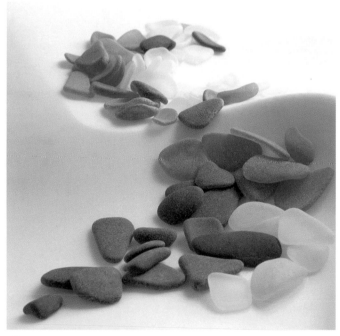

Uncommon

Soft Green	Golden Amber
Soft Blue	Amber
Forest Green	Jade
Lime Green	

Common

Kelly Green
Brown
White (Clear)

Extremely Rare Colors

Orange

Orange sea glass from original orange glass, not golden amber or Amberina, is the most rare of all. Several glass manufacturers (Jeanette, Federal, Fire-King, and Imperial) made translucent orange tableware they called "iridescent" in the early 1900s, and its pieces are still possible to find. Intensely iridescent "Carnival glass" was also made in orange at that time by exposing the glass to heated metallic vapors that left a distinct rainbow effect on the glass surface.

Producing orange glass by using colorants for making red and yellow was one option, but little documentation exists on making basic orange glass. Selenium combined with cadmium sulfide can produce colors from orange-red to orange-yellow. Pure oxide of iron can also create an orange-red glass color. In reality, the challenge of holding a consistent orange color between batches may have been a key factor that limited production, but another was simply the lack of demand. When it comes to bottle glass, the list of items produced in orange is virtually limited to some rare "Milk glass" versions. Transparent orange sea glass is undoubtedly one of the most rare finds of all. Chances of finding a genuine piece of orange may rate as slim as one in every 10,000 pieces collected.

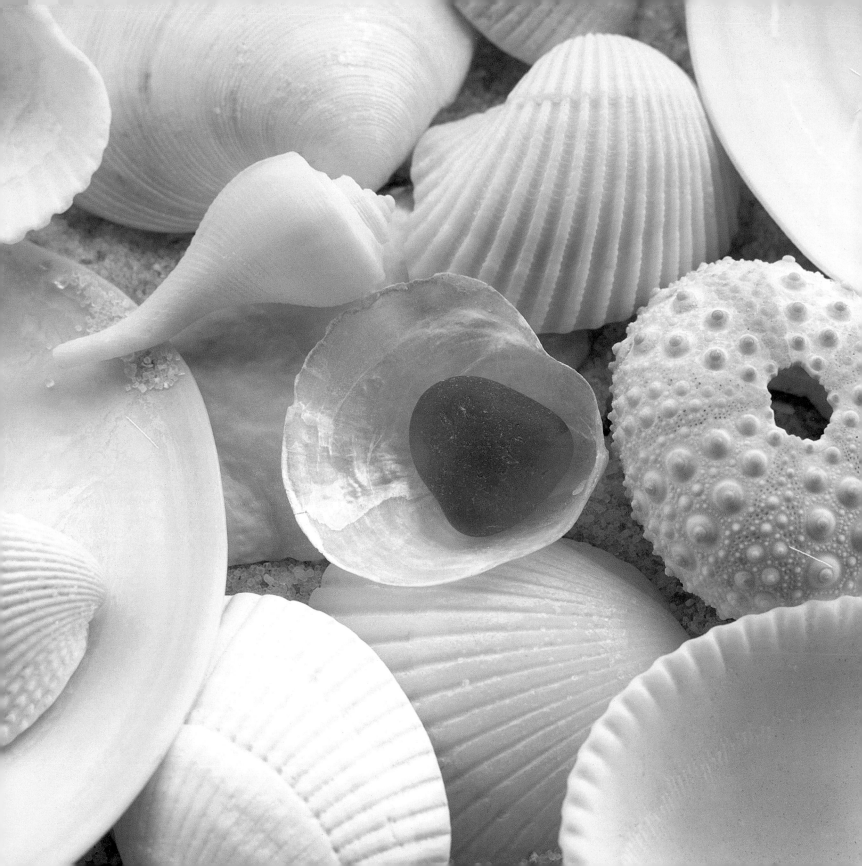

Red

Some sea-glass hunters have been lucky enough to find red, the most coveted of all sea-glass colors. Most pieces of red are likely from Victorian lamps and lanterns, discarded stained glass, layered or "flashed glass" tableware, various pieces of Depression glass, automobile brake lights, and marine lights. Though other colors may arguably be more attractive, most collectors of sea glass consider red their Holy Grail. A very limited amount of red glass has been mass-produced in the last 50 years, so one can make assumptions about its age. Some people have found pieces of old Schlitz beer bottles in a deep ruby-red color resembling maroon. The color was called "Royal Ruby" and was produced for Schlitz by Anchor Hocking Glass from 1949 to 1950 and again in 1963. Bottle collectors claim some "Royal Ruby" bottles were also used by breweries producing the Old Milwaukee and National (Baltimore) brands of beer.

The basic reason why red is so rare is because gold chloride, in a specific powder form, was employed in the simplest method to produce a deep ruby-red color. When used in small quantities, a medium red color was created. Because of its obvious expense, other methods were also used. For example, Anchor Hocking created the Schlitz bottles using copper in a carefully controlled colloidal suspension under chemically "reducing" conditions. In other words, they used very special heating and reheating treatments with carefully controlled chemistry to remove all of the oxygen from the batch.

While copper could be used to produce red glass, a highly purified oxide of iron could also create an orange-red color. Both methods were much more challenging to produce than creating red using gold, but the cost tradeoff was obvious. More modern methods to produce red include a combined mixture of selenium and cadmium sulfide. Chances of finding true red or ruby-red pieces of sea glass are projected at only one in every 5,000 pieces collected.

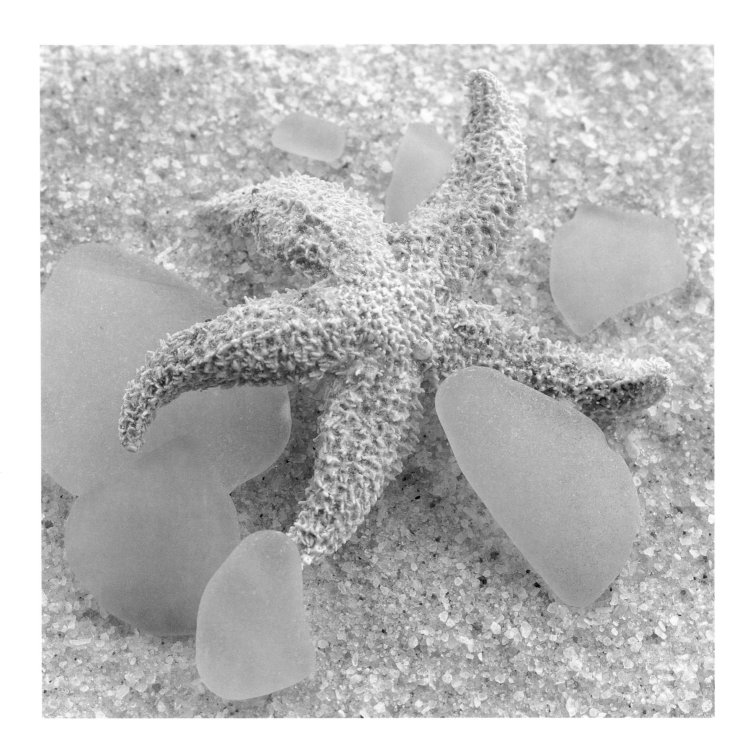

Yellow

Yellow sea glass may not be as desirable as red, but there were few mass-produced yellow bottles, making it almost as rare. Yellow glass has been used primarily for tableware and ornamental pieces, and these were less frequently discarded near the shore. Some pale yellows were made in transparent Depression glass tableware, and a very limited amount of opaque yellow was produced, sometimes using fused layers known as "flashed glass."

There are several ways to produce yellow glass, and one of the more fascinating variants is commonly known as "Vaseline glass." Originally called "Uranium glass," this color is unique in that it is produced by using 2 percent uranium dioxide, and it can be easily identified since it will glow a brilliant "neon" lime-green under ultraviolet (UV or "black") light. There is a similar yellow-green-colored glass that produces a softer yellow-green glow under a black light, since it contains some iron as well as uranium. However, true Vaseline glass viewed under a UV light in a dark room has an unmistakably bold fluorescent color. The softer yellow-green color was used more frequently during the Depression glass period. Other methods of producing yellow glass include adding silver, chromium, zinc, antimony, iron, minium, nickel, or cadmium with sulfur.

Some yellow glass can appear as a soft pastel yellow or straw color resulting from prolonged exposure to sunlight. Pieces of what is called yellow sun-colored glass, which was originally clear, are easier to date since they most likely contain selenium. Selenium was mainly used as a replacement for manganese to decolorize glass after 1915 but was replaced by arsenic around 1930. It can be a struggle to find true yellow rather than yellow-green, so it would be appropriate to estimate the chances of finding yellow as only once for every 3,000 pieces collected.

"Black Glass"

Since spirits and medicines frequently needed protection from sunlight, early glass manufacturers often produced dark, almost black, glass. During the 1700s, numerous Dutch "onion-shaped" black flasks containing gin were imported into the United States. In most cases, the glass was actually an exceedingly dark green but at times was dark amber. By shining a bright light behind the glass, one can see the true color tone hiding behind what appears to be black. Producers added iron slag to the glass batch to create the dark green color, but this ingredient also provided an additional benefit in that it made the vessels resistant to breakage. As a result, shards in this color are routinely found as large, chunky pieces rather than petite and rounded.

Finding "black glass" should be considered fortunate, since it can often be presumed to be glass made prior to 1900 for beer, wine, and other alcoholic beverages. In many cases, the use of "black glass" bottles waned heavily by the mid- to late 1800s.

Some manufacturers claimed cobalt and copper could be combined to produce a near black color, and cobalt with manganese was used in the 1920s to create black amethyst tableware. However, the majority of "black glass" was made with iron slag since it was the most economical colorant.

Between 1879 and 1885, the West Side Glass Company in Bridgeton, New Jersey made one of the first tableware sets of opaque "black glass," fashioning a unique assortment called "Ferroline." Several companies also made "black glass" tableware during the 1920s and 1930s, such as Fostoria, McKee, and Hazel-Atlas, but in very limited supply. At that time, "black glass" buttons became desirable and remain a popular collectible.

It is implicit that pieces of "black glass" containing small bubbles or seeds are quite old and rare. Finding "black glass" might occur once for every 2,500 pieces of other colors collected.

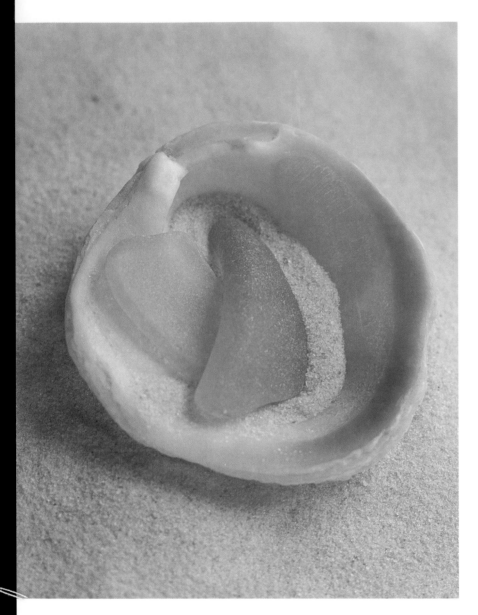

Teal

Teal is another member of the blue color family that is far more rare than cobalt blue. There was not a wide variety of items made in this unique blue-green color. With a small amount of cobalt and iron, the teal color could be created, but holding it consistently between batches provided a challenge similar to that for turquoise, contributing to its rarity. Chromium was sometimes added to boost the green color, and in more recent years, aluminum oxide has been used with cobalt to produce a teal color.

In high production volumes, teal was not a commonly used color, though it was used in a variety of containers such as baking soda bottles, mineral water bottles, and ink bottles. Since there was not much teal glass produced after the early 1900s, other than an occasional Mateus wine bottle, one can assume that pieces of teal are likely older than many of the common colors. Like others in the extremely rare category, finding one piece may be a single chance in 2,500.

Gray

Gray-colored glass is especially atypical, as it was often an undesirable by-product resulting from what was originally intended to be clear glass. Manganese was commonly used to remove the green or blue color created naturally from iron impurities in the sand, but if both copper and iron were present, the collective elements could slowly develop a gray tint. If certain elements within the glass were oxidized by extended exposure to sunlight, the "color mixing" of purple, green, and light blue (from the manganese, iron, and copper) could create differing shades of gray, which could resemble smoke-colored glass with slight blue-gray or green-gray tints. It is also possible that pieces of antique lead crystal can develop a gray cast. In more recent times, nickel was used to produce smoky gray-colored glass.

Well-worn shards of this glass may date to before the early 1900s. Gray may not be the most desired color, but it is a good indicator of a site that contains historic glass. This is one of the more challenging colors to identify, but finding it would likely be on a difficulty level of one in every 2,000 pieces.

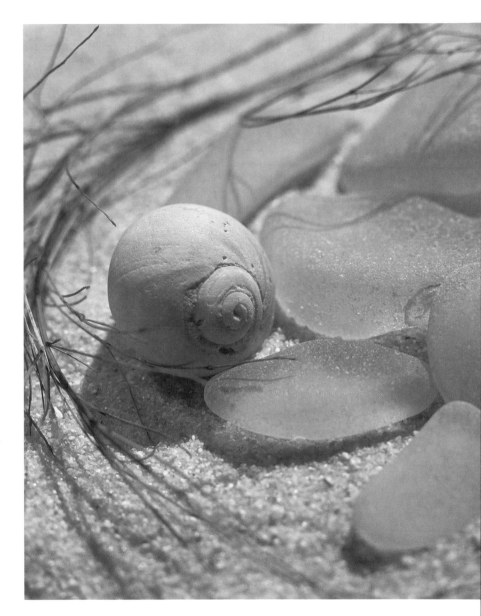

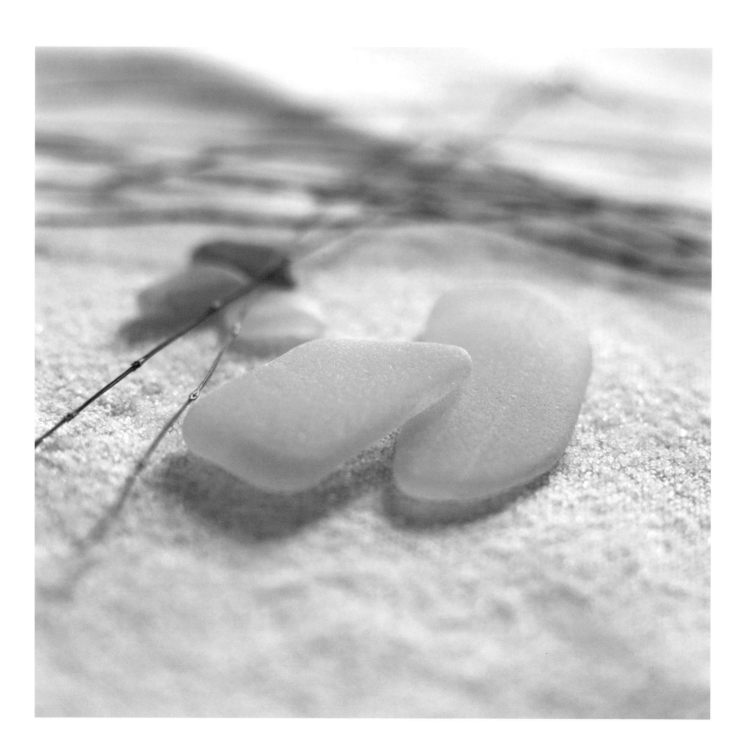

Rare Colors

Pink

Pink glass is another rare color that was primarily produced as tableware during the Depression era. Selenium was added to produce pink-colored glass and even shades of red. But it is much more likely that the sea-glass collector might find shards of "sun-colored" pink from pieces that were originally clear. "Sun-colored" glass refers to the process of altering the atomic structure of glass colorants through interactions with ultraviolet radiation.

Selenium was being widely used to make clear glass between 1915 and 1930, replacing the manganese supplies that were restricted during World War I. Another reason it became popular was because selenium proved to be a more stable decolorizer for use in larger glass furnaces. Selenium was replaced in 1930 by arsenic, so its short run makes it relatively easy to date pieces of sun-colored pink sea glass. (As noted earlier, sun-colored glass that contains selenium can also be found as straw or champagne-colored shards.) As glass made with manganese slowly shifts in sunlight to purple or lavender, it also can easily be mistaken for pink. The chances of finding pink are estimated at one for every 1,000 pieces collected.

Aqua

Unlike the deep blue hue created by adding cobalt, copper is used to create a rich aqua color. Aqua-colored glass, especially deep aqua, is less common than the cobalt-blue color. Before the turn of the century, a generous amount of aqua glass was used for soda, mineral water, and even beer bottles before later becoming a popular color for fruit jars, such as the Ball Mason jar. Another later form of aqua glass, which is easily recognizable, is the mass-produced telephone pole insulator. In general, the thicker the piece of glass and the deeper the aqua color, the more likely the shard is from an antique bottle or an insulator. For example, the upper shoulder or collar of a fruit jar may show a more concentrated form of the aqua color than a piece from its midsection.

Look carefully at the thickness of every aqua-colored piece of sea glass. While much of aqua sea glass appears to be thin, many pre-1900 soda or beer bottles are actually quite thick and may have a lighter shade of aqua that borders on a sky blue color. Due to the wide use of fruit jars, the lighter tone of aqua is only moderately rare. Deep aqua tones are far more difficult to collect. While lighter tones might be found once for every 250 pieces located, the deep aqua color might be more in the range of one for every 1,000 pieces found.

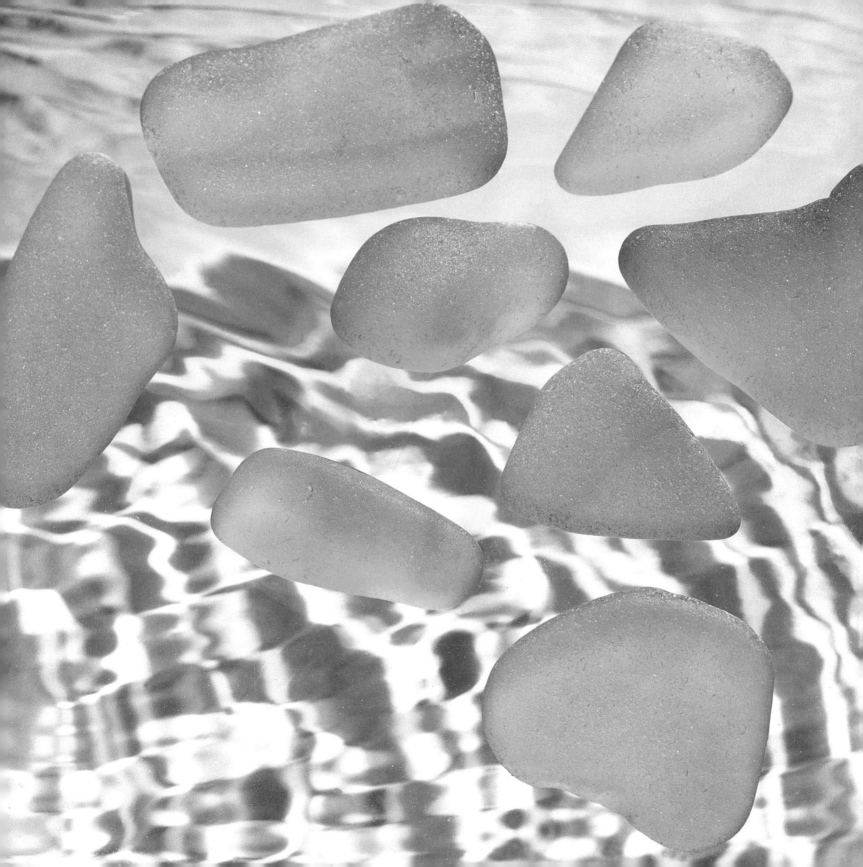

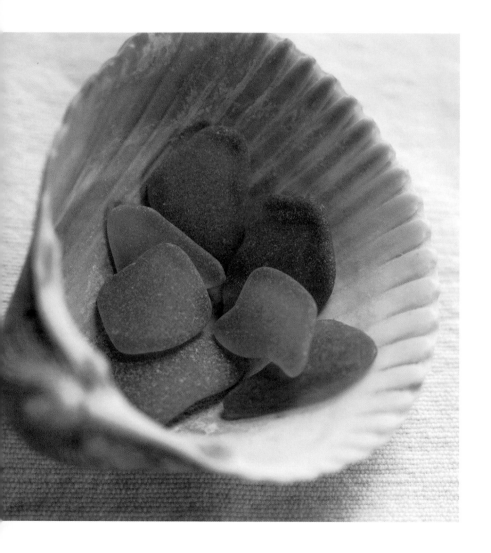

Cobalt oxide is a bit costly, so limited beverage bottles were made in cobalt colors as compared to medicine-related bottles. For this reason, cobalt-blue bottles are far more likely to be found discarded in dumps or privies rather than along beaches since medicines were consumed close to home. The use of cobalt in making blue glass goes back several thousand years. The cobalt mines of central Africa have been popular sources since before Roman times and are still active today. Though most of the cobalt used by American manufacturers is still imported, Minnesota has the most plentiful domestic supply of cobalt-bearing minerals.

Common cobalt or royal-blue containers used in recent years include those from Vicks VapoRub, Bromo-Seltzer, and Milk of Magnesia products. An advantage when hunting for cobalt-blue sea glass is that it stands out quite boldly on the beach, making it easy to locate. Finding cornflower-blue sea glass is more challenging, so chances are a hunter may only find one piece for every 500 other pieces collected. For cobalt blue, the chances are much better and can be estimated at one shard for every 200 collected.

Opaque White

Opaque white glass, commonly referred to as "Milk glass," has been produced worldwide for hundreds of years. The Venetians are recognized as its originators during the 1500s. In the United States, Milk glass was quite popular during the late 1800s and up until the 1950s. To create its opaque white color, tin or zinc compounds were added as the primary colorants. Other opaque colors also referred to as being "Milk glass" include green, blue, and purple. There was also a limited amount of a nearly translucent, off-white glass produced named "clambroth" because of its virtual skim-milk appearance.

Between 1910 and 1936, a number of Ball jar lids were made of an almost "opalescent" white Milk glass. These were called "White Crown" closures, and because of their prevalent use, the opportunities for finding these shards on beaches are quite good. Opalescent glass can range from translucent to opaque with respect to color density. It can transition from one color to another, such as aqua or turquoise to a near white. It will be covered further in the Tableware section for opalescent glass.

"Slag glass," which is a swirled mixture of white Milk glass with green, blue, or purple, will also be discussed later in the Tableware section. Since finding pieces of Slag glass is very challenging, any well-worn shards should be considered far more valuable than cobalt blue. Chances of finding pieces of opaque white Milk glass are estimated at one in every 500 items collected.

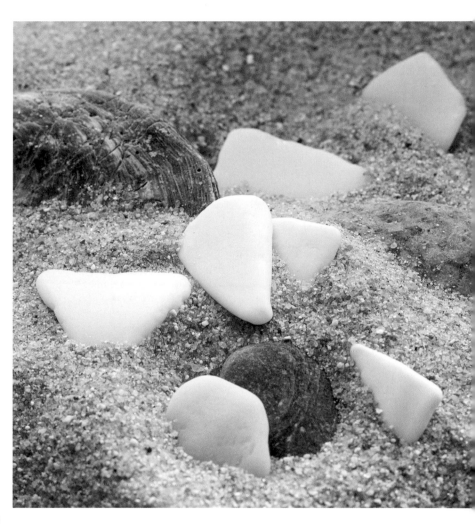

Citron

The yellow-green color termed "citron" is also one that falls in the rare category for sea-glass collectors. Since this was often a color used to bottle wine, it can be found more frequently in some areas than others. There were a number of fruit jars, snuff jars, and various other bottles made in the color citron, but they are far less common, and they often command high prices in the bottle-collecting market.

Unlike "lime" green, which is not as rare, this color has a darker hue, possibly from the addition of copper or iron. The presence of oxidized chromium in potassium-containing glass could create this color, but since it was not produced in high volumes, it is difficult to locate these remnants of antique barber bottles, bitters bottles, and ink bottles. However, locating pieces from a 20th century wine bottle is not as challenging. As a result, the rarity of finding citron will be roughly one piece for every 250 to 500 pieces found.

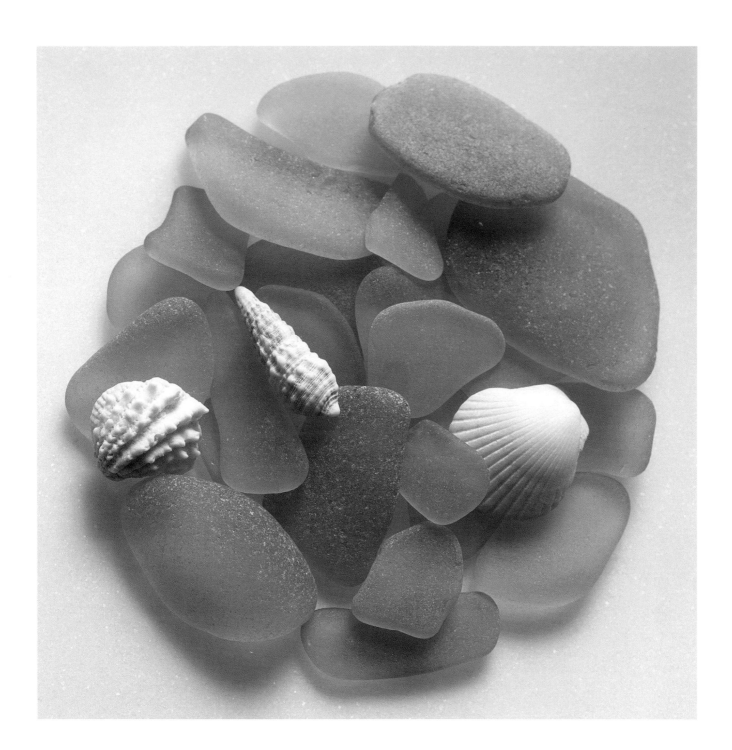

Purple/Amethyst

Early glassmakers dating as far back as 2,500 B.C. found that manganese oxide could be added to glass to mask the aqua or green color that normally resulted from iron and other impurities in the sand. When too much manganese was accidentally combined in the batch, soft purple colors could develop instead of the intended clear glass. Later it was purposely added in excess to give the glass a deep amethyst color. Some glass producers, such as The Boston and Sandwich Glass Company in Massachusetts, claim to have used raw amethyst quartz in the 1800s to produce deep purple colors. However, manganese was clearly less expensive.

The use of manganese in the United States was at its peak between 1880 and 1915. During this time, Germany had been the primary world supplier. When World War I broke out, reserves were depleted, and most American glassmakers switched to using selenium by 1920. The amount of amethyst color in early 20th century glass is directly related to the amount of manganese used in the formula, the chemical and thermal conditions during the glass melt, and, for sun-colored glass, the amount of sunlight the glass had been exposed to over time.

For the collector of sea glass who finds what appears to be clear or frosted clear glass, it can be rewarding to arrive home and find it is actually a piece of purple sun-colored glass close to 100 years old. By using a black light in a dark room, the presence of manganese can be detected if the piece actually glows a pale orange color. A tremendous amount of clear glass was used for food containers in the early 1900s, so the projected odds of finding pieces of sun-colored amethyst glass are one for every 200 to 300 collected.

Uncommon Colors

Soft Green/Sea Foam

The experienced collector can easily identify the soft green color from a piece of the ribbed Coca-Cola bottle. This bottle began its reign in 1915 and saw a good 60-year run on the market. Sea glass hunting near beach resorts that flourished in the early to mid-1900s should reveal a fair number of these shards. The color of the Coca-Cola bottle actually fluctuated a bit from a soft green to a soft blue-green, and then to almost a light aqua color during its reign. (Coca-Cola bottles were initially made in clear glass.) Iron was the primary ingredient for creating the soft green color. However, if copper was present, a mild amount of blue could sneak into the bottle color. Coca-Cola bottles were produced all over the world, so slight color variations could be expected.

Many soda and beer bottles in the late 1800s and early 1900s were produced in soft green or aqua colors until eclipsed by mass-produced clear bottles. Soft green shards can also come from a variety of other bottles, such as baking soda, ink bottles, and fruit jars. Even RC Cola and Dr Pepper had vast runs in bottles of light blue-green. The collector can assume that most pieces in this color date back prior to the 1970s. The much thicker, soft green pieces with a more bluish tint are most likely older than thinner shards of the same color. Chances of finding pieces of this very popular color run about one for every 50 to 100 pieces found.

Soft Blue

Late 19th and early 20th century items—soda bottles, fruit jars, patent medicine, and ink bottles—are common sources for soft blue sea glass. One may note that the soft pastel blue pieces from bottle shards often contain bubbles within the glass. This is indicative of bottles made before automated machinery virtually eliminated the bubbling defects (called seeds) in the early 1900s. Windows and windshields are also frequent sources of soft blue glass shards. These can be easily identified by their flat surface and uniform thickness.

Copper found within the sand used to produce the glass could create the light blue color, but it was normally created using copper oxide as a colorant. While there are some Coke bottles that display a soft blue color, soft green was far more prevalent for their brand. Another common bottle made in light blue in the early half of the 20th century was the baking soda bottle.

In summary, chances are if you find a well-rounded piece of soft blue sea glass, and it appears to be from a bottle with bubbles within the glass, it could date prior to 1920. Opportunities for locating pieces of soft blue sea glass run about one for every 50 to 100 pieces sighted.

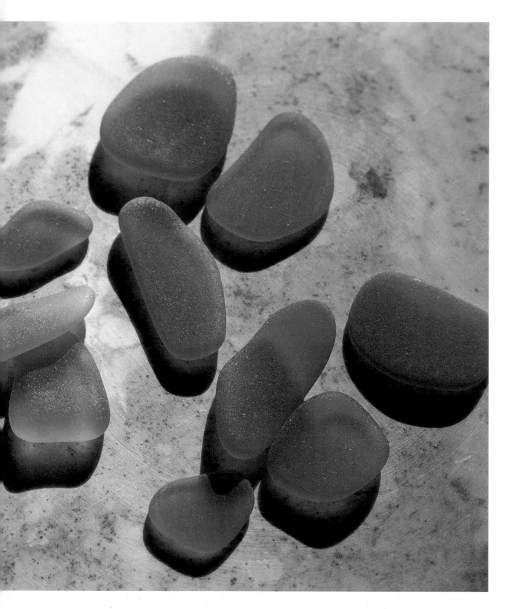

Golden Amber

The most rare hue in the family of brown colors is the soft yellow tone of brown sometimes referred to as golden amber or "mustard" color. It can be surprisingly attractive when wet, as it shows a rich yellow-gold hue. This color was used for spirit bottles, some patent medicine bottles, a few bitters bottles, and a variety of small bottles. Larger brown bottles were usually made in darker brown colors due to the greater durability lent by increased amounts of iron oxide. The golden amber color can be produced with cerium colorant and iron. Some claim it can also be produced with oxidized manganese and iron. Often the color will appear very close to yellow as the glass becomes worn and thin.

It would be quite extraordinary to find large thick pieces of mustard-colored sea glass since only a limited amount of this color was used for robust bottles (with the exception being some early pint Clorox bottles prior to 1930). There have been some modern beer bottles made in a darker version that should not be confused with the true mustard color. Due to its use in recent decades, the chances of finding golden-amber shards are as high as one for every 25 to 50 pieces found.

Amber

Dark reddish-brown bottles were commonly used for holding whiskey, bitters, snuff, and even a few poisons in the late 19th century. This dense amber color provided strong ultraviolet protection for some spirits, medicines, and even chemicals. Some well-worn pieces of early Clorox bottles can show this tone of red amber, but when the sea-glass collector finds an antique shard of brown, it may require a quick dip in the water to tell if it is a true amber or standard brown.

Iron was used with sulfur or selenium to create amber glass, along with a small amount of carbon. As noted before, bottle glass made with iron stood up quite well to the rigors of shipping. Today, several breweries and numerous other current bottlers use this color for their glass, but with normally far less wall thickness. Unless the sea glass shows many years of weathering, it could be a more recent piece. An excessively corroded piece with wall thickness of at least three-eighths of an inch could indicate an older shard. Not to be confused with standard brown, the reddish-amber color can be found about once for every 25 to 50 pieces collected.

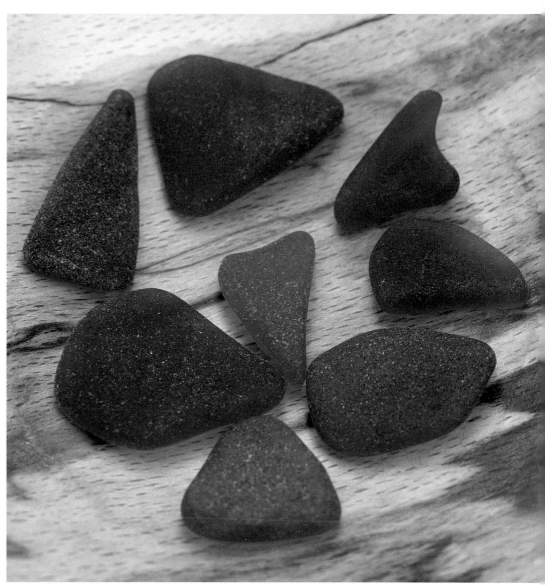

Jade

A deep jade-green color is actually a favorite for many collectors of sea glass because of its similarity to emerald gemstones. Since it is a color that has been made throughout both the 19th and 20th centuries, dating pieces can be a formidable challenge. The color actually has a much richer hue than the common Kelly-green color. Finding thick pieces of jade-colored glass is more probable than finding thick pieces of Kelly-green or lime-green shards, as those are more recent productions and usually of thinner construction. Not many bottle designs were produced predominantly in jade green, but several flasks, soda bottles, bitters, mineral water bottles, and even some poison bottles did come in this color.

Chromium—as well as iron and carbon additives—were used to create the jade color. Theoretically, cobalt and silver could also have been used to produce a deep jade coloration. Chances of finding jade are estimated at one in every 25 pieces of sea glass sighted.

Common Colors

Kelly Green

Medium or "Kelly" green falls into the category of common colors since it has been a mass-produced color for bottles during the second half of the 20th century. This green shade has been popular with various contemporary beer and soda manufacturers such as Heineken, Molson, 7Up, Sprite, Mountain Dew, Schwepps and Canada Dry. Prior to the 1950s, this medium hue of green was used far less, so most pieces can be dated as produced in the late 1900s. Copper and iron have been common colorants for green, but chromium-containing compounds mixed with arsenic or tin will also create a vivid emerald-green color. The variable thickness of the shard will make the color range from a rich green to a pale almost pastel green.

While Kelly green is one of the more common colors, it is normally less abundant than brown and white. For every 10 pieces of sea glass found, it is likely that at least two to three will be in Kelly green.

Brown

Dark brown-colored bottles were popular in the late 1800s, especially for whiskey and bitters, but remain in particularly frequent use today for American beer, liquor, and wine bottles. The brown color protected the bottle contents from sunlight and was more compatible with large production demands than some other colors. Clorox bottles were made in dark brown since sunlight rapidly diminishes the strength of chlorine. A great site for dating those shards can be found at "The Clorox Bottle Guide" noted in the bibliography in the back of this book.

Finding a thick, squared-off corner in brown could be from an antique bitters or whiskey bottle, since modern brown bottles mostly have a cylindrical shape. If the corner shard is small and thin, it is likely from an antique medicine bottle.

Iron combined with sulfur and carbon produces brown colors that can be darkened by the addition of extra carbon. An interesting anomaly about brown sea glass is that when it is found, most of it looks the same. However, when wet or held up to the light, one can usually sort it into about three or four shades of reddish-amber to golden-amber tones. It may be safe to say that Anheuser-Busch is the largest producer of brown or amber-colored bottles in the world. For every 10 pieces of sea glass found, it is likely that at least three to four will be brown.

White (frosted clear)

What begins as clear glass is slowly pecked away by abrasive and corrosive environments to produce a practically snow-white piece of "frosted" sea glass. When wet, its transparency nearly returns, but as it quickly dries, a well-worn piece becomes almost opaque again. To make clear glass, black oxide of manganese was the preferred ingredient to add during the first several centuries of glass making. It was even used to help clarify high-quality leaded glass in 1674, when George Ravenscroft developed the first formula for leaded glass in England.

Making clear glass requires that an element be added to counteract any undesirable natural color in the sand, such as green from iron impurities. In this instance, manganese or another color used to produce a red hue (green's complementary color found on the opposite side of the color wheel) cancels out the green tone thus producing clear glass. The proper additive to create the required complementary color was simply included in the glass formulation.

As described previously in the sections on yellow, pink, and purple glass, selenium started to replace manganese prior to 1915, since it was a more stable decolorizer for larger production furnaces being set up for more automated factories. Smaller producers continued to use manganese, but World War I limited its availability, and selenium became a standard decolorizer between 1915 and 1930.

While sun-colored glass containing manganese will turn purple, glass that contains selenium will turn a straw-like color. After selenium use waned in the early 1930s, other oxidizing agents used in making clear glass (such as oxides of arsenic or antimony, along with nitrates) aided in keeping the iron impurity in a colorless chemical state. Cerium oxide was another additive used as a decolorizer in the 1940s.

As the leading color found by sea-glass collectors, it is estimated that for every 10 pieces of sea glass found, four will likely be "frosted" white in appearance.

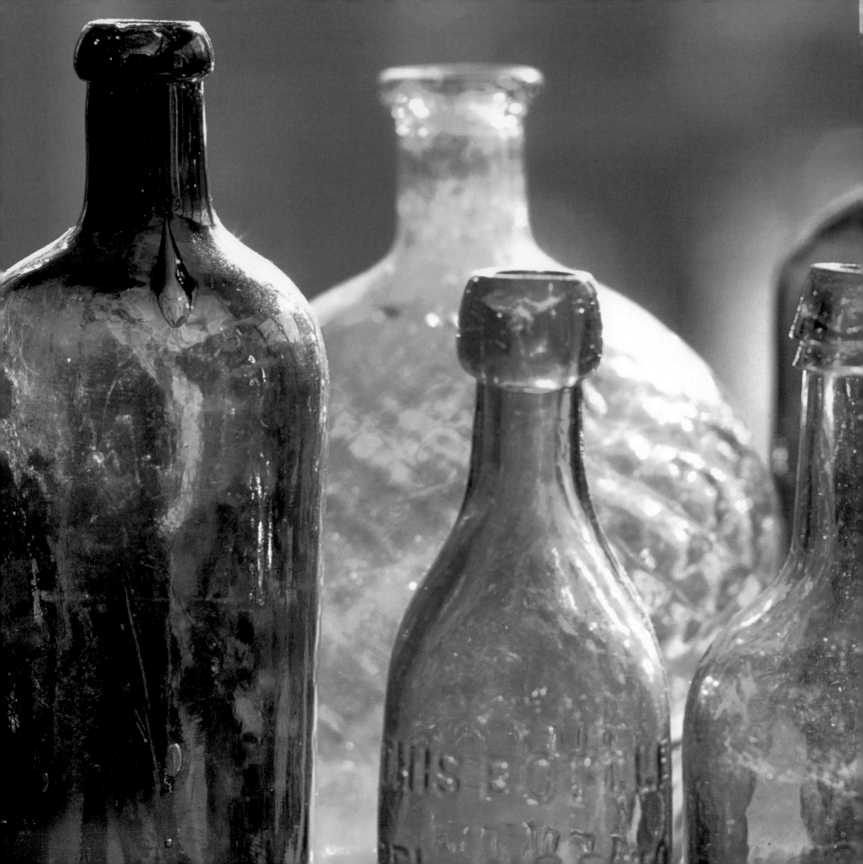

Six
BOTTLES
CONTAINERS

A beautiful form is better than a beautiful face; it gives a higher pleasure than statues or pictures; it is the finest of the fine arts.

Ralph Waldo Emerson

Bottles and Containers

The study of American-made glass bottles from the mid-1700s to early 1900s provides a fascinating journey through U.S. history. Bottles made during that period tell a tremendous amount about the traditions of those times. Though the first glass vessels were produced briefly in Jamestown, Virginia, founded in 1607, the bottle and glass industry within the United States saw only a few short-lived manufacturing operations throughout the 1700s.

By the mid-1800s, glass bottles were being readily produced in most Northeastern and Midwestern states, although rarely in the South. This expanding industry helped increase the corresponding sale of alcohol, poisons, and patent medicines, so much so that a concerned federal government stepped in to regulate the use of such products for the protection of society. In the case of poisons, bottle designs had to become more distinctive to help reduce the incidence of accidental poisonings.

In order to draw attention to their products, glassmakers displayed marvelous ingenuity in creating unique bottle designs. These were often patented, since the design was sometimes more important to the sale of a product than its contents.

Triloid poison bottle, circa 1920

Studying historic bottles greatly enhances the odds of identifying sea-glass shards and estimating their dates of manufacture. For example, the upcoming text on the distinguishing features of bottles will assist the sea-glass hunter in detecting the ages of many neck and lip shards. Finding pieces with bubbles within the glass can, in some cases, date the shards as having been made before 1920, since by then, automatic bottle machines were in full use and virtually eliminated this frequent defect. Collectors should be aware that even today some contemporary glass from foreign countries, especially Mexico, could contain bubbles.

Another flaw common in pre-1920 bottles is called "crazing"—more simply described as stress lines in the surface of the glass along the neck. It usually occurs when making the lip or removing the bottle from a base mold. Unlike cracks that go all the way through the glass, crazing is usually seen on the surface of the outside of the glass.

Bottle bottoms can also help determine the age of glass and will be discussed in more detail in the next section. It is, however, a substantial challenge to identify shards from the side walls of a bottle without an embossed name or pattern. Those pieces present the biggest test, but as sea-glass hunters increase their levels of knowledge of key colors, shapes, and patterns, the opportunities for making educated assumptions also increase. Seeking the counsel of someone who has long studied glass bottles is also a convenient avenue to determining age estimates.

Eagle flask, circa 1840

The American glass-bottle industry during the 18th and 19th centuries reflects the specific wants and needs of the people during the infancy of a new nation. Americans were anxious to break political and economic ties with Britain. The new American consumer eagerly embraced using American-made glass bottles over British stoneware. However, domestic ornamental tableware was not nearly as popular as European tableware.

While beverages were the primary item contained in bottles, a host of other products such as fruit, pickles, and medicine were being placed in glass containers in the mid- to late 1800s. By the early 1900s, annual demand for glass bottles (especially clear glass) had approached half a billion units. The urgency to automate the bottle-making process escalated every year, so when Michael J. Owens invented the first automated bottle machine in 1903, bottle manufacturing quickly became one of this country's largest industries. However, in less than 100 years, the glass industry had lost a considerable share of the food and beverage container market to inexpensive, less fragile vessels.

Today, bottles and containers made from inexpensive plastic and aluminum have supplemented, and in some cases replaced, traditional glass bottles for soda, beer, milk, and a variety of other liquids. There are public vending machines everywhere filled with plastic bottles of water for $1 to $2 each. Some soft drink conglomerates that remain from the beginning of the soda era in the late 1800s now own majority shares of the burgeoning bottled-water industry. In early America, water was hardly a beverage worth bottling unless it was either carbonated or considered to be mineral water. Today, however, pure water is a multi-million dollar business, and the vast majority of it comes in plastic bottles.

Around the country, antique bottle collectors and clubs sponsor shows in virtually every state. These provide a relative feast for bottle collectors and sea-glass hunters looking to enhance their knowledge of bottle glass. Also, a plethora of web sites exists with detailed information on bottle history with many featuring bottles for sale. Antique dealers specializing in bottles and glassware are abundant. Since much of the American public is not aware of the increasing value of historic bottles, one can still amass an impressive collection for a relatively small amount of money in a short time. There are upscale auctions for exemplary bottles that can fetch thousands of dollars, and the values continue to grow. The serious sea-glass collector is strongly advised to study bottles closely, since as much as 80 percent of sea glass likely originated from bottles.

Carter's master ink, circa 1925

Bottle Distinguishing Features

The collector that develops a keen eye for recognizing unique glass patterns and shapes will appreciate far more about their sea glass beyond the radiant colors of the shards. After careful examination of the bottle photographs within this chapter, it should become easier to estimate the origin and era of many pieces of sea glass. Scrutinize the uniform shapes of bottles within each specific category. Pay special attention to the lip and collar features as well as the colors. Finding a piece of sea glass with legible text is always a great bonus, but the mouth of a bottle speaks volumes about its history. Many of the bottle tops shown are pre-1950 examples since there were few changes after that time, and it is these older shards that yield the most exquisite forms of sea glass.

Bottle Lips and Collars

In the early years of bottle design, lips and collars were hand-fabricated using scissor or tong-like devices to shape a uniform mouth for accommodating a good cork seal or efficient pouring. These crude tooling processes were the final detail in manufacturing most bottles, and names for the forms they created normally reflect their descriptive shapes.

In the late 1800s, as molding techniques were rapidly developing, numerous new lip and closure designs poured into the United States patent office. Some became commonly identified by the name of the patent holder or its designer. One early design patent, which has remained in active use, was awarded to John L. Mason in 1858. Though external threads for a screw-on closure were not new, his patent was for a zinc screw-on lid that became the standard for food canning jars. Identifying threaded Mason jar shards with their familiar broad circumference is easy, but without text to indicate the manufacturer such as Ball, Atlas, Kerr, and others, it is a struggle. Dating aqua-colored Mason jar pieces can be a challenge since they were produced for so many years. If the shard is a citron color, it dates to earlier models in the late 1800s, while clear shards indicate a post-1915 release.

The most distinguished design patent for a bottle closure in the late 1800s was that by William Painter of Baltimore. His 1892 patent for what he called the "Crown Cork" seal remains today as the only copious rival to common aluminum screw-cap lids on beer and soda. The original version had a thin cork disk inside a tin crown with a corrugated edge that is crimped firmly down over the bottle lip. This solved a key hygiene problem with other closures on the market, and it could withstand the high-pressure levels required to maintain good soda and beer. Almost 10 years later, Michael Owens adopted the Crown Cork closure for his automatic bottle machines, and, by 1915, the beer and soda industry was using its first uniform closure. The half-inch bulbous collar beneath a rounded, one-eighth-inch lip is an easy mark as sea glass, but if the bottom edge of the collar is wavy or roughly shaped, it indicates a Crown Cork bottle that was likely made between 1897 and 1915. If the collar is more beveled than round, it is a much more contemporary piece.

The most common soda seal prior to the Crown Cork was the Hutchinson-style stopper developed by Charles Hutchinson of Chicago. It used a rubber gasket secured to a sturdy, peanut-shaped wire and was inserted just below a stout, doughnut-shaped collar. The gasket was held in place just below its very short neck by the wire and the carbonation in the beverage. To open the bottle, the wire was pressed down to release the rubber gasket, and the result was usually a loud pop. This closure is actually not credited for the nickname of "soda pop," but it certainly may have helped extend its use. Unfortunately, the deeply recessed gasket in the base of the neck allowed residual dirt and debris to fall into the soda upon opening. Thus, the pressing demand for a more hygienic bottle made Painter's Crown Cork closure a timely invention. It will be interesting to see how the aluminum-can industry resolves similar challenges to their soda and beer closures. Ironically, the company started by Painter, now called Crown Holdings, has a share of the aluminum-can industry.

There are detailed references on bottle glass closures, but the guide that follows will help sea-glass collectors identify and date most lip shards they find. Note that the dates shown are when the lip and collar designs were in most prevalent use. Keep in mind that remakes of traditional lips are made on occasion, and wine producers frequently use Old World-style closures to add romance to their brands.

Hand-tooled Crown Cork lip, circa 1900

Lip Identification Guide

Pre-1850 styles

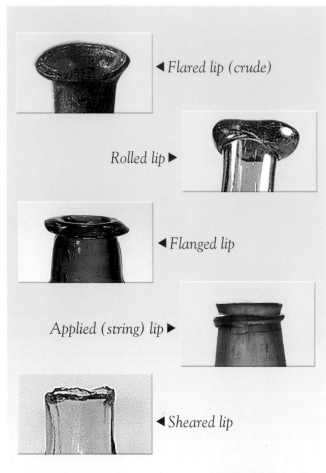

◄ Flared lip (crude)

Rolled lip ►

◄ Flanged lip

Applied (string) lip ►

◄ Sheared lip

Tapered lip (crude) ►

1800-1900 styles

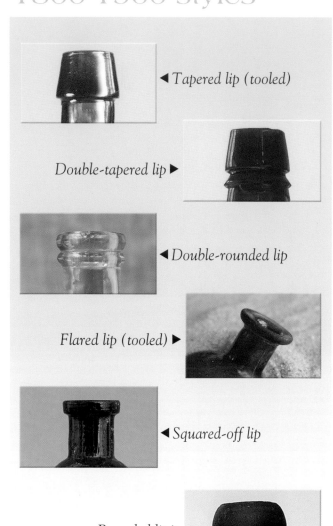

◄ Tapered lip (tooled)

Double-tapered lip ►

◄ Double-rounded lip

Flared lip (tooled) ►

◄ Squared-off lip

Rounded lip ►

1850-1920 styles

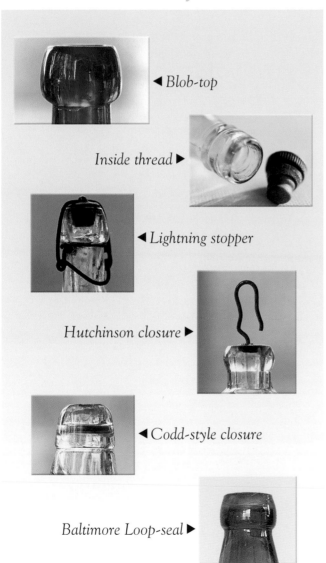

◄ Blob-top

Inside thread ►

◄ Lightning stopper

Hutchinson closure ►

◄ Codd-style closure

Baltimore Loop-seal ►

1890-Today styles

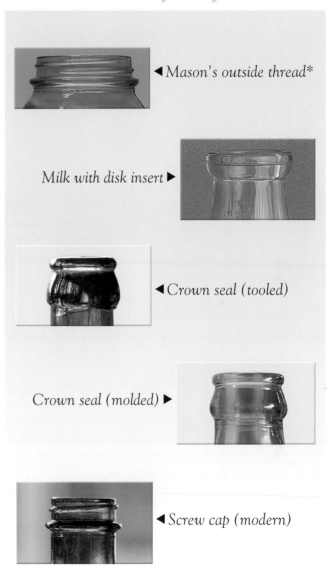

◄ Mason's outside thread*

Milk with disk insert ►

◄ Crown seal (tooled)

Crown seal (molded) ►

◄ Screw cap (modern)

*Initially patented in 1858 and still in use today

Bottle Bases

Some general conclusions can be made on certain types of bottle bases to help fit them into broad date categories. For example, if the base is smooth but shows several numbers, it was probably machine-made after 1910. If a distinct molten scar is in the center of the base, it was likely made from a pontil rod connected to that point while the glassmaker was hand tooling the bottle lip. This was a common practice prior to 1860.

Before 1903, glass vessels were inflated by blowing into the blowpipe, while the bottom portion of the molten glass "gather" was resting in a mold. While still attached to the blowpipe, the vessel was removed from the mold and a pontil rod was connected to the center of the bottle base. This would be either inserted directly into the glass, or indirectly connected to the base with a small gather of glass on the tip of a pontil rod. The goal was to disconnect the blowpipe and quickly form the top half of the bottle by hand tooling the lip. It was this process that often caused crazing, diagonally stretched lines, or bubbles in bottles made by hand.

With the pontil rod connected to the base, the vessel was rotated while the lip was shaped and trimmed. When the pontil rod was directly connected, it would leave scars. The marks are rather obvious and sometimes would be dramatically colored by residue from the pontil. If connected by a gather of glass, a process called "wetting off" was used to release the vessel. Water was dripped near the connection between the pontil rod and base allowing the vessel to be quickly snapped off of the rod. This would leave what is known as an "open" pontil scar, unless the craftsman elected to remove the mark either by flame polishing or grinding it off. This finishing step was often done on higher quality glass vessels such as crystal decanters.

Iron pontil scar dates bottle prior to 1860

Open pontil scars date bottles prior to 1860

In the mid-1800s until around 1900, a tool called the "snap case" was used to reduce problems with pontil scars on bottle bases. It had a pair of claw-like, hinged arms that would hold the bottle just below the shoulder and a shallow cup-shaped support upon which the base would rest. This was designed to leave a smoother base but could still leave a pronounced convex dimple in the center of the external base.

After studying the bottle shapes on the following pages, it will become easier to identify forms and make knowledgeable assessments as to the origin of shards. Keep in mind that a bottle shard with variable wall thickness was likely made before automation, and ones with anti-slip, embossed treads on the base were made after the 1950s.

Barber Bottles
1850-1920

In the late 1800s, barbershops were a popular meeting place for men who made regular visits for a shave or beard trim. Frequent customers were provided with personalized bottles that held their specific hair tonic, shampoo, and cologne, as well as bay rum and witch hazel used to soothe chafed or irritated skin. These bottles were the most decorative of all the Victorian-age vessels.

Barber bottles became popular in the mid-1800s and were primarily imported from the Bohemia region of Europe until domestically produced containers by the Boston and Sandwich Glass Company and the New England Glass Company of Massachusetts were available. Whitney Glass in New Jersey and Hobbs, Brockunier and Company of West Virginia began to produce these as well. Most barber bottles have a characteristic long neck with a rounded or onion-shaped bottom half. They often had metal (pewter), porcelain, or cork closures and spouts. Many of the bottles were exceptionally decorated with floral patterns, hobnail patterns, stripes, or even figural scenes of children, such as the famous Mary Gregory designs. Gregory was an employee of the Sandwich Glass Company on Cape Cod who specialized in engraving children, usually at play.

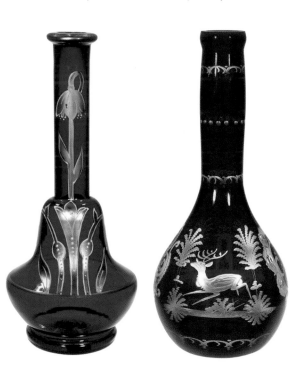

Barber bottles, circa 1900

Barber bottles come in an array of colors from blue, green, ruby red, amber, lime, yellow, pink, purple, and various shades of milk glass. It was the glass milk bottles that often included a personalized lithograph under a contoured clear glass panel. The lithograph normally included a famous individual pictured beneath the client's name. Since these were on paper, the sea-glass hunter is not likely to find any intact, but for bottle collectors, these are quite prized.

By the early 1900s, the invention of the safety razor started the movement toward shaving at home. Then the Pure Food and Drug Act of 1906 made it unlawful to refill unlabeled bottles with products containing alcohol, so by the 1920s, most manufacturers had ceased production of barber bottles. Finding pieces of sea glass with these very unusual patterns and coloring can be problematic since many people found other uses for these attractive bottles.

"Witch Hazel" is a Northeastern shrub that produces yellow flowers in the late fall and early winter. The name was given in Colonial times since some used its Y-shaped branches to prospect for underground water, and the leaves were similar to the Hazelnut tree. Native Americans in New York had been using it successfully to heal wounds when Theron T. Pond consulted with a medicine man in 1840 to later develop a formula with alcohol as a preservative. Though he only lived for another 10 years, his formula is still in active use, and the Pond's name remains synonymous with skin care today.

Mary Gregory design, Sandwich Glass Company, circa 1900

J. Wise beer bottle, circa 1870

Beer & Ale Bottles
1870-1920

Beer and ale were abundantly produced throughout the 18th and 19th centuries but primarily consumed in taverns or inns, so only a few glass bottles were used prior to 1860. Those early bottles were normally made of thick dark green glass known as "black glass." Some of these were made in America beginning around 1820. Stoneware jugs were quite popular for beer in the 1800s since they could be used repeatedly and maintained cooler temperatures. Breweries sprouted in many cities during the 1860s, and by 1870, brewers started providing their beer in embossed bottles. Many were initially in blob-top bottles similar to soda bottles, and in colors such as amber, aqua, and green. If a shard is found with embossing noting either "porter" or "ale," it likely dates to before 1900 and originated in the Eastern states. Beer manufacturers in the Midwest (St. Louis and Milwaukee) were more partial to lager-style beer.

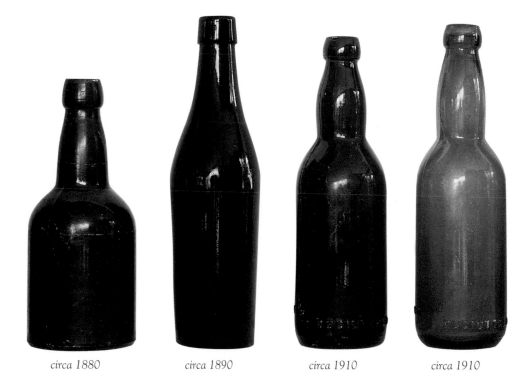

circa 1880 *circa 1890* *circa 1910* *circa 1910*

Common beer-bottle shapes from the 19th century are not too different from those of today. A routine design by the 1870s was a traditional round base moving up to slowly sloping shoulders. Most beer bottles before 1875 were sealed with corks secured by wire. In 1875, Charles de Quillfeldt developed a closure called the "Lightning stopper" enabling the user to open and reseal their bottle. His device remained popular for beer bottles up until 1915 when the Crown Cork closure dominated the bottle industry.

Unfortunately for brewers, a national Prohibition on alcohol went into effect in January of 1920 under the 18th Amendment of the United States Constitution. The civil unrest that ensued resulted in the only repealed U.S. amendment. Breweries were back in business by April of 1933, and the 21st Amendment, allowing regulated distribution of taxed alcohol, was ratified by December. As a thank you gesture to new president Franklin D. Roosevelt, August Busch delivered the first case of post-Prohibition Budweiser to the White House on their famous red wagon drawn by eight Clydesdale horses.

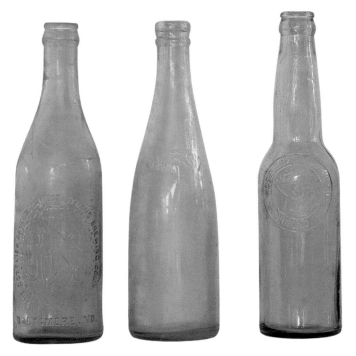

Aqua-colored beer bottles were common by 1920

Popular brands that started ages ago and remain today include Molson (1786), Yuengling (1829) Coors (1873), Budweiser (1876), Pabst Blue Ribbon (1882), Michelob (1896), and Miller High Life (1903). Dark brown glass became a standard color for beer in 1933 as Prohibition ended. Two years later, canned beer was introduced but had a slow start. However, today it is believed that close to 70 percent of packaged beer is in cans.

One of the most coveted colors of beer bottles and sea glass is a deep red shade formerly produced by Anchor Hocking for Schlitz called "Royal Ruby." Bottles of Royal Ruby were made in the 1950s and again in 1963. The Anchor Hocking Glass Company made these now rare red bottles by oxidizing copper to a precisely controlled state within the glass batch.

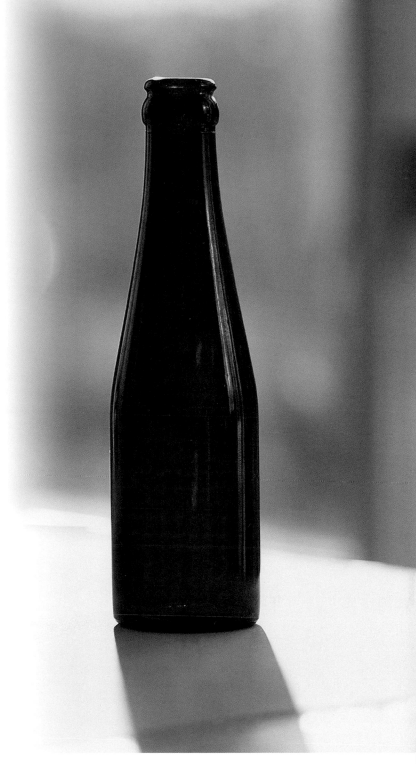

"Royal Ruby," circa 1950

Bitters Bottles
1840-1920

Bitters began as European medicine made with bitter herbs and water. Gin was later added to the mix, and when a tax on gin went into effect in England during the 1700s, bitters became a popular alternative. It is said that the original name of bitters came from its unpleasant taste, but hiding an alcohol content of sometimes 40 to 50 percent behind a medicinal name became a convenient front for reducing tax obligations.

In America, bitters usually contained whiskey or rum, and the drink was quite popular during the mid- to late 19th century. A trendy flavor was Sarsaparilla, made from whiskey and sarsaparilla roots. Most bitters bottles were made in shades of amber color, but a few were also in aqua, green, and even milk glass. Bottle shapes were often boxy and rectangular with tapered lips, sloping shoulders, and, at times, beveled edges. As demand increased, their uniqueness also blossomed. While initially the containers were similar to medicine bottles, figural bottles in the shapes of log cabins, barrels, fish, pigs, and pineapples helped manufacturers grow their brands. There were an estimated 1,000 brands of bitters being made by the turn of the 20th century.

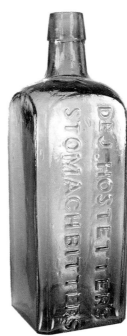

circa 1870

circa 1870

circa 1880

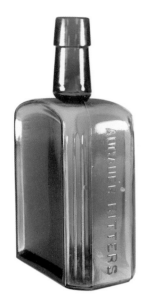

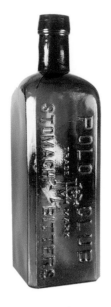

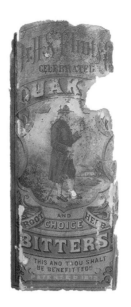

circa 1900

circa 1900

circa 1900

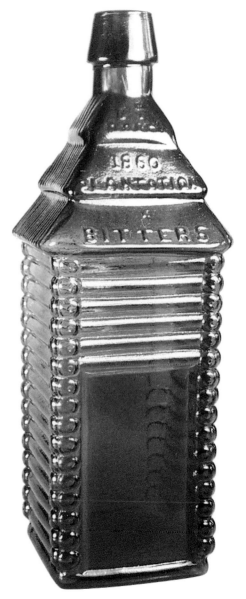

circa 1870

Bitters bottles were primarily made domestically between 1840 and 1910. In 1920, the nationwide Prohibition eliminated what producers were still surviving after the Pure Food and Drug Act of 1906. Consequently, the bottles have become a hot commodity for collectors, fetching prices as high as $68,000 for a single rare Bryant's Bitters bottle.

Popular company names found on bitters bottles from the latter 1800s include Atwood's, Brown's, Drake's Plantation Bitters, Greeley's, Hall's, Hostetter's, McKeever's, National, Old Sachem and Warner's Tippecanoe. The Union army is said to have used Hostetter's during the Civil War to decrease fear in troops heading off to battle. A rather unique attempt to reach a conservative sector of the bitters market was Dr. Flint's "Quaker Bitters." On its label it read, "Drink This And Thou Shalt Be Benefitted!!"

In some cases, manufacturers did admit on labels to using whiskey to better preserve the drink's shelf life. Unlike patent medicines, most bitters consumers knew it was primarily liquor. The drink was promoted for regular use as a medicine but was a socially acceptable alternative during Prohibition.

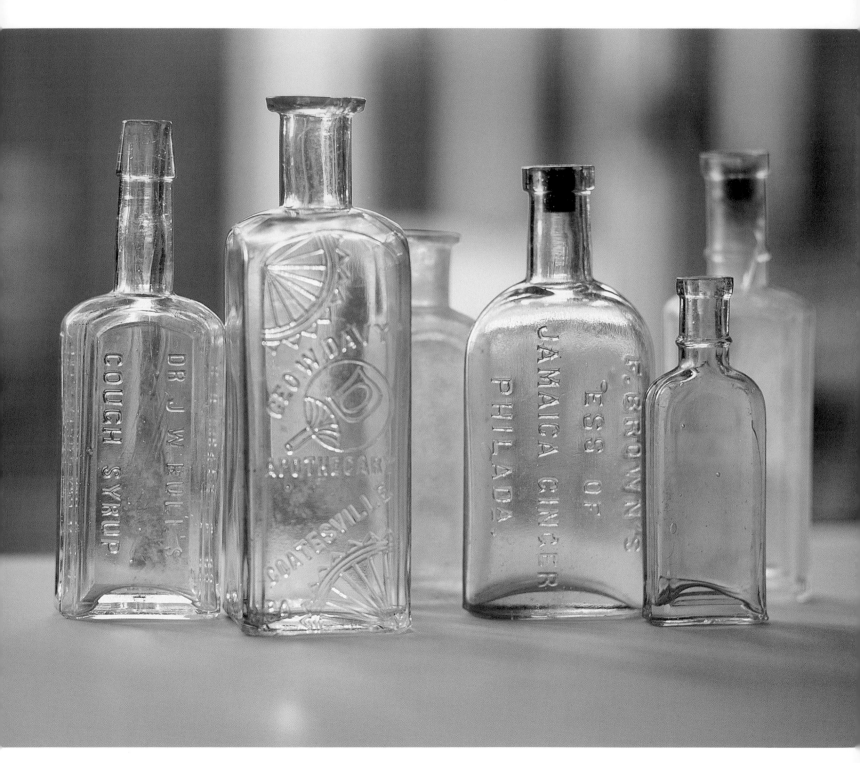

Pre-1900 drug bottles

Drug Bottles
1750-1950

Unlike patent medicine bottles, most early drug bottles were not produced for sale with bulk formulas. These were often sent empty to local druggists or doctors for the specific task of filling a dry or liquid prescription. While many druggists and chemists used wide-mouth bottles with corks, they also used apothecary-style bottles to protect dry medicines and chemicals from moisture intrusion or oxygen exposure. The familiar apothecary ground-glass stopper was not suited for long distance travel, so the medicine sent home was usually in a corked bottle.

One of the great prizes for any sea-glass hunter is an apothecary stopper. Significant volumes of apothecary bottles were made between 1850 and 1900 mostly in clear glass, as well as some in amber and cobalt blue. Glass stoppers in teardrop shapes were also made at that time but primarily for perfume bottles. If exposed to the elements long enough to cause hydration, the entire stopper handle could be as roughly ground as the portion of the "fritted" glass stopper itself. The coarse "fritted" area on the stopper was actually quite effective in protecting its contents and was convenient to open and close.

In 1872, Charles Phillips of Stamford, Connecticut developed Milk of Magnesia with magnesium hydroxide to settle upset stomachs and use as a laxative. Bottle shards in light to medium blue can be found embossed with Phillips' name, "Glenbrook, Conn." and a circular belt logo. Most have screw-cap collars, but the lighter blue colors are older, and may have a square-edged collar for a cork stopper. A fair amount of the cornflower-blue sea glass found today is possibly from this immensely popular product.

In the early 1890s, Isaac Emerson of Baltimore started bottling Bromo-Seltzer, and Richard Miller of San Francisco began bottling medicine for The Owl Drug Company. Both businesses mass-produced their drugs in cobalt-blue bottles. The Owl Drug Company aggressively promoted their product throughout the West and then went national. They were the self-proclaimed "Dictators of drug prices" per a 1902 ad in the Los Angeles Times. Shards from either of these cobalt-blue bottles can be found with distinctive text or designs, such as the "Emerson Drug Company Baltimore, MD" for Bromo-Seltzer or an owl perched on a mortar and pestle with markings of "T.O.D.Co." In 1933, Rexall Drug purchased The Owl Drug Company and continued the use of its familiar logo.

In the late 1800s, a vast number of clear and light aqua-colored medicine bottles were being made for drug store use that included embossed lettering for local drug stores. In time these were made with recessed front and rear panels to accommodate paper labels. Without the label, attempts to tell a drugstore prescription bottle from a patent medicine bottle are a challenge. If a neck shard is found with a very small diameter, such as less than three-fourths of an inch round, it can be attributed to a medicine bottle.

Owl Drug Company, circa 1910

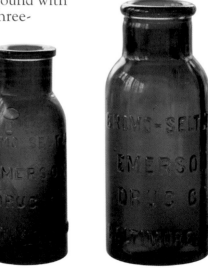

1900-1920 Bromo-seltzer bottles

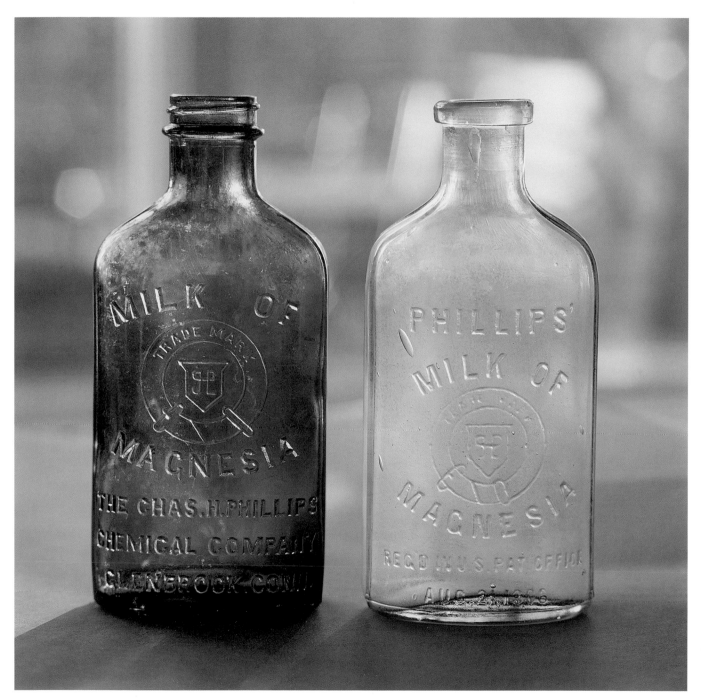

circa 1930 *circa 1910*

Fire Grenades
1850-1910

Early Harden Ad

Before the invention of the fire extinguisher, glass balls with handle-length necks filled with chemicals or salt water were used to dowse small fires. These were first made in England during the 1860s and were being produced in the United States by the early 1870s. The glass balls, known as fire grenades, were made with fragile walls that would burst open when they were lobbed into a burning area. The chemical inside (carbon tetrachloride) would help extinguish the fire by briefly eliminating available oxygen. Some of these simply contained a less volatile solution of ammonia with salt water.

Fire grenades were often mounted on walls in homes, hotels, schools, churches, trains, and even barns. The most common shapes were balls about five- to six-inches in diameter with fluted, quilted, or diamond patterns and embossing with names like Harden's Star, Fire-X, Haywards, Hazelton's, Comet and Babcock. Some were pear-shaped versions, while fire grenades in the shape of rolling pins were less common.

Popular colors include cobalt, green, amber, clear, and, in some cases, aqua. There were latter-day models made in red and clear glass. As beautiful as many of these bottles are, it is important to note that the contents, known in the chemical industry as "carbon tet," are very hazardous to the lungs. So while sea-glass shards may be safe, antique collectors should take special precautions when handling filled fire grenades. By the early 1900s, other more effective, hose-style fire extinguishers took their place.

It is possible to find a spherical-shaped shard from a glass target ball and confuse it with a piece of a fire grenade. Both were used during the late 1800s and had some similar patterns and colors. But target balls were normally smaller, about 2 to 3 inches in diameter, and had very short necks or no neck at all. Target balls began to replace the shooting of live pigeons for sport in the 1860s. The peak production periods, for names like Ira Paine, Bogardus and Greener, were between the late 1870s through 1890. Many of the balls contained confetti or feathers but the ever-popular clay pigeon (disk) quickly took over the market in the early 1880s. A variety of colors were used such as aqua, green, blue, amber, and, to a lesser degree, some purple. Glass target balls were still being made in the very early 1900s, but few were produced after 1910.

Annie Oakley and Buffalo Bill made extensive use of glass target balls while touring the United States performing their shooting expositions. A comprehensive reference book on target balls by expert Ralph Finch will debut in 2005.

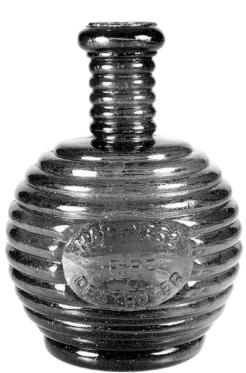

Fruit & Food Jars
1820-Today

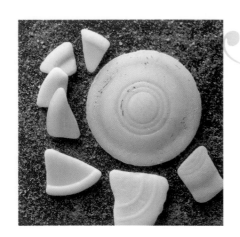

Initially produced in the late 1820s, Philadelphia glassmaker Thomas Dyott first popularized glass fruit jars. Most fruit jars are recognized by their wide-mouth design and were made in light aqua, clear, and sometimes citron green colors. A vast array of fruit jar closures came into use in the 1800s, but the most recognizable was a zinc screw-top cap designed by John L. Mason in 1858. Prior to this time, wide-mouth jars were filled with product, topped off with a wax seal, and then corked for a less than perfect container. Mason did not invent the threaded closure; it was the specific zinc cap that he patented and sold to several bottle makers such as the famous Ball Brothers in 1885. Though he did well, his success was almost short-lived due to fear over zinc contaminating the food contents. Fortunately, an opal glass liner was developed in 1869 by Lewis Boyd to alleviate the zinc concerns. Shards from these liners can be found with a slight bluish tint and are quite attractive.

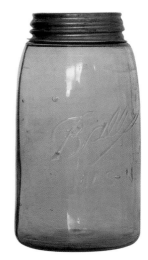

circa 1850 "wax-sealer" fruit jars

circa 1870

circa 1890

After the introduction of the convenient Mason jar screw cap, the industry started to boom in the 1860s. Another entry to the closure market during that period was the thumbscrew design that was mounted directly on top of the glass lid. It saw limited use, but by the late 1800s, a hinged-metal closure was developed for the fruit-jar market that had good success.

In the early 1900s until the mid-1930s, many fruit jars used what was known as a "White Crown Closure" that was made of white opalescent Milk glass. It was a flat disk that was used with a rubber gasket and screw-top lid but was later replaced by a similar-looking hard plastic disk.

Early Gulden's mustard container, circa 1880

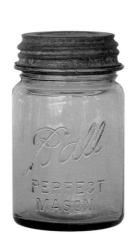

circa 1900 *circa 1925* *circa 1930* *circa 1930*

Cathedral-style pickle jar, circa 1860 *Rumford bottle, circa 1890*

Fortunately for the sea-glass collector, many fruit jars were embossed, and internet references are available noting when specific fonts were used on items like the "Ball Improved Mason" jar (1896 to1990) or the "Ball Perfect Mason" jar (without underlined logo from 1923 to1933). Finding light blue sea glass with a portion of the familiar Mason or Ball logo is a good possibility. It is easy to recognize pieces of neck rings from these jars as they often show vibrant aqua tones on the familiar broad rim below the threads.

In the area of food jars, one of the most unique designs was the Cathedral-style pickle jar used for both pickles and peppers. These are now highly collectible containers. According to bottle collector and writer Glenn Poch, pickles were as popular in the 1800s as salads are today.

Numerous other versions of glass food containers were popular in the early 1900s for condiments and other items. Candy containers were made in hundreds of designs, such as ships, cars, planes, and animals with automated molds. These were customarily made in clear glass.

"Goofus glass" fruit jar, circa 1915

Early to mid-1900s condiment bottles

Gin Bottles
1800 - 1900

In the mid-1600s, a Dutch medical professor developed gin while attempting to find a treatment for kidney disease. One of the unique ingredients was juniper fruit, but for optimal formulation, considerable alcohol was needed. By the mid-1700s, numerous pharmacists had begun producing the drink, and laws in England were introduced to reduce its abuse. This led to the use of gin in bitters to hide the gin as a medicine, which incidentally was its originally intended use.

Bottle collectors refer to most gin bottles made in the late 18th and 19th centuries as "Case gin" or "Dutch gin" bottles. This is because they were initially designed in octagonal or square shapes to fit six or 12 bottles securely in wooden cases for long voyages. Some gin bottles today still have the familiar shape designed almost three centuries ago. Most case gin bottles are 10 to 11 inches tall and have a distinctive tapered shape with a square bottom, rectangular sides, and sharply rounded broad shoulders. They routinely have a short neck and either a flared lip, common in the 1700s, or an applied tapered collar, that was prevalent during the 1800s. A number of these also were marked with a blob seal on the shoulder that included a client name along with a symbol, such as an anchor, lion, or bird.

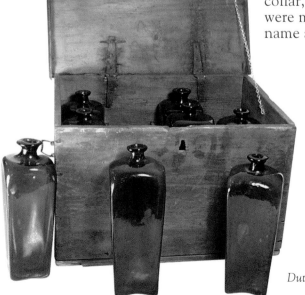

Dutch Case Gin bottles with captain's chest, circa 1790

Prior to 1900, nearly all of the case gin bottles were produced in dark olive-green or olive-amber-colored glass. Far less frequently, gin bottles were also made in "black glass" and Milk glass.

One of the better-known early gin producers still active today is Beefeater of London. It was started by James Burrough in 1820 and was titled after a familiar nickname for the Royal Palace Guards provided by the Duke of Tuscany in 1669. The Duke evidently had heard that the formidable palace guards dined amply on meat and thus noted they "might be called beef-eaters."

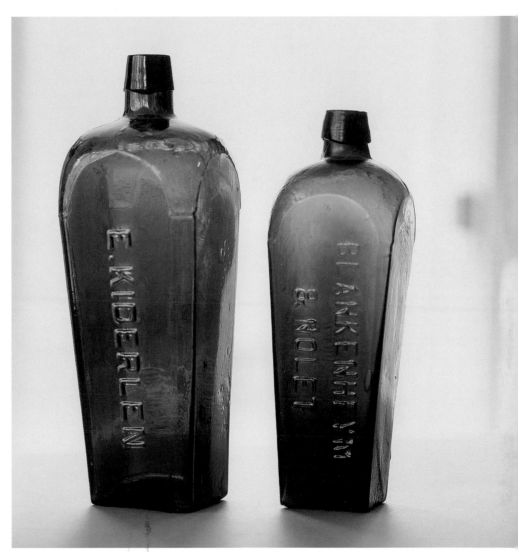

Case Gin bottles, circa 1880

Ink Bottles
1840 - 1950

The famous Manheim Glass Company of Pennsylvania produced the first glass ink bottles in the United States during the late 1700s. Prior to this time and for years to come, much of the ink was sold in ceramic vessels. Ink was a critical item for document generation in commerce and at schools in the new nation. General merchants as well as druggists and bookstores sold ink in individual or large "master ink" sizes. The master ink bottles usually ranged from 5 to 10 inches in height and frequently had pour spouts. They came in a variety of shapes and sizes making the identification of shards a challenge for even the expert bottle collector.

In the 1840s, petite conical and umbrella-shaped ink bottles evolved that reduced spills at work and school. By the mid-1800s, the quality of the ink and its bottle designs improved. This led to the creation of several patented ink bottles by the 1860s.

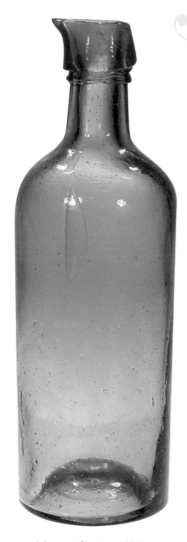

Master ink, circa 1880

Umbrella ink, circa 1860

Cone ink, circa 1860

Aqua and light green were the most common colors, but blue, amber, amethyst, and a few clear ink bottles were also made in the United States. Imports from overseas originally came in pottery-style bottles, but there were a limited number of pottery versions made domestically. Since ink bottles once served both a functional and design use, such as for decorating one's desk, a variety of interesting shapes evolved: turtles, igloos, umbrellas, cones, teakettles, schoolhouses, and log cabins. One of the more popular master ink bottles of the early 1900s was a 9-inch, cobalt-blue bottle made by Carter's Ink that had a cathedral design on all six sides. A rather unique feature of several other master inks is the pour-spout lip. In addition to Carter's Ink, other famous companies from the mid-1800s include Harrison, Sanford, Moore, Hall and Stafford.

The automatic bottle machine of the early 1900s helped mass-produce many more simply designed ink bottles. However, the umbrella and other more complex shapes were not likely made by automation. By the 1920s, screw-cap lids began to replace what had always been a cork closure.

The ballpoint pen was invented in 1935 and became popular after World War II. It initiated the demise of ink bottle production that culminated by the 1950s. Sanford is one of the only remaining companies from the early years that still produces ink for pens.

Teakettle ink, circa 1880

Quilted ink, circa 1830

Milk Bottles
1880 - 1960

The familiar, round milk bottle appeared around 1880, and its design hardly changed until 1940, when square milk bottles gained popularity. By 1890, milk bottles had begun using a paper disk closure designed by Dr. Harvey Thatcher of New York. Just inside the wide lip of these bottles was a beveled edge where a flat, circular cardboard disk was inserted to seal the milk. Since milk bottles were designed for continuous use, they were normally made of thick glass. Many had a cylindrical shape, with a broad, elongated neck flaring out to a sturdy wide-mouth lip.

While most people are familiar with the standard clear glass milk bottle, there were some very rare green and amber colors produced. Finding sea glass from milk bottles is not easy because most were returned to the vendor for recovery of a cash deposit. Though few were disposed of, millions were made each year, and the thick glass holds up well in a rugged, aquatic environment. Identifications can be made through embossed lettering that is still legible or shards of broad rims with beveled areas for the cardboard inserts.

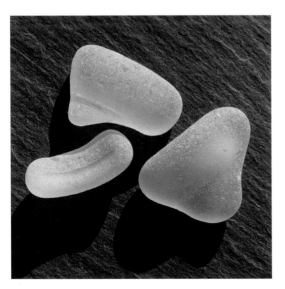

By the late 1930s, most milk bottles were being printed with red text and logos using baked on enamel. The process was called "applied color labeling," (ACL) commonly referred to as "Painted Label" by bottle collectors. Bottle producers were able to provide this printing service for such nominal fees that dairies everywhere soon had their own line of returnable bottles.

The bountiful years for milk-bottle production were between 1920 and 1945. Production had dropped off heavily by the late 1940s when coated-paper cartons came on the scene and delivery services waned.

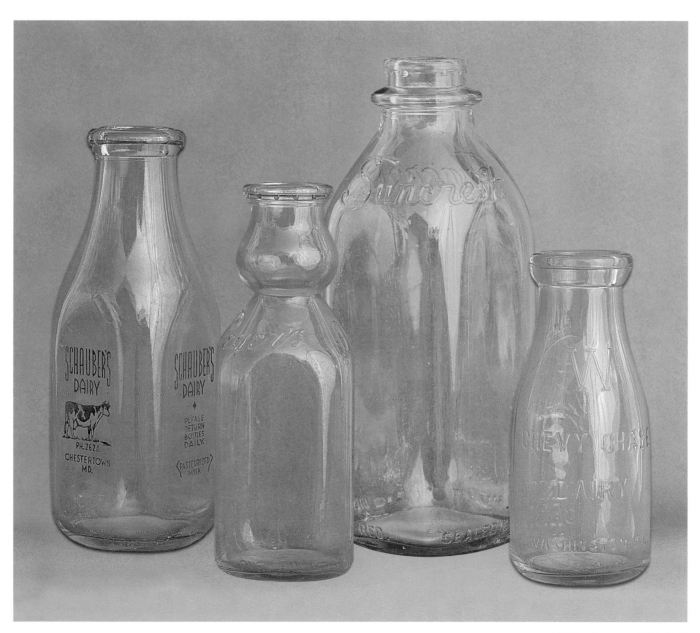

Milk bottles, circa 1920-1960

Mineral Water Bottles
1840 - 1900

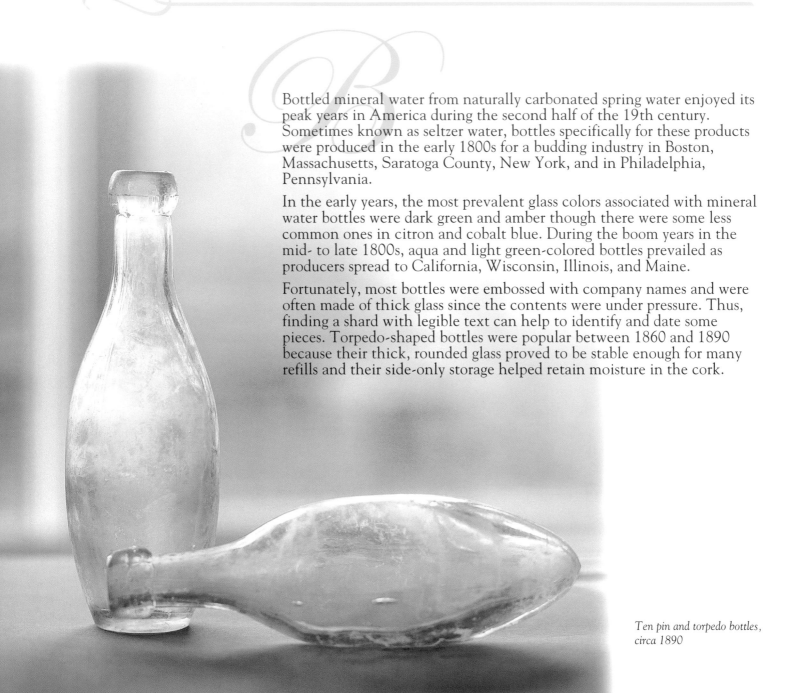

Bottled mineral water from naturally carbonated spring water enjoyed its peak years in America during the second half of the 19th century. Sometimes known as seltzer water, bottles specifically for these products were produced in the early 1800s for a budding industry in Boston, Massachusetts, Saratoga County, New York, and in Philadelphia, Pennsylvania.

In the early years, the most prevalent glass colors associated with mineral water bottles were dark green and amber though there were some less common ones in citron and cobalt blue. During the boom years in the mid- to late 1800s, aqua and light green-colored bottles prevailed as producers spread to California, Wisconsin, Illinois, and Maine.

Fortunately, most bottles were embossed with company names and were often made of thick glass since the contents were under pressure. Thus, finding a shard with legible text can help to identify and date some pieces. Torpedo-shaped bottles were popular between 1860 and 1890 because their thick, rounded glass proved to be stable enough for many refills and their side-only storage helped retain moisture in the cork.

Ten pin and torpedo bottles, circa 1890

One of the more unusual mineral water bottles came from Poland Springs in Maine beginning in 1876. It was a tall figural bottle designed to look like Moses. A breakage problem contributed to its rapid withdrawal from the market, but the mold was used again in the 1920s and 1930s for other beverages, and for alcohol in the second half of the 20th century. Artificially carbonated soda water gained popularity in the late 1800s, so by 1900, the mineral water industry was considerably reduced in size.

Most mineral water bottles had blob-top collars for wire-bound cork closures or distinct, applied double-tapered collars for mounting a dispensing spigot on top. Lightning and Hutchinson stoppers were also used in the late 1800s, as was the Crown Cork seal during the early 1900s. Common names embossed on mineral water bottles include Saratoga, Cherry Valley, Excelsior, Empire, Highrock Congress, and G.W. Merchant.

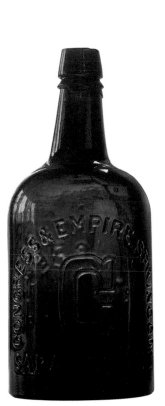

Congress Empire,
circa 1875

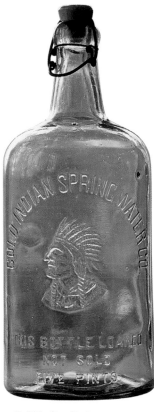

Cold Indian Spring,
circa 1890

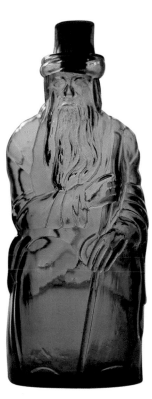

Poland Springs,
circa 1900

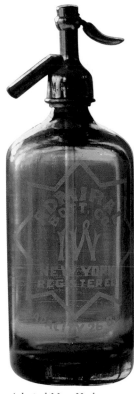

Admiral-New York,
circa 1920

Patent Medicine Bottles
1810 - 1910

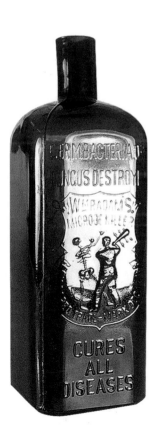

Most proprietary medicine bottles made between 1810 and 1910 have become known as "patent medicine bottles." They were usually produced in colors such as aqua, clear, and amber, but a few were also made in green and cobalt-blue glass. Many of these medicine bottles were rectangular in form, quite thin, and sometimes had concave front and back panels. The less common forms were cylindrical. Patent medicine bottles frequently had sloping shoulders and an elongated, round neck with a square-edged collar or tapered collar. The bottles often included embossing to help manufacturers protect their patented formulas. In many cases, the bottle designs were patented more readily than the formulas within, since patents call for full disclosure of ingredients, which could sometimes be questionable in nature.

Though accredited medical doctors did develop some of the formulas, spurious self-proclaimed doctors often fabricated testimonials to sell containers holding nothing more than a mixture of water, whiskey, flavoring, herbs, and even sometimes a bit of narcotics, such as opium, morphine, and cocaine. Patent medicines, also called "nostrums," were promoted by claims that they could purify blood or cure various diseases that are still not curable today. Common claims included cures for liver and kidney disease, rheumatism, diabetes, malaria, or even gonorrhea.

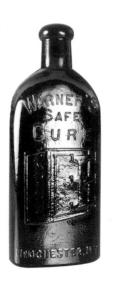

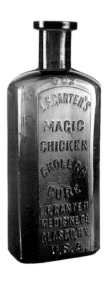

By the mid-1830s, the "penny press" newspapers became a popular advertising medium for a thriving patent medicine industry. Both industries became quite dependent on each other by the late 1800s. Traveling "snake oil salesmen" were also peddling their wares throughout the countryside and were especially effective in reaching vast numbers of illiterate Americans. The term "snake oil salesman" had its roots in the early days of patent medicines when some formulas did boast about the health benefits of snake oil within their mixtures.

One of the most popular patent medicines of the late 1800s was Lydia Pinkham's Vegetable Compound. Found to contain 20 percent alcohol (40 proof) along with its vegetable extracts, it was a huge success since it was marketed specifically for the ailments of women. As her brand actually grew to become an international sensation, Pinkham was recognized as the first female American entrepreneur. She started the business in 1873 in Lynn, Massachusetts at the age of 54 to support her four children during an economic collapse. Though she died only 10 years later, versions of her formula were actively sold under her name for 100 years.

In the early 1900s, years of exaggerated claims finally caught up with the rest of the patent medicine industry. Inspired by muckrakers like Samuel Hopkins Adams, the official medical community embraced his expose called The Great American Fraud and began their battle against the nostrum-peddling industry. The public demanded appropriate labeling for patent medicines. But the newspaper lobby, supported by the advertising dollars from an $80 million patent medicine industry, kept national legislation tied up for months. Finally, the Pure Food and Drug Act was adopted in June of 1906 with regulations forcing the sellers who made patent medicine to disclose contents and give quantities of ingredients such as alcohol, morphine, opium, cocaine, and heroin. Six years later, the government passed an amendment forbidding the use of the word "cure" on a bottle. Thus, a shard of sea glass with the word "cure" dates it to before 1912.

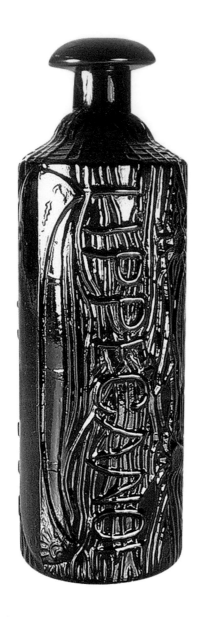

As a result of the Pure Food and Drug Act, many producers failed to stay in business past 1910. Some tried using the word "remedy" instead of cure and managed to survive for a while. Even after complete disclosure, Lydia Pinkham's products still enjoyed some of their best years during the Prohibition era of the 1920s. While this may be due in part to the fact that the alcohol-laden product was considered legal to drink, her reputation for herbal medicines and advice was also hard earned.

In the defense of Pinkham and her contemporaries, alcohol is a popular solvent that does help keep dissolved solids in suspension while in liquids. Thus, the alcohol helps to extend the shelf life of almost any product made from dissolved materials while making one "feel better" at least temporarily. Other famous patent medicines of the late 1800s and early 1900s include Dr. Kilmer's Swamp Root, Swaim's Panacea, G.W. Merchant (Gargling Oil), Kickapoo, Perry Davis' Pain Killer, Radam's Microbe Killer, Warner's Safe Cure (for diabetes) and Tippecanoe, which had a log-shaped bottle with a canoe on the side. By 1860, patent medicines had grossed over $3 million and were close to $70 million in annual sales by 1900.

Bottles or shards with markings noting "For Medicinal Use Only" can easily be dated as produced in the Prohibition years between 1920 and 1933. From 1933 to 1954, "Federal Law Forbids The Reuse Or Resale Of This Bottle" was embossed on all alcohol bottles.

Poison Bottles
1870 - 1930

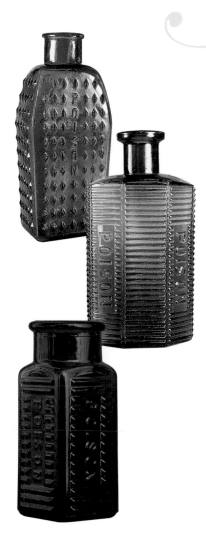

In the early half of the 19th Century, there were numerous household cleaners available (such as carbolic acid) or substances needed to kill mice and a host of other pests. Unfortunately, many Americans remained illiterate at that time, so evening trips to the medicine chest resulted in a growing number of accidental poisonings. By 1829, the state of New York had already mandated that the word "poison" be placed on appropriate bottles. By 1853, The American Pharmaceutical Association mandated the same to their members, but ineffective home lighting and poor reading skills still led to far too many fatal poisonings. As a result, the American Medical Association strongly urged all manufacturers in the 1870s to use colored, textured glass and the word "poison."

Glass manufacturers responded by creating bottle designs with spiked surfaces and unusual shapes, routinely in cobalt blue. By the late 1800s, patents were being registered for unique designs including triangular and hexagonal shapes, skull and crossbones embossing, a figural skull, coffin shape, and even bottles with odd safety closures. Well-recognized poison bottle suppliers from the late 1800s and early 1900s include the Owl Drug Company, Whitall-Tatum with its blue quilted apothecary bottle, and Eli Lilly with its triangular "triloid" shape. Though poison bottles were also made in colors such as amber and forest green, cobalt blue was far dominant. By the 1930s, specialty closures such as screw caps had made the ornate poison bottles obsolete. For collectors, dealers of poison bottles abound, but the bottles are rapidly gaining in price and value.

The sea-glass hunter should look for specific text that may include the word "poison" or for cobalt pieces with diamond-shaped nubs or a skull-and-crossbones design. While hard to locate, they can be easily identified once found.

Snuff Jars
1750 - 1960

Snuff bottles may be one of the easiest forms to recognize by their box-like shape leading to sharply rounded shoulders, ending in a short neck and a wide, rolled lip. The prominent colors used for most snuff bottles were amber, olive, and dark green. However, collectors of Oriental snuff bottles have numerous colors and ornate designs to choose from. Since it is very unlikely to find shards of Chinese snuff bottles along the American shoreline, this text will focus on domestic glass snuff bottles. These normally ranged from 4 to 5 inches in height and included cork closures. Very few bottles had embossing, but the ones made in the late 1800s did have labels. Other than a unique squat collar and wide lip, the only other unusual marks on snuff bottles were a series of dimples set in the middle of the bottle bottom that merely indicated which machine and arm of the machine the glass company used in manufacture.

Snuff is basically tobacco in a powdered form mixed with different essences or spices such as lavender, cinnamon, cloves, or nutmeg. It was inhaled to incite an abrupt sneeze that was then considered pleasurable. There was also a moist form that could be chewed. Supposedly the Chinese were the first to use snuff, but the French and English began using snuff more readily in the 1600s. By the mid-1700s, Caspar Wistar's glass factory in New Jersey was producing snuff jars. Snuff jar lip shards should be easily identified while other portions of the jar would be more challenging.

circa 1890

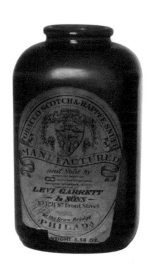

circa 1960

Soda Bottles
1840 - 1960

Beverages with man-made carbonation originated in England in 1772 when Joseph Priestly developed the means to create the fizz in soda by adding carbon dioxide to water. Two decades later, Schwepps of Bristol, England became the first major soda company. In the United States, the first patent was granted for artificial carbonation in 1810. Shortly thereafter, soda water was marketed for settling upset stomachs and sometimes to assist weight loss. Unlike naturally carbonated mineral water, carbonic acid is added to water creating the bubbly fluid we know today as the soft drink. Sodas flavored with fruit juice were once attempted in Philadelphia in 1807 but were not well accepted. Flavored sodas were attempted again in the 1840s, but it was not until the 1880s that sodas made their true mark on history.

Soda fountains were quite popular from 1820 to 1840 but by the late 1830s, mass production of bottled soda water had begun in Saratoga Springs, New York. By the 1850s, soda water producers were established in New York, New Jersey, Pennsylvania, Massachusetts, Ohio, California, and Maryland. But without the addition of flavoring, success was still a few ingredients away.

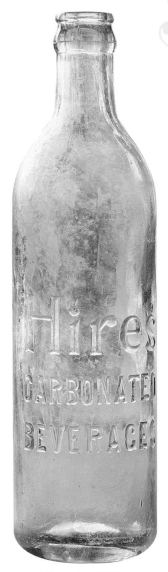

Hires, circa 1920

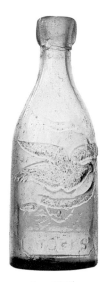

circa 1850

circa 1865

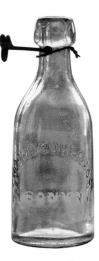

circa 1865

Flavored sodas were slowly gaining momentum in pharmacies during the late 1800s when Hires Root Beer was introduced as an extract in Philadelphia during the 1876 U.S. Centennial Exhibition. In 1885, Dr Pepper was established in Waco, Texas, Coca-Cola in Atlanta, Georgia in 1886 (not bottled until 1892), and Pepsi in North Carolina in 1898. Other notable producers include Chero-Cola in 1905, which became Royal Crown, Orange Crush in 1915, NEHI in 1924, and 7UP in 1928.

Like patent medicines, many were supposed to help ailments such as headaches and sometimes included minor amounts of narcotics. For example, Coca-Cola contained traces of cocaine up until 1905. An Atlanta pharmacist, Dr. John Pemberton, began producing Coke in 1885 calling it "French Wine Coca - Ideal Nerve Tonic Health Restorer and Stimulant." A year later, he removed the wine from the formula and added caffeine and kola nut extract. Promptly afterward, Pemberton's bookkeeper, Frank Robinson, drafted the scripted Coca-Cola logo that remains a trademark for the most recognized brand in the world.

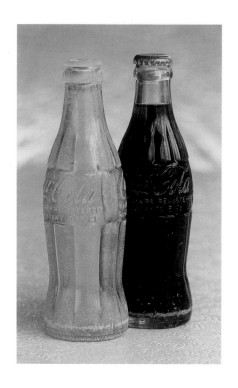

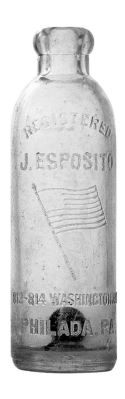

By 1889, Pemberton sold the business to Asa Candler. Candler figured that more money was to be made selling Coca-Cola syrup at drug store soda fountains than in bottles. So when two Chattanooga, Tennessee lawyers, Benjamin Thomas and Joseph Whitehead, approached him about bottling rights, he sold them for $1 in 1899. In the beginning, most bottles of Coca-Cola were in glass containers with Hutchinson-style stoppers. The familiar Coke bottle with "hobble-skirt" design and its Crown-Cork seal was launched in 1915. It remained mostly light green in color but at times could be found in aqua. Coke logo shards can reveal their ages by the text below the logo. It shows key patent dates and fluid volumes.

Coca-Cola Embossing

"Nov.16 1915"
from 1917 to 1928

"Dec.25 1923"
from 1928 to 1938

"PAT.D 105529"
from 1938 to 1951

"CONTENTS 6 FL OZ"
from 1951 to 1958

"CONTENTS 6 ½ FL OZ"
from 1958 to 1965

Common shapes for soda bottles from the mid- to late 19th century included a cylindrical body with sloping shoulders leading to an elongated neck and blob-top applied lip. General bottle colors were aqua and light green as well as some amber, blue, and dark green. Because the contents were under extreme pressure, thick glass and a variety of stoppers were developed to properly protect the carbonation. Wired and toggle-style cork stoppers were prevalent until the late 1870s when Hutchinson and Lightning-style stoppers were introduced. The Hutchinson-style stopper became more popular since it was far more economical than the Lightning stopper, which found a niche in the beer industry.

A truly fascinating soda bottle was developed in England in 1872 by Hiram Codd and was consequently named after its inventor. The Codd-style stopper required a unique bottle shape with a double indented neck where a marble was placed. The force of the internal carbonation held the marble against a washer-like insert in the lip. The consumer had to poke the marble away from the stopper to release pressure and then tilt the bottle up to drink. Since Hutchinson and Codd-style bottles were prone to dirt and deposits inside the lip, the more sanitary Crown Cork seal, still in use today, made all other soda stoppers obsolete by 1912. In the late 20th century, Americans were drinking more soda than water. That trend appears to be shifting in the early 21st century.

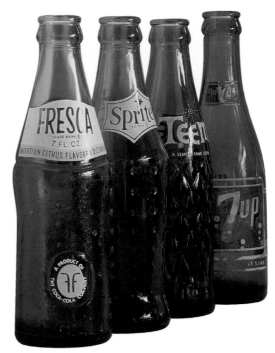

"Un-colas," circa 1965

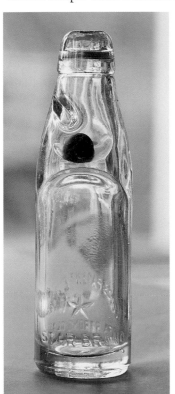

Codd-style bottle, circa 1900

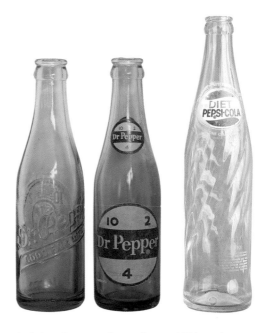

Early Dr. Pepper with period, circa 1920; without period, circa 1960. Diet Pepsi, circa 1970

Whiskey Bottles and Flasks
1740 - 1920

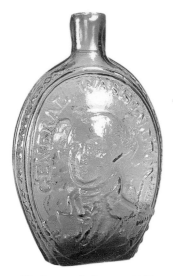

Washington flask, circa 1830

Steigel-type flask, circa 1850

Most bottles made specifically for whiskey were made from the mid-1800s to the 1920s when Prohibition put an economic end to many bottlers. Prior to the mid-1800s, whiskey jugs were made of stoneware with handles, so when glass whiskey bottles first came out, many also were produced with handles. By the late 1800s and early 1900s, shapes similar to those still in use today began to develop, and figural bottles became popular for luring customers to specific brands. Some well-known figural whiskey bottle shapes include barrels and cannons from Bininger, an old cabin form from E.G. Booz, and a variety of bottles embossed with the names of political candidates. At that time, it was a common practice for companies to bring free samples to bars in order to entice voters to support specific presidential candidates. Thus many historic flasks will display political slogans or busts of a candidate and their running mate.

One of the more successful producers in the late 1800s was young Jack Daniel. He began working at a still at the age of eight, and purchased a small whiskey business when he was 13. By 1866, a 20-year-old Jack Daniel owned the first officially registered distillery in the country. Located in Lynchburg, Tennessee, they bottled in stoneware jugs for over 50 years. In 1895, they introduced their first square glass bottle, and its shape has changed little since then.

Whiskey bottles between the late 1860s and the early 1900s were almost exclusively made in either amber or clear glass. On the other hand, flasks, used for storage, sampling, and sales came in a broader array of colors. For bottle collectors, flasks represent a sentimental category because of their rich history. While some flasks are said to be part of America's first industry at Jamestown, Virginia between 1608 and 1609, in reality they became more prevalent after Caspar Wistar set up the first successful American glass manufacturing operation in 1739. He established Wistarburgh in southern New Jersey as the first American glassmaker's village and kept it running for some 35 years. The next notable glass manufacturer to provide flasks was Henry Steigel in Manheim, Pennsylvania who developed his familiar "Diamond-Daisy" and "Daisy-in-Hexagon" patterns between 1763 and 1774.

Following the American Revolution, other notable flask manufacturers arose including William and Elisha Pitkin in 1783, John Amelung of New Bremen, Maryland in 1784, and Timothy Twitchell and Henry Schoolcraft who started Keene Glass Works in Keene, New Hampshire in 1815. The Pitkin flasks were double-walled glass vessels with vertical ribs beneath angled swirls, while Amelung used a pattern of four dots inside a diamond. Keene Glass was noted for flasks with Masonic symbols and sunburst designs. All were sealed with cork stoppers and are very valuable.

For the sea-glass collector who finds a piece of extremely old amber glass, the likelihood of it being from some type of liquor bottle is quite good. If the shard notes "Federal Law Forbids Sale Or Re-use Of This Bottle," then it contained alcohol and was made between 1933 and 1964. Following Prohibition, federal law forced makers to mark their bottles with this warning, enabling the government to collect appropriate tax revenue from each bottle sold.

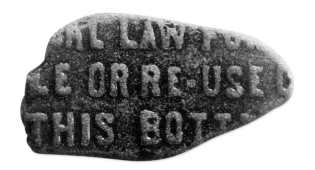

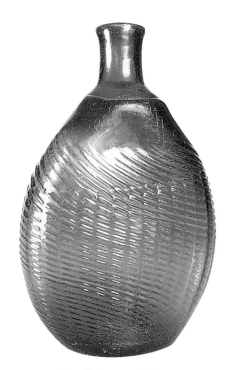

Pitkin flask, circa 1800

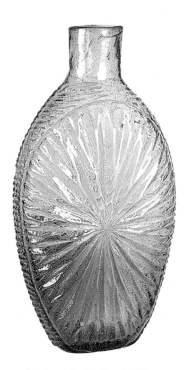

Sunburst flask, circa 1830

Wine Bottles
1700 - 1920

Through the ages, wine bottles have evolved from the fat, bulbous, onion-style bottles and mallet shapes made with "black glass" in the late 1600s and 1700s, to the more cylindrical and slender longneck bottles in the early 1800s. Many wine bottles from the 18th century included embossed seals and are now known as "applied seal" bottles. These include a glob of glass added near the shoulder that would then be embossed with a brass stamp showing the name or symbol of the buyer or manufacturer. The oldest known applied seal is dated 1652.

By the 1800s, most wine bottle producers were using dip molds or three-piece molds, and to aid transportation, the more slender style became common. These forms are quite similar to those in use today. A few manufacturers continued to use applied seals well into the 1800s, extending their use to whiskey, beer, and olive oil containers.

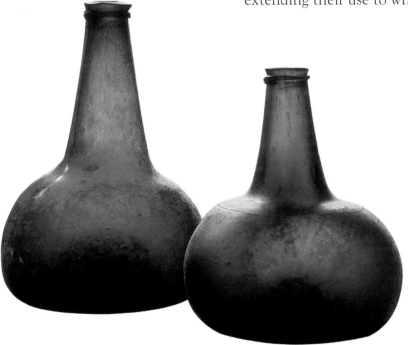

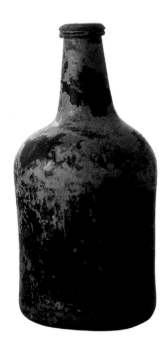

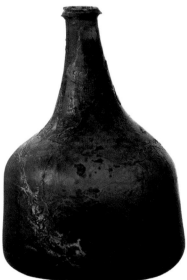

Onion-shaped wine bottles, circa 1730 (Left: Dutch, Right: English)

Mallet-shaped and cylinder wine bottles, circa 1760

One very common element of 18th and 19th century wine bottles was their dark-colored, near "black glass". While the collector of sea glass may not initially be excited about finding a shard of "black glass," they should realize this glass is possibly 200-years-old. It was principally used for spirits and wines in the 18th and 19th centuries, and may show vast amounts of bubbles within the crudely formed glass. Iron slag was added to the glass to make an extremely dark green or, in some cases, dark amber color that blocked out light and also helped strengthen the glass. Lighter shades of these colors remain popular today with wine producers. Many wine bottles also had thick bases and sharp kick-ups or conical indents in the base to help fortify the bottle for transport.

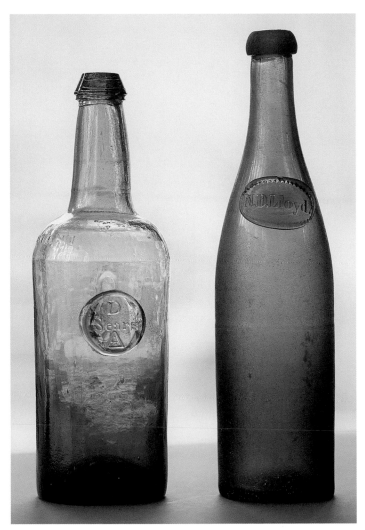

Seal wine bottles, circa 1830 and 1860

Until the 19th century, the wine consumed in the United States was imported from Europe. Thomas Jefferson was one of the early Americans who nurtured the birth of the domestic wine industry. Concerned about the consumption of beer and hard liquor, Jefferson preferred the lower alcohol content of wine. The first successful producers of domestic wine were in Ohio, but California quickly became the most successful region after winning international competitions in the late 1800s.

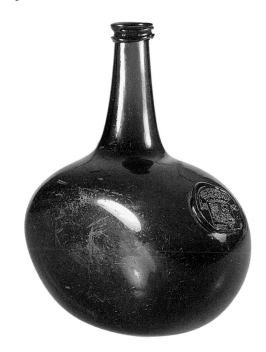

Bladder-shaped wine bottle dated 1739

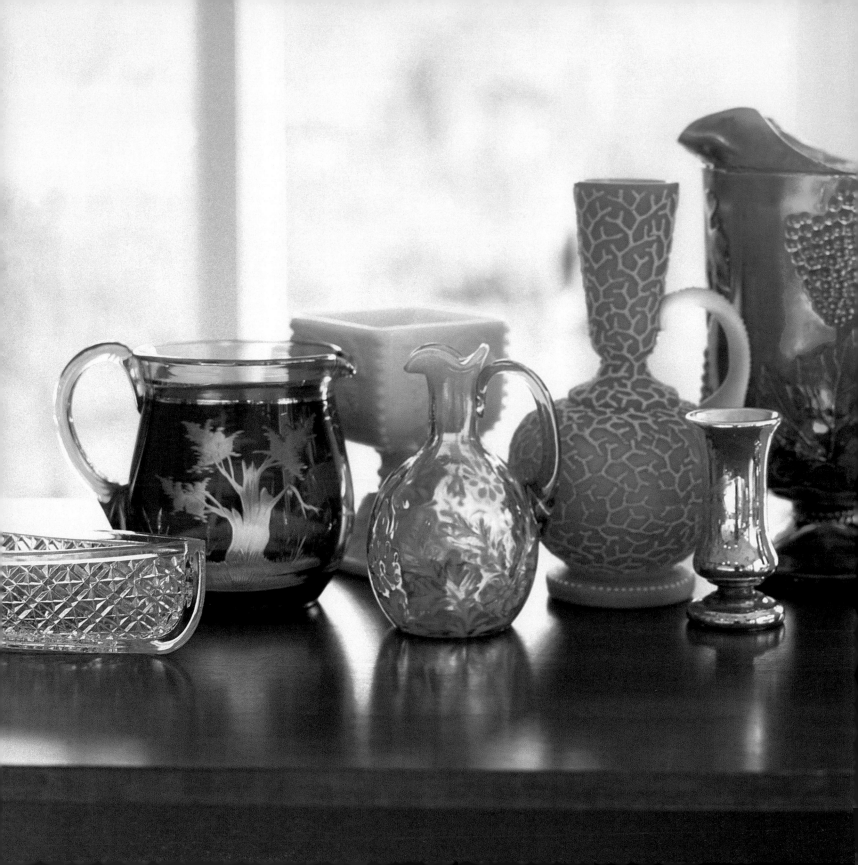

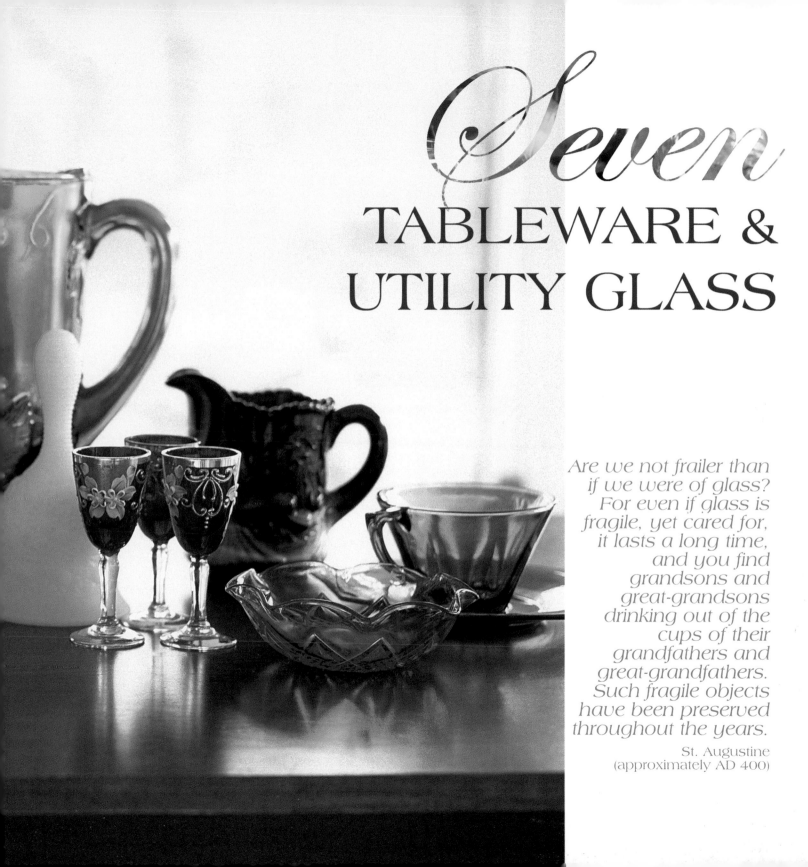

Seven
TABLEWARE & UTILITY GLASS

Are we not frailer than if we were of glass? For even if glass is fragile, yet cared for, it lasts a long time, and you find grandsons and great-grandsons drinking out of the cups of their grandfathers and great-grandfathers. Such fragile objects have been preserved throughout the years.

St. Augustine
(approximately AD 400)

Tableware And Utility Glass

One is far less likely to find shards of tableware along the shore than sea glass from bottles. Nevertheless, it does happen often enough that sea-glass collectors should familiarize themselves with many of the more popular designs produced around the turn of the 20th century. Any waterfront site that is prone to presenting the remnants of household items from that period can provide a diverse selection of sea-glass colors and shapes. In the mid- to late 1800s, broken tableware was commonly discarded in privy pits or at town dumps. If these waste areas were located near shorelines or rivers that flowed out to open water, they make ideal sites to look for sea glass.

During the first half of the 1800s, many people were still using stoneware and porcelain at home since glass tableware was not yet mass-produced. But by the late 1800s, glass tableware was a thriving industry with a vast array of artistic styles. Much of what is listed in this section began in either the Pressed glass era of the late 1800s or the Depression glass era of the late 1920s through the 1930s. The items being shown are those made in relatively ample supply since the chances of finding these as sea glass are also higher. Note that there are many more styles of tableware in addition to those that follow. To get a more comprehensive view of glass forms, it would be prudent to spend time at the Corning Museum of Glass in New York and The Museum of American Glass at Wheaton Village in New Jersey.

Amberina Glass

Amberina is a unique glass designed with two colors that transition from golden amber to a ruby red. It was initially patented by Joseph Locke and produced by the New England Glass Company of Cambridge, Massachusetts in 1883. The color was purportedly developed by accident when a glassblower's gold ring slipped into the batch. Since the gold necessary to produce this color of glass is required in a liquid form, most agree this story was mere legend.

Specifically reheating only that portion of the vessel where the red color was desired created this unique transitional coloring. The complex of gold within the glass only developed into the red color at a specific temperature while the cooler base remained golden amber. Initially called "Rose Amber" or "Aurora," this distinctive design was licensed to

Hobbs, Brockunier and Company of West Virginia in 1886 to make pressed glass. Amberina was frequently used for tableware such as pitchers, drink ware, and vases during the late 1800s and early 1900s. Patterns were frequently made with swirled or vertical ribs. Libbey Glass of Ohio produced some Amberina in the early 1900s and 1920s. Even Baccarat of France started using Amberina designs in 1916. Another latter- day producer of Amberina glass was Mount Washington Glass in New Bedford, Massachusetts. Amberina ushered in a phase of transitional glass soon copied by others in the more opaque forms of Burmese glass and Peachblow.

Burmese Glass

Burmese glass is rare, two-toned, nearly opaque glass in which the top half is soft pink and the bottom half is often a creamy, pale yellow to white. The surface was often given an acid finish leaving it with a satin texture. It is very similar to a glass called Peachblow, which is also opaque but has more red up top, instead of pink.

Burmese glass has a distinct opacity similar to Milk glass produced by the addition of calcium-based minerals such as fluorspar and feldspar. A small amount of gold is added to produce the top pink portion when reheated by the glassmaker in what is called the "glory hole." A moderate amount of uranium oxide was used to produce the soft yellow tone in the lower half. (Uranium is the primary constituent for creating the brilliant, transparent yellow of Vaseline glass, but was also used in smaller amounts to make Burmese glass and Custard glass.)

Mt. Washington Glass Company of Massachusetts introduced Burmese glass in 1885 to the American market. Queen Victoria was credited for the name, as it resembled a sunset in Burma, then part of the vast British Empire. The Mt. Washington line of Burmese glass included numerous small vases, bowls, and fairy lights often decorated with flower motifs. It was only produced in the United States for about 10 years. Later, in the early 1900s, Steuben Glass Works produced small amounts of Burmese glass, and, in 1970, Fenton Glass of West Virginia recreated some recent versions.

Cameo Glass

Cameo glass is an historic form of glass dating to Roman times in which two or more layers of different colored glass were used to allow artisans to carve decorative pictures or faces on the outer surface. Popular in China and Europe, it was made far less frequently in the United States. The Chinese made extensive use of Cameo glass when producing decorative snuff bottles in the 1700s and 1800s.

The English Cameo glass movement of the 1860s with its ornate designs increased in popularity, fetching extremely high prices by the 1880s. American manufacture of Cameo glass began in 1887 with firms such as the Boston & Sandwich Glass Company, the New England Glass Company, and Mt. Washington Glass Company, followed years later by Corning and Tiffany. Since Cameo glass was expensive to produce as both tableware and jewelry, it is considered art glass. Therefore, chances of finding shards of true Cameo glass must be considered remote.

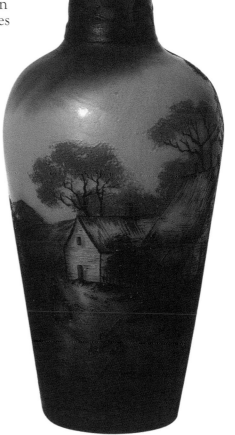

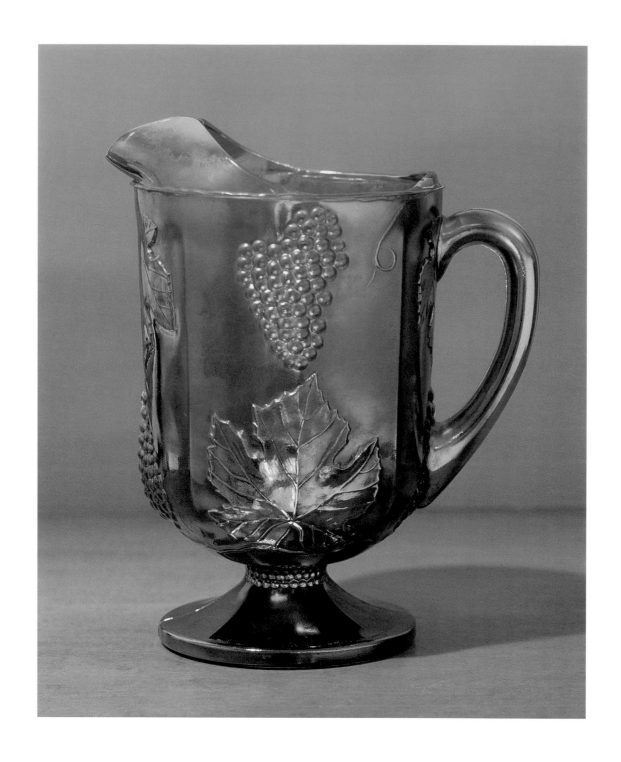

Carnival Glass

 One of the most unusual types of glass produced just after the turn of the 20th century was the brilliantly iridescent Carnival glass. The surface of the glass was given a strong rainbow-colored sheen by adding a metallic spray or gas to the glass just after the initial molding process. Carnival glass is routinely found in base colors of dark blue, amber, orange, and green, with multi-colored, prism-like effects reflecting off its surface.

Fenton Glass of West Virginia produced the first examples of true Carnival glass in 1907 under the name of "Iridescent" after seeing the success of similar, but subtler, items made by Tiffany and Steuben. Soon Northwood, Imperial and Dugan followed with comparable versions. Once also called "Rainbow Lustre," Carnival glass was popular in the United States in the early 1900s, but by the late 1920s, demand had dropped. It then became a popular giveaway at carnivals until most production ceased by 1930. In 1998, Northwood Art Glass in West Virginia began offering Carnival glass again. Sea glass found with this unusual coloring would be in the very rare category.

Ceramics

The term ceramics, or "potter's clay," includes such items as earthenware, porcelain, bricks, stoneware, and even some forms of tile. Pieces of all these can be found exposed on the beach. Due to their strength and durability, many ceramic shards, possibly several hundred years old, can reveal a wealth of clues about their history. Strong as they may be, these materials are brittle enough to break when dropped and are considerably weakened by dramatic temperature changes. Theoretically, small ceramic shards are more likely to be found in the Northeast since they are easily weakened by winter freezes and tumbled against more rocky shorelines. Of course, the overall population density in the Northeast is another contributing factor to their abundance.

Identifying the origin or age of a ceramic shard is made easier if the piece still shows evidence of a distinct pattern or a unique core color. The discoverer can use a host of references to determine the manufacturer or locate a savvy antique dealer who specializes in ceramics.

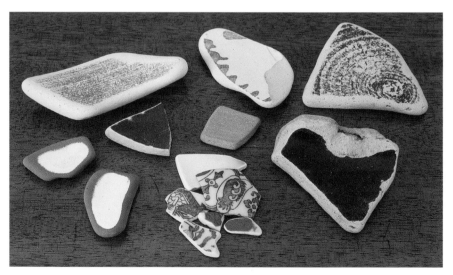

The manufacture of ceramic pottery is one of the oldest known man-made arts dating from 10,000 BC in Japan. The process of making earthenware has virtually remained unchanged since ancient times. It was not until the late 19th century, that the potter's creative art suffered from the introduction of automated production technologies.

Clockwise from left: earthenware, tin-glazed earthenware, salt-glazed stoneware, Albany-slip stoneware, porcelain, redware with white slip, and in center, buff stoneware and gray stoneware.

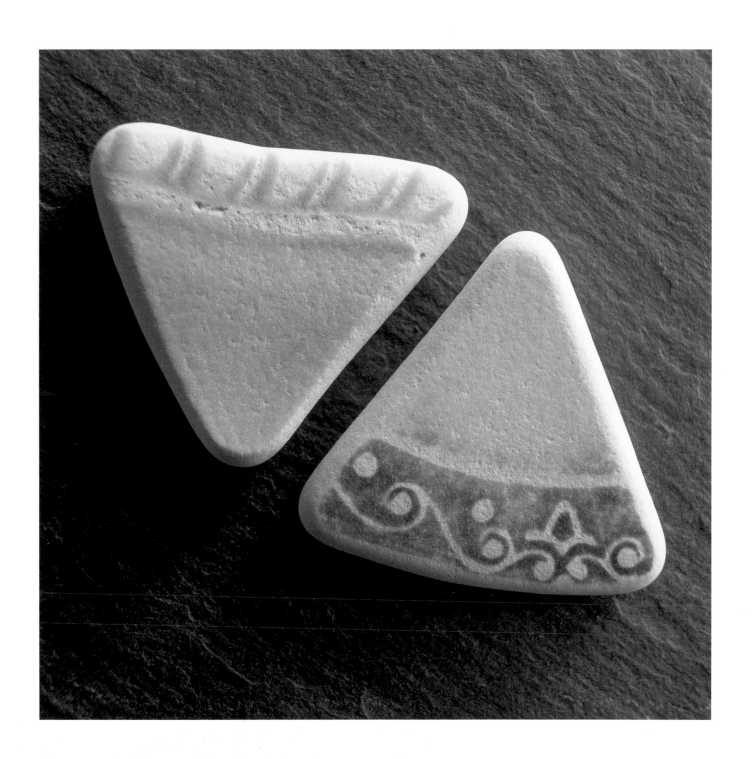

Earthenware

Earthenware is composed of clay and baked to rocklike firmness at an intense heat. Almost all ancient, medieval, Middle Eastern, and European-painted ceramics were earthenware, as well as a large proportion of contemporary household dinnerware. Though the origin of the first glazed earthenware is unknown, its designers likely intended to render its surface waterproof and make it easier to clean between uses. Ironically, most glazes are a form of glass that consists of silica or boron, common glass-forming ingredients. As in glass production, metal oxides such as copper, iron, cobalt, and manganese were used to give color to glazes. Cobalt was often used by the Egyptians to add a decorative blue color to ceramic vessels.

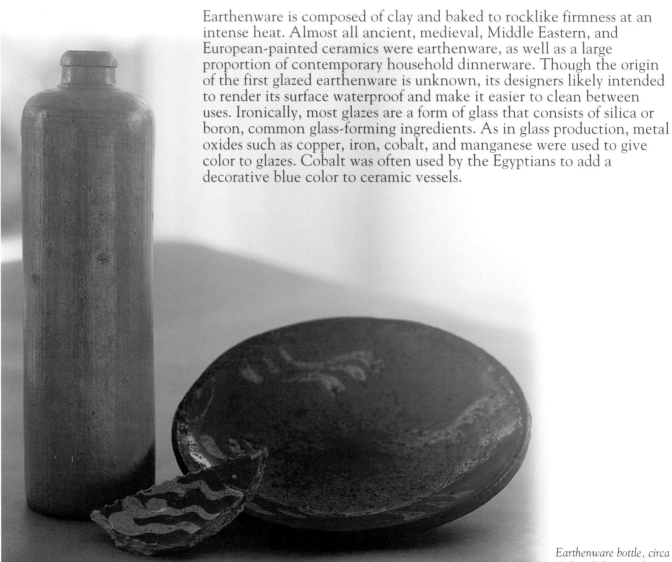

Earthenware bottle, circa 1870;
Colonial slipware plate

Stoneware

Stoneware is said to have its origin around 500 BC in China. It is known to be more durable than earthenware and more water resistant. This form of pottery, fired at higher temperatures, turns white, buff, gray, or red and is often glazed for decorative purposes. "Salt-glazed" stoneware became a preferred vessel for domestic use in Europe in the 1600s due to its nonporous properties and ability to keep liquids cool. A blue and gray style of stoneware, sometimes called Rhenish stoneware, was a popular style of tableware imported into Colonial America in the early 1700s.

In the 1830s, tan-colored stoneware bottles were being widely produced in Europe to hold ginger beer. Creators frequently imitated metal jugs and tankards in stoneware during this time. By the 1920s, stoneware bottles rapidly lost their popularity due to consumer questions regarding cleanliness (noting sediment in the bottoms) and an increasing preference for glass containers. Refrigeration had become more popular, so the benefit of keeping liquids cool in stoneware bottles was less critical. Shards from these bottles can be identified by a glimpse of the bottler's name, city or date on pieces that remain from the shoulder of the vessel.

Many American whiskey manufacturers made frequent use of stoneware jugs but other popular uses included canning jars, crockery, and beer bottles. In 1877, one of the largest manufacturers of pottery in the Unites States was KT&K —Knowles, Taylor & Knowles. Founded in 1854, their huge enterprise in Ohio remained profitable until 1920 with the demise of the stoneware bottle market due to National Prohibition.

Beachcombers may often come across these hard ceramic shards lying on the shoreline, and some may be white. If it is a delicate-looking piece that at first glance appears to be opaque in color but is actually semi-transparent, it is likely a piece of porcelain.

Porcelain

Porcelain was originally discovered in China during the T'ang dynasty (AD 618-907.) and is a type of ceramic commonly called china or chinaware. It has been valued through history for its beauty and strength. Its noteworthy durability made it practical for applications such as electrical insulators and laboratory equipment. Porcelain beach shards most likely originate from high-quality tableware and vases.

Unlike earthenware and stoneware made from a source of natural clay, porcelain was made with a unique mixture of two specific ingredients, kaolin and petuntse. Kaolin is the base ingredient used and is a pure white, claylike substance that is highly resistant to heat. Petuntse is a mineral found only in China and is a type of feldspar. Both ingredients, when mixed together and fired at approximately 2,300 degrees Fahrenheit, vitrify—melting together and forming a nonporous, natural glass. Small shards can easily be confused with Milk glass.

For centuries, the Chinese dominated the porcelain market. It was not until the 1100s that the secret of making porcelain was learned by Korea, and four hundred years later by Japan. By the 1700s, the European market began to compete with China, as France, Germany, Italy, and England became major production centers. By the 1800s, the renowned French Limoges region had become the largest producer of porcelain in Europe. In 1842, an American named David Haviland opened a porcelain factory at Limoges to make tableware to export to America.

Today, extensive production of porcelain takes place in the United States, Europe and Japan. Some familiar names of contemporary porcelain are Japanese Noritake, American Lenox, and German Rosenthal.

Despite the strong properties found in all ceramics, the sea-glass hunter may find a piece of pottery that appears to have cracks throughout. This process is called "crazing" and is similar to the physical breakdown that occurs on the surface of sea glass. Pieces of stoneware or earthenware coated with a glass-like glaze are subject to a similar surface destruction as glass. The severity of the crazing would also indicate whether the piece in question has spent many years exposed to the elements.

Coralene

Originating in Germany in 1883, Coralene has a uniquely textured surface comprised of carefully applied petite glass beads. The beads were fused onto the surface of the glass creating an appearance much like coral itself. In some cases, decorative coral patterns were actually applied to vessels.

Mt. Washington Glass was the first to produce this decorative glass in the United States during the late 1880s. It was more frequently used for vases than general tableware and was popular until the late 1920s. Shards of sea glass with Coralene beads intact would be considered extremely rare.

Custard Glass

Custard glass is best known as an opaque, pale-yellow glass often decorated with gold rims or designs. It was quite popular in the United States from the late 1890s until around 1910, but had been made years before in Europe, Egypt, and China. Early forms displayed a more ivory color, so the glass was initially called "Ivory glass." Later the yellow, custard-like color predominated what was made in the nation around 1900. The yellow, American-made custard glass was produced with small amounts of uranium dioxide. Thus, an ultraviolet lamp can be used to confirm shards, as they will glow a pale green.

Popular forms of Custard glass were novelty items, cups, and saltshakers, even though Northwood Glass of Wheeling, West Virginia created several table settings. Other notable U.S. producers such as Dithridge, Fenton, Heisey and McKee participated as well. Since the bottom half of Burmese glass also has a pale yellow tone, it may be hard to positively identify small shards. There is an active Custard Glass Collectors Society holding annual conventions in the United States each year.

Depression Glass

Depression glass is a descriptive term used for an assortment of pattern-molded tableware made in numerous transparent colors in America from the late 1920s through the 1950s. Unlike the deeply indented patterns characteristic of 19th century Pressed glass, machine-made Depression glass often had very shallow surface patterns in order to maximize output and eliminate labor. The height of production was during the actual Depression years of the 1930s when affordable tableware was a necessity. Automation reduced the manufacturing costs to such a level that Depression glass was given away in cereal containers, with soap, and other consumer goods.

Though most pieces were made in transparent shades, there were some tableware patterns created in translucent pastel blue and green. Well-known producers during the early years include Fostoria, Jeanette, McKee, Morgantown, Fire King, Duncan, Imperial, and Westmoreland. Demand dropped sharply after the 1950s, but some forms were made even into the 1970s.

Common colors included yellow, pink, green, light blue, and clear, but also some red and light amber patterns were created. There are a great number of collectors of Depression glass in America as evidenced by the formation of the National Depression Glass Association.

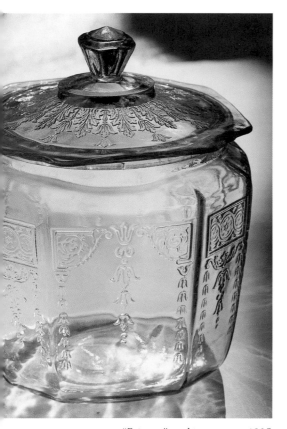

"Princess" cookie jar, circa 1935

Latter-day Depression glass

Flashed Glass

Flashed glass is a description of a manufacturing process in which one or more layers of a desired color of glass comprise the inner portion of a clear glass vessel. The initial colored form inside was created first and then dipped into a batch of clear glass. The clear glass formed a much thicker outer shell but still made the entire unit appear to be colored. In many cases, the color inside was to bear a resemblance to a much more expensive color, such as ruby red. A layer of white was sometimes created first, behind the colored surface, thus giving the vessel a rich reflective color tone. The primary difference between Flashed glass and layered glass, used to make Cameo glass vessels or stained glass windows, is the clear glass outer layer. Flashed glass is not to be confused with Ruby-stained or Amber-stained glass. Those were made with transparent coatings brushed onto clear glass and can be easily scratched off.

New England Glass, as well as other early 20th century manufacturers, used Flashed glass to produce bowls, goblets, lamps, and a variety of other objects. If a collector is fortunate enough to find a piece of red sea glass, look carefully at the edge for a thick layer of clear glass that would indicate Flashed glass.

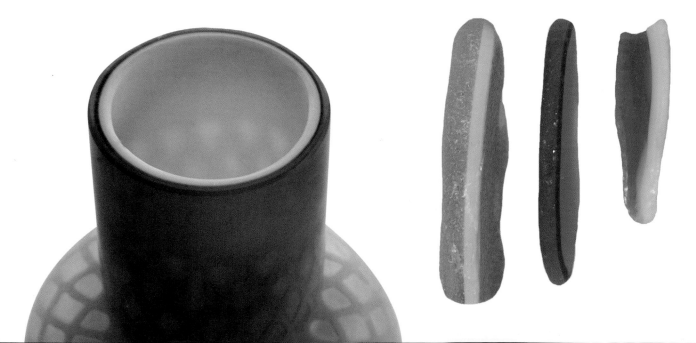

Hobnail Glass

Hobnail glass was an extraordinary form of glass with dramatically extended nubs protruding from its outer surface. Developed at Hobbs, Brockunier and Company of West Virginia in the 1880s, it was once called "Dewdrop glass." A blown, preformed vessel was placed into a mold to produce its uniformly spiked surface. Frequently the designer would add white opalescent details to its surface by coating the formed vessel in bone ash and arsenic and reheating the vessel.

Hobnail glass was commonly produced as pitchers, barber bottles, vases, bowls, and even vanity sets. It became quite popular in the 1930s and 1940s and was used for a line of perfume containers. During that period, there was a Hobnail tableware pattern called Moonstone produced by Anchor-Hocking Glass with rounded, less pointed nubs.

Mercury Or Silvered Glass

A small shard of silver-colored glass could be easily mistaken as a piece from a mirror, but if it shows a rounded shape, chances are it was Mercury glass. Also commonly known as "Silvered glass," Mercury glass was primarily made between 1855 and 1890 as an economical alternative to silver tableware. A solution of mercury or silver was poured through a hole in the bottom of a double-walled vessel and then sealed. The silver-colored stain left on the inside of the glass closely imitated silverware but with the added benefit of no tarnish to clean. Initially patented in England by Frederick Thomson and Edward Varnish in 1849, it was frequently formed into goblets, candlesticks, lamps, and salt urns.

This design provided tremendous convenience, but the handling of hazardous mercury compounds in manufacturing was undesirable. So, in later years, silver nitrate was used to produce items like flasks and thermos-style liners. New England Glass was one of several notable U.S. producers of silvered glass. Mercury glass was often decorated with acid-etched or engraved designs on the surface, and sometimes a transparent color was flashed on the inside. Glass Witch balls and Christmas tree balls are a derivative form of this once popular glass.

Milk Glass And Slag Glass

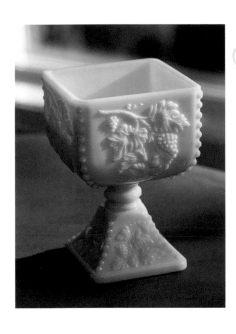

The initial popularity of Milk glass was credited to Venetian glassmakers prior to the 15th century. Early Romans used calcium antimony to create an opaque white glass with remarkable similarity to porcelain. At one time, fluoride compounds were added to produce this familiar white-colored glass, and then later, calcium phosphate, tin, and zinc were used.

Milk glass has remained popular for more than 500 years, though after the 1950s, its demand dropped significantly. Dating pieces of Milk glass can, therefore, provide a fair challenge, but if shards are found with extensively worn edges, they are likely from before 1960. The dense structure of Milk glass actually holds up quite well in aquatic environments.

The likelihood of finding shards from the white lids used for food canning jars is quite good. These were known as White Crown closures and were used in great volumes during the early 1900s. They were discussed under Opaque White in the Colors section and under Fruit & Food Jars in the Bottles & Containers section.

In the United States, the National Milk Glass Collectors Society maintains a web site and sponsors an annual national show. Colored forms of Milk glass include pastel tones of blue and green, turquoise, or varying shades of purple and brown. A pastel green color with a semi-translucent effect was called "Jade-ite" and is quite similar to the more opaque Milk glass. By mixing colored shades with the white base color, a popular swirled pattern known as "Slag glass" is created. Slag glass became very popular in the 1880s and should be considered quite rare as sea glass. A limited number of contemporary pieces in red slag glass have also been produced. Boyd's Crystal Art Glass of Ohio began making some Slag glass in 1978 and is still producing several items.

Opalescent Glass

Opalescent glass is primarily a transparent glass that transitions into translucent white or cloudy-colored edges. Frequently made in pale blue or clear glass, it displays nearly opaque, milky-white trim or surface textures. Controlled cooling and heat-treating conditions activate the additives within the glass, such as fluorides, phosphates, tin, and zinc into a near crystalline state, thus providing a "milky" appearance. In a molding process, this was accomplished by varying the thickness of the mold in areas where the opacity was desired. Earlier methods included reheating the vessel after it was coated with materials such as bone ash and arsenic to create the familiar cloudlike effect.

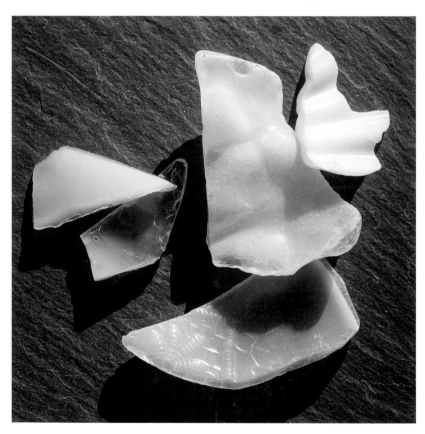

In addition to blue and white opalescent wares, there were several yellow vessels with white edges made in Vaseline glass. In the case of white, the glass made a transition from a clear core to a milky-white trim.

Opalescent was another glass style that was very popular during the Victorian age and was sometimes made in green and red. A version without the white surface accents became a popular art glass form in Europe during the 1920s and 1930s. A cloudy precipitate of light blue was developed within the inner portion of the glass, instead of its surface extremities, and became a popular style for Lalique of France. Its appearance was the result of light rays scattering off finely divided particles or crystals within the glass, often showing multiple colors of the spectrum in reflected light.

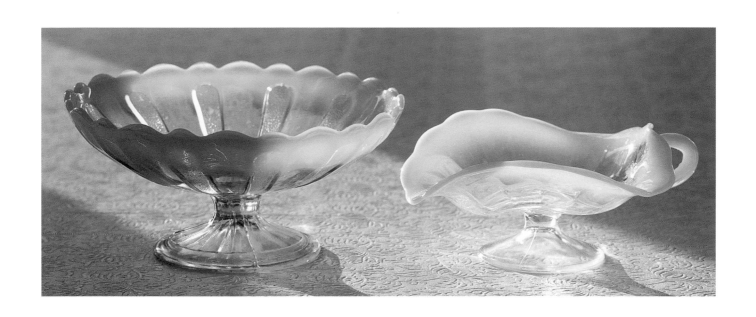

Pattern Or Pressed Glass

When it was discovered that operating a plunger-style press could efficiently mold glass, American manufacturers quickly designed machines to reduce labor and, for the first time, led a movement in the global glass industry. In 1825, Bakewell and Company of Pittsburgh earned a patent for the manufacture of furniture knobs. By 1828, Deming Jarves of the Boston and Sandwich Glass Company (located in Sandwich, Massachusetts) had a broader patent for molded glassware and became a major manufacturer of Pattern glass tableware in the 19th century.

Much like Depression glass, Pattern glass covers a rather broad category. Initially it was made of clear "pressed" glass designed to mimic the extravagant cut glass being imported from England. Just prior to this time, there were various bottles and wares made by a process in which a glass object was blown into a multi-hinged mold. Their designs, however, lacked the surface detail that became attainable with the strong pressure applied by the plunger-style machines of the Pattern glass process. Intricate and delicate patterns then evolved using stippling designs in the background, starting a category of glass nicknamed "lacy glass."

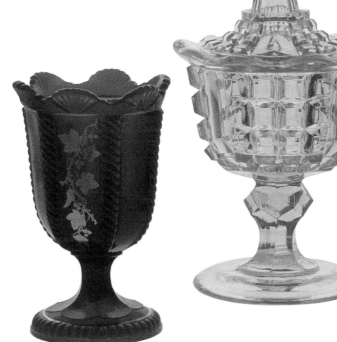

Sandwich Glass

Though the pressed-style of glass lacked the same luster of cut glass, Pattern glass had made a substantial mark on the tableware market by 1850. Entire sets of matched glassware in assorted colors were then being manufactured for a completely coordinated table setting. Unlike the fully automated Depression glass process, Pattern glass required a hand-operated press. Therefore, items would normally require some hand finishing after coming out of the molds.

A majority of Pattern glass pieces were made of clear, lead glass, but other colors included amethyst, opalescent, blue, emerald, and canary yellow. By the late 1800s, several more colors were in use. An ideal place to get more background on Pattern glass is at the Sandwich Glass Museum in Sandwich, Massachusetts on Cape Cod. The Early American Pattern Glass Society offers a quarterly newsletter and web site.

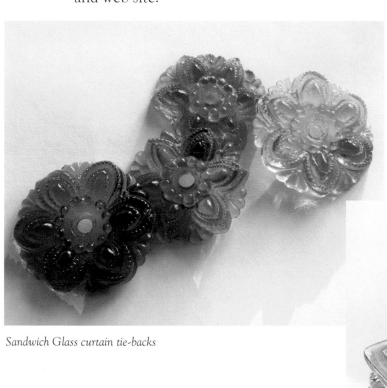

Sandwich Glass curtain tie-backs

Peachblow

New England Glass Works of Cambridge, Massachusetts initially produced Peachblow in 1886, around the same time Mount Washington Glass of Cambridge, Massachusetts was producing some as well. In George and Helen McKearin's book, *American Glass*, it is noted that Mount Washington was awarded legal use of "Peachblow" while New England Glass was to use the name "Wild Rose." Its popularity came from attempts to mimic a Chinese porcelain vase that sold at auction in 1886 for $18,000.

Peachblow is similar to Burmese glass in that the glass transitions from a pink upper half to a lighter color toward the base. Peachblow was normally either cherry red or deep pink up top, but the lower half was usually milky white or a soft peach color, while Burmese was rather yellow below center. By late 1886, Hobbs, Brockunier and Company of West Virginia was also making Peachblow. The Hobbs, Brockunier versions always used a white lining inside their Peachblow vessels while the other two producers did not. The coloring was very similar to transparent Amberina glass but with the inner white casing making their Peachblow virtually opaque. Mount Washington Glass manufactured their version of Peachblow with a pale bluish-gray bottom that transitioned up to pink at the top.

New England Peachblow

West Virginia Peachblow

Ruby-Stained And Amber-Stained Glass

In the late 1800s, many U.S. manufacturers used staining as a means to economically colorize clear glass vessels. This was usually fashioned by painting a thin enamel paste on the vessel, and then after a mild heating process, a red or yellow stain remained on its surface. Ruby-stained glassware, designed to mimic Bohemian glass, was far more popular than the yellowish, amber-stained glassware. The staining was sometimes uneven and can be easily scratched or worn off. Thus, finding well-worn pieces of sea glass that still show remnants of staining are rare.

This form of glassware was a popular gift—sold or given away—at resorts in the late 1800s and early 1900s. The demand for ruby-stained and amber-stained glass waned by the late 1950s.

Satin Glass

Satin glass was once called "Mother of Pearl" and refers mainly to the specific frosted, matte finish on the glass surface of vessels normally having a white lining covered with an exterior color. Created in a manner much like flashed glass, these would have a clear glass outer layer. The outer layer would be exposed to hydrofluoric acid to etch the surface, presenting a satin-like appearance. Developed in 1885, the Phoenix Glass Company of Pittsburgh, Pennsylvania was a major American producer of Satin glass.

Many pieces were two-toned in color, pattern-molded, and frequently decorated with painted floral scenes. Though used for tableware, much of Satin glassware was ornate and saw limited table use. It is unlikely one will find shards of Satin sea glass. Coincidentally, imitation sea glass is also made with hydrofluoric acid, but, since it only softly etches the surface, it can be easily spotted as fake.

Vaseline Glass

Vaseline glass is certainly one of the more fascinating forms of glass tableware. It is made by adding 2 percent uranium dioxide to produce a vibrant yellow to greenish-yellow color. Though Custard glass and Burmese glass use small amounts of the same element, it is the only glass that dramatically produces a transparent, neon-lime color under an ultraviolet light. This is entirely due to its unique atomic structure.

Joseph Reidel created Vaseline glass in Germany around 1830. He initially named it "Annagelb" for his wife, but in the United States, it was called "Canary Yellow." The term "Uranium glass" was used for a long time until antique dealers supposedly renamed it in the mid-1900s to reduce fear of its contents. Experts agree that the amount of uranium contained in the glass is in such low levels that there are no health risks with which to be concerned.

Vaseline glass enjoyed great popularity in America between 1880 and 1930. Companies such as Boston and Sandwich Glass, New England Glass, Fenton Glass, and McKee were enjoying success with Vaseline glass until the availability of uranium immediately halted during World War II. Currently Fenton Glass, Boyd's Crystal Art Glass, Summit Glass, and Mosser Glass are noted as producers of Vaseline glass.

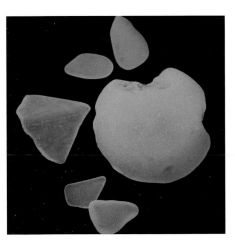

To obtain confirmation that a piece of yellow-green glass is composed of the unstable atoms characteristic of Vaseline glass, put it under a black light in a dark room. The bright neon-lime color is easily identified. Note that some Depression glass made prior to World War II was made with iron and uranium and will give a soft green glow rather than the bright neon glow of true Vaseline glass.

Eight
FLAT GLASS

*People are like
stained glass
windows.
They sparkle and
shine when
the sun is out,
but when the
darkness sets in,
their true beauty
is revealed...*

Elizabeth Kubler-Ross

Flat Glass

When a rather sizeable piece of flat sea glass is found, the collector can initially consider the millions of homes and automobiles that use flat glass as possible sources. The volume of glass produced annually for both industries is staggering. The events that can cause a piece of flat glass to be discarded are also plentiful. Perhaps a ball went through a window, a family retreat was lost to the sea, or a well-meaning pet knocked over a picture frame. Whatever the reason, most flat glass items produced in the 20th century, particularly window glass, were designed to last for a very long time. On the contrary, many bottles made since the 1920s, other than milk bottles, have been intended for one-time use and lack the robust thickness of their predecessors.

Pieces of sea glass from flat-sided tableware and bottles can at times be confused with flat glass, but they are far less common than contoured fragments from cylindrical bottle forms. Even bottle bottoms have variable levels of contour. Laying the piece of sea glass on a counter top, to see if it is truly flat on both sides is an easy test.

It can be argued that the vast majority of flat glass located by sea-glass collectors is either clear or soft blue. Since much of this glass is from windows and windshields, it is specifically designed to withstand both breakage and the elements. Consequently, a tremendous amount of research has been done over the years to protect flat glass from the elements. Though glass for picture frames and mirrors may not need the same level of protection against the elements as windows, they both fall into this category as well.

Windows

In ancient Rome, a few homes used large pieces of alabaster shell to let in light. Glass fragments from archaeological digs suggest that some window glass was even used on a rare basis during the first century. Approximately a thousand years ago, Europeans called the small openings in walls under the eaves of roofs "wind eyes." The term "window" is derived from this initial description for holes that were covered with oiled cloth or animal skins and used for venting smoke and letting in fresh air and light. In later years, Northern Europeans sometimes used alabaster as window coverings to insulate and protect glass panes. Glass was initially not considered a practical item for windows. The cost and difficulty of making clear flat glass, along with the desire for security, made glass windows an infrequent luxury.

Around the 10th century, most early glass windows were stained glass mosaics for cathedrals. Pieces of glass were painted and then reheated to secure the paint (stain) to its surface. Several hundred years later "flashed" glass was used for stained-glass windows. It was produced by fusing a thin layer of colored glass behind a layer of clear glass. Artisans could use a wheel to grind away portions of the color layer to achieve variable hues of the color, and when a third layer of white was added, they could expose that as well. Stained-glass windows in cathedrals were at peak production in the early 1200s. By the 1500s, colored enamels were being used to paint the back of most stained glass. It was not until the early 1840s that stained glass windows were produced in the United States.

Victorian Pressed-glass pane, circa 1880

Back in the 13th and 14th centuries, clear flat glass called "broad sheet" and "Crown glass" were being produced in England. Crown glass was produced by initially blowing a globe-shaped vessel at the end of a blowpipe. It would then be intentionally cut open and the blowpipe was vigorously spun to produce a large flat disk. The spinning action would create an ever-broadening sheet of glass several feet in diameter. The glass itself would be a bit wavy and even contained small bubbles. Sometimes a "bulls-eye" mark remained on the finished pane, left from the blowpipe in the center of the Crown glass disk. In some cases, these were sold as decorative "roundels" for Victorian-era windows.

In the mid- to late 1600s, the English and French both became proficient, high-volume producers of flat glass. The English specialized in "Blown Plate glass" while the French became known for their "Polished Plate glass." By the mid-1800s, flat glass was being made by a process using rolling cylinders. In the late 1880s, Pittsburgh Plate Glass (PPG Industries) of Pennsylvania entered the market and quickly became the dominant U.S. supplier of flat glass. They developed a "drawn cylinder" process for making sheet glass that became an international standard by the early 1900s. Prior to this, glass houses in Pittsburgh, Pennsylvania and West Virginia that specialized in pressed-glass began making small, decorative windowpanes in both clear and colored glass. Though this started in the 1830s, their popularity grew in the late 1800s as other pressed-glass houses in Massachusetts and New York began to produce their own versions of these ornate glass panes. Most were square or rectangular shapes ranging from 6 inches by 6 inches, to 5 inches by 10 inches with patterned Gothic arches, grapevines, ivy, and various floral designs.

The most significant recent invention in mass-produced flat glass came in 1959. In Britain, Sir Alastair Pilkington developed what became known as the "float glass" process. This innovative procedure involved floating a batch of glass on top of a bath of molten tin. The process permitted a broad, continuous ribbon of clean glass to be drawn from the surface of the tin bath. The system took many years to perfect, but it is now used everywhere for the manufacture of window glass.

Window glass used on coastal homes has long been a source of environmental challenges for manufacturers and homeowners. Treatments to protect the glass before installation, and even after partial hazing, are under continuous development. The constant exposure to a saline environment can degrade window surfaces in ways similar to the hazing on the surface of sea glass.

There is a rather unique requirement on window glass that coastal homeowners or business owners must address in Florida. An ordinance to protect marine turtles mandates heavily tinted window glass on buildings within 1,000 feet of the coastline. This is because turtle hatchlings and their parents were being attracted to the building lights at night instead of heading out to sea. So an industry for tinted window glass called "Turtle Glass" has now been firmly established that will limit the emission of interior light to no more than 45 percent. Thus, tinted glass is no longer simply to reduce solar heating or to add privacy.

Tinted windows on coastal buildings help prevent sea turtles from becoming disoriented at night

Automobile Glass

Automobile windshields began to evolve in the early 1900s from precarious flat plates of glass to laminated safety shields by the late 1920s. Curved glass on front and rear windshields was uncommon until the 1950s. It was found that reheating a sheet of glass and placing it in a mold could create the unique curved surfaces desired on latter-day auto glass.

By the 1960s, safety glass continued to improve in impact resistance through the introduction of "tempered glass," made for side and rear windows. These were designed to break into small, less harmful pieces when shattered. Today, a compound known as polyvinyl butyral is added to windshield glass to provide superior strength. Finding sea glass from automobile glass is surprisingly common. Internet sources note that in the late 1990s, almost half a billion square feet of glass was being produced for automobiles each year.

Mirrors

Originally referred to as looking glass, small glass mirrors were produced in Venice during the 1500s. Long before this, the Romans used small, polished metal disks to gaze at themselves. The reflective qualities of metal compounds such as mercury, tin, lead, bismuth, and silver were used to make mirrored glass for many years. By the mid-1600s, the English were producing large plate-glass mirrors, and the French also became active in the mirror industry. The gifted painters of the Renaissance period found great beauty in mirrors and used them regularly in their work.

In the 1700s, mirrors were made on flat tables using a process called "foiling" in which a large sheet of tinfoil would adhere to the glass surface with a solution of tin and mercury.

Near flawless flat glass was a critical requirement for making high-quality mirrors. Distortions have their obvious drawbacks. Polishing of the glass was therefore an important step in mirror production, so in the 1700s, a common practice was rubbing two pieces of glass together to smooth their surfaces. By the mid-1800s, silver became a standard material for the back side of mirrors. In recent years, aluminum has been widely used. The origin surrounding the superstition of seven years of bad luck after breaking a mirror is unknown, but some feel it came along as a result of the high cost of mirrors hundreds of years ago.

Other Common Flat Glass

In contrast to tinted windows that have been customary on homes and cars, picture frame glass is intended to be optically clear. Over the years, advancements for minimizing sunlight damage to photographs and paintings have contributed to forms of flat glass with transparent ultraviolet filters. In addition, there have been developments in nonglare formulas free from tints that can ever so slightly distort the color within the protected image. As Plexiglas became more common in the late 20th century, it also required refinements to reduce slight color distortions.

In addition to the multitude of window glass used for architectural purposes, building designers are still using fused and cast Pattern glass for tiles, glass block walls, stairs, handrails, showers, partitions, and various other applications. Intricate patterns placed on this glass are used to provide privacy or anti-skid surfaces for stairs or flooring. Since PPG Industries introduced their "House of Glass" at the 1939 World's Fair in New York, there have been several glass producers who have specialized in architectural glass components.

For the collector of sea glass, identification of flat glass without a color or pattern is impractical. In general, pieces with a very soft blue tint are likely automobile glass while window glass from homes is more likely a faint soft green.

Nine
MARBLES, INSULATORS, & BONFIRE GLASS

*The light of other
days is faded,
And all their
glories past.*
Alfred Bunn

Glass Marbles

For several thousand years, marbles have been widely used as toys. Marbles made of stone or clay have been found alongside the remains of Egyptian children. Ancient art has depicted children and adults enjoying games with marbles, but their popularity waned rapidly in the second half of the 20th century.

The first ornamental glass marbles have been credited to the Venetians, but they did little to promote these for games. It was a German, Elias Greiner, who is recognized as the first manufacturer to mass-produce toy glass marbles. In 1849, he received a patent from the Bavarian government for a device known as marble shears. It was designed from a similar tool his stepbrother used to make animal eyes for taxidermy. Soon his affordable, imitation agate marbles were in use all over Europe and imported into the United States. Some were shipped to England for use as stoppers in Codd-style soda bottles.

By the late 1880s, clay marbles were being mass-produced in the United States. Several companies located in the Akron, Ohio area were making the common clay spheres nicknamed "commies." One of the original marble producers, Sam Dyke, hired glass expert James Leighton to make the bold leap into glass marbles in November of 1890. Dyke established the first production system for American-made glass marbles. By 1891, he had renamed his business, The American Marble and Toy Manufacturing Company. While Leighton was credited with a patent for a hand tool to create marbles, it was the more dramatic invention by Akron's Martin Christensen that truly revolutionized modern marble production. His machine was comprised of two edge-to-edge wheels with concave outer rims. A small gather of molten glass was placed between the two wheels as they were spinning in opposite directions. A perfectly round marble was then rapidly formed between the two wheels he called "rollers." Christensen filed a patent in 1902 for this innovative mechanical device and confidently started his own company (M.F. Christensen & Son) a year later. His patent was granted in 1905, and he successfully ran his company for 14 years.

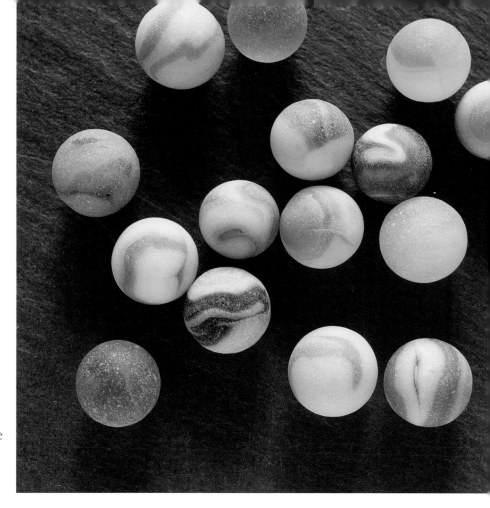

Unfortunately, Christensen's bookkeeper, Horace Hill, left with some company money to join a firm in 1913 that ultimately became the most well-known marble producer of the 20th century— "Akro Agate." The company was started in Akron in 1910 and coined the slogan, "Shoot Straight as A KRO Flies" along with a trademarked black crow inside the letter "A." Hill moved Akro Agate to West Virginia in 1914, repaid his debt to Christensen in 1915 and then died a year later. Akro Agate went on to dominate the marble market for almost 35 years, closing in 1951.

Today, many enthusiastic collectors of antique marbles are active members of the Marble Collectors Society of America. One look at the remarkable work of years gone by can easily capture the interest of those who are only familiar with the simple Cat's Eye marbles made since 1950. Some feel the vast number of Cat's Eye marbles that flooded the market led to the ruin of marble popularity.

Collectors are certainly looking for the rare versions of their favorite pre-1950 spheres such as 1930 "Guineas" or pre-1930 onyx-styles. Christensen's machine-made marbles with distinct swirls in the shapes of an S, 6 or 9 are quite collectible. Early marbles were often made using two or more glass rods that created specific swirled designs. Many of today's production marbles are made simply with mixed pieces of broken glass, reducing artistry and value. However, the modern art glass studio movement has done an extraordinary job of revitalizing some of the glamour in marble design.

Collectors of sea glass find that when traditional marbles are rolled along the shoreline, they take on a smooth frosting and can slowly reduce in size. This process can expose layers that were once under the clear, polished glass. While the etched surface will decrease the value to a marble collector, their rarity to the avid sea-glass collector is indisputably high. In some cases, marbles were hard-earned prizes at seaside amusement parks or brought along by a young "mibster" looking to challenge another for his marbles in a contest. A dramatically frosted sea-glass marble is truly a prize to discover since these were seldom discarded carelessly.

Insulators

In May of 1844, Samuel F. B. Morse sent the first telegraph message from Washington to Baltimore. To provide reliable transportation of telegraph messages across miles of wire without loss of current, pin-style glass insulators were developed in the 1850s by Ezra Cornell (founder of Cornell University).

In 1865, Louis Cauvet of New York patented a unique glass insulator design for mounting the inner cavity onto a threaded wooden pin. Prior to this, insulators only had a tapered inner core, but this design was obviously difficult to secure to wooden pins suspended high atop telegraph poles. Cauvet contacted the nearby Brookfield Glass Company who began making threaded insulators under license. These threaded-core design insulators quickly became the industry standard. Brookfield produced insulators embossed with their name between 1869 and 1909.

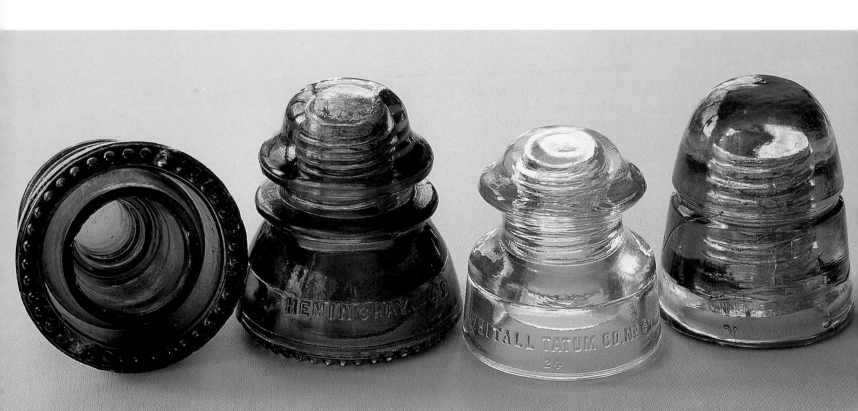

Another successful manufacturer was Hemingray, which had an early patent for insulators in 1871 and then earned a patent in 1893 for drip points designed to wick rain away from the inside. Hemingray was sold several times and finally stopped insulator production in 1967. Other notable insulator producers in the late 1800s include Whitall-Tatum and McKee. Whitall-Tatum produced insulators during much of the 20th century, as did Corning Glass Works from 1924 through 1951.

Usual insulator colors are light blue to aqua, clear, light green to dark green, amber, and sun-colored purple. Some clear ones were treated with iridescent orange. The light blue and clear versions were preferred by Western Union since it was thought that the sunlight passing through them would discourage spider and insect nesting.

In 1876, Alexander Graham Bell invented the telephone, and demand for glass insulators escalated further. But when electrical power distribution gained momentum in the late 1890s, the preferred insulator choice became porcelain. Due to its ability to handle much higher power requirements, porcelain insulators began to replace glass on electrical lines by 1900. These were usually glazed in brown, but other colors such as green or yellow were also used to help designate the purpose of specific lines.

By the late 1940s, demand for glass insulators was rapidly diminishing, and most companies ceased production in the 1960s. Finding sea-glass shards from insulators is fairly common since their exceptionally thick structure is sturdy. The threaded core of a thick piece of a glass insulator can easily be identified. Historic background and an assortment of styles are available through the National Insulator Association and at most bottle shows.

Bonfire Glass

Bonfire glass is an informal name for any molten, free-form glass shards often including specks of ash and sand. These vary greatly in shape and are undoubtedly the most difficult of all sea-glass pieces to identify. Their ambiguous forms are created by a variety of sources such as beach bonfires, building fires, and controlled landfill burns. Glass melts at just over 2,000 degrees Fahrenheit, and at lesser temperatures, glass becomes pliable enough to change form. Finding glass with embedded ash and sand provides a profound respect for the energy generated by a seemingly innocent bonfire. When these molten shards are worn smooth by exposure to a rough shoreline environment, they can become an attractive oddity. They are always distinctive in form and usually more bulbous than most pieces of similar age.

The first pieces of bonfire glass were not bottles thrown into a seaside fire, but actual raw glass produced by accident back in 3000 BC. The familiar story by historian Pliny, written in the first century AD, tells of Phoenician sailors on a Syrian beach near the Beleus River who used blocks of natron (soda) to support a cooking pot. As the fire burned, they noted a clear substance flowing in the sand. Pliny remarked that this was how glass was discovered, but scientists refer to this as a mere tale since it is believed glass was developed earlier in the decoration of pottery. Nevertheless, the location given by Pliny was an ideal site for high quality sand—an essential ingredient of glass.

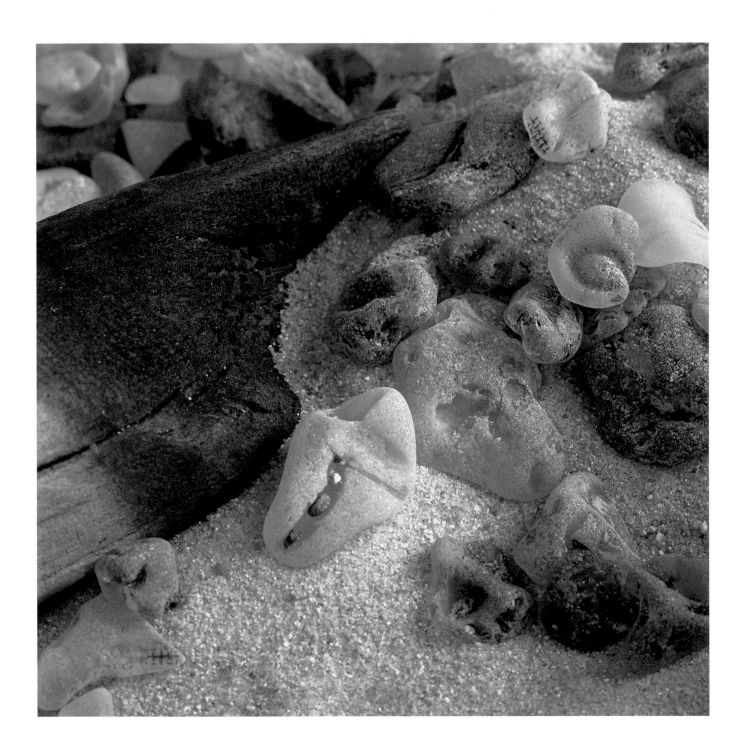

Ten
APPRAISING RARITY

*Rich and various
gems inlay*

*The unadorned
bosom of the deep.*

John Milton

Appraising Rarity

Opportunities to find well-worn pieces of sea glass continue to diminish every day. In the United States, a significant reduction in the use of glass, along with a remarkable cultural change in environmental responsibility, have collectively contributed to cleaner beaches. Fortunate collectors who still find pieces of genuine sea glass realize that the value of these vanishing gems appears to be increasing. Several key factors are important in interpreting the level of rarity of pieces in their sea-glass collection. These factors include: color, condition, type, and age of each piece. Color is simple to discern, and the other characteristics discussed in previous chapters help establish a comprehensive basis for evaluation. The following list of premium sea-glass features will help to assess which pieces are considered the most desirable by serious collectors of sea glass.

Extremely rare piece of red Depression glass likely from the pattern "Coronation," circa 1940

Color

The grading scale shown below is relative to the rarity of sea glass found in the United States, but could apply to almost anywhere. Bottles are the most frequent source of sea glass. Very few bottles were ever made in orange, red, and turquoise, so it is easy to realize why these colors top the list of extremely rare. The chapter on color provides approximations for the chances of locating specific colors. This was based on studying over 30,000 pieces of sea glass collected over a four-year period in the Mid-Atlantic states, Florida, and California.

People were much more likely to discard bottles than they were colorful tableware, which was often made in rare colors. Considering that most bottles made during the last 50 years were in clear, green, or brown glass, it is obvious why these colors are at the bottom of the rarity list.

Grading Rarity Based On Color

Extremely Rare
Orange
Red
Turquoise
Yellow
Black
Teal
Gray

Rare
Pink
Aqua
Cornflower Blue
Cobalt Blue
Opaque White
Citron
Purple/Amethyst

Uncommon
Soft Green
Soft Blue
Forest Green
Lime Green
Golden Amber
Amber
Jade

Common
Kelly Green
Brown
White (Clear)

Condition

Antique bottle collectors go to great lengths to unearth pristine vessels without a single flaw. Sea-glass collectors, in contrast, search for shards that have been enhanced by nature's conditioning and weathering processes. Discovering a completely worn and rounded piece in practically any color can be exciting. Sea glass is frequently found in triangular forms, but it is the rounded or oval-shaped shards that are especially rare. These reflect the mastery of Mother Nature and advanced surface hydration during long periods of exposure. Sea-glass jewelry designers have found ways to highlight this coveted gemlike quality in their stunning creations.

Chesapeake Seaglass Jewelry

Scale For Grading Sea Glass Condition:

A Extremely worn and rounded piece with no blemishes or chips.

B Extremely worn piece with soft edges and one or two minor blemishes or chips.

C Fairly worn piece with at least one hard, straight edge and blemishes.

D A barely worn piece with several blemishes or hard edges/corners.

Type And Age

To determine the origin of a piece of sea glass, refer to the previous chapters on bottles and tableware. It is also useful to research historical bottles and glass by visiting museums and antique shops. An expanded familiarity with vessels of the past will generate far better estimates regarding the general manufacturing period of shards. For example, a piece of sea glass containing several bubbles inside generally signifies a bottle made prior to 1930. By that time, most manufacturers had implemented automation that eliminated bubbles in glassware. A piece of "black glass" that is actually dark green and is laden with dozens of bubbles (see photo) likely derives from the 1700s. Legible text or distinct patterns visible on worn-glass shards help determine age, but bottle lips and bases are also great sources for pinpointing time periods. By visiting web sites dedicated to bottle collecting, one can quickly review photos of numerous bottle types. A book on antique bottles, such as *The Illustrated Guide to Collecting Bottles* by Dr. Cecil Munsey, is a highly recommended text, as well as the magazine, *Bottles and Extras*, produced by the Federation of Historical Bottle Collectors. The industry bible for antique glassware and flasks is *American Glass* by George and Helen McKearin. These great books may be out of print but still can be located at libraries, on the internet, or at used book stores. The internet also provides a wealth of background sources on glass in general. Many of these are noted in the reference section.

Microphotography of sea glass shards from antique "Black glass," circa 1750-1800

Since the origin of most sea glass is from bottles, the majority of tableware automatically falls into the categories of uncommon to extremely rare. Chances of finding shards of art glass such as Coralene, Satin glass, and Cameo glass are very remote. Collectors are much more likely to find ceramics, Milk glass, and Depression glass than most other types of tableware.

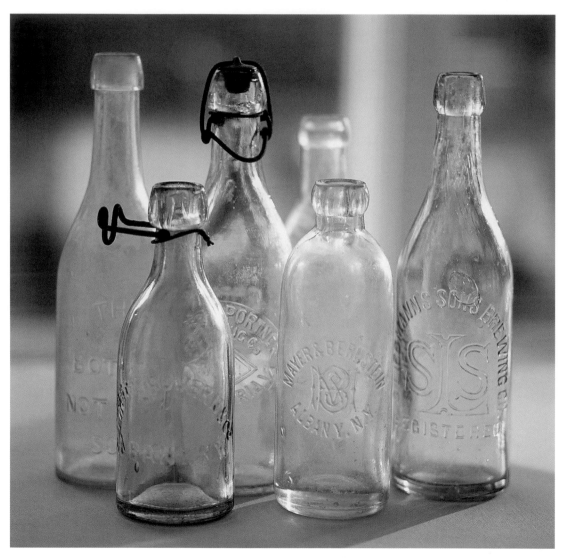

Around 1900 most beverage bottles were aqua colored

BOTTLES & CONTAINERS
(shard rarity based on type and age)

Extremely Rare	Rare	Uncommon	Common
Barber bottles	Bitters bottles	Beer, Pre-1900	Beer, Post-1900
Case Gin bottles	Drug bottles	Ink bottles	Fruit/food
Cathedral pickle	Medicines, Pre-1900	Medicines, Post-1900	Soda, Post-1900
Flasks, Pre-1900	Mineral water	Milk bottles	Wine, Post-1900
Fire grenades		Soda, Pre-1900	
Poison bottles		Whiskey, Post-1900	
Snuff jars		Wine, Pre-1900	
Target balls			
Wine, Pre-1800			

TABLEWARE
(shard rarity based on type)

Extremely Rare	Rare	Uncommon	Common
Burmese	Amberina	Depression glass	Ceramics
Cameo	Amber-stained	Flashed glass	Milk glass
Coralene	Carnival glass	Ruby-stained	
Hobnail	Custard glass	Slag glass	
Mercury glass	Opalescent		
Peachblow	Pattern glass		
Satin glass	Vaseline glass		

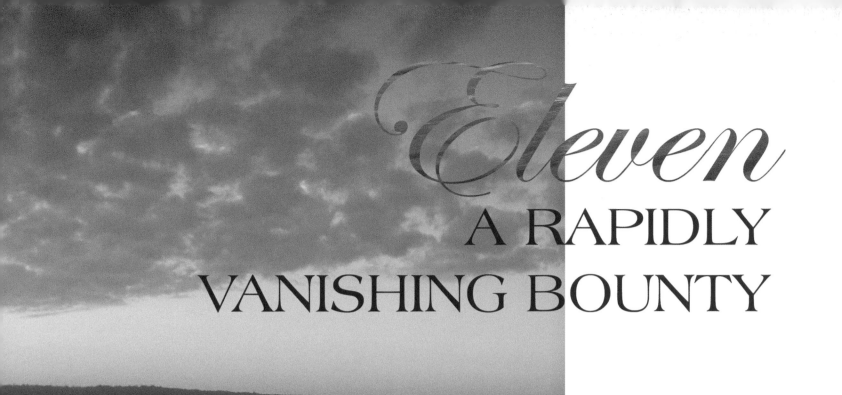

Eleven
A RAPIDLY
VANISHING BOUNTY

*There is nothing
more practical in
the end than the
preservation of
beauty, than the
preservation of
anything that
appeals to the
higher emotions
of man.*

Theodore Roosevelt

A Rapidly Vanishing Bounty

Beachcombers who have frequented shorelines for 20 years or more have noted that the amount of sea glass apparent now is far less than they observed years ago. In many cases the beaches have either diminished in size or have been supplemented with imported sand that is less likely to contain sea glass. Another reason for the increasing scarcity of sea glass is the transition over the last four decades from glass containers to vessels in plastic and aluminum. American recycling and anti-litter campaigns have also effectively developed environmental awareness to a level that has reduced the amount of glass discarded into open waters.

A large percentage of our national tourism depends on the availability of clean beaches to attract domestic and international travelers. In 1998, a spokesperson for the Office of Water at the U.S. Environmental Protection Agency (EPA) estimated that coastal recreation and tourism serves 180 million Americans per year and ranks as the second largest employer, supporting 28 million jobs.

Steady increases in coastal population density as well as rising water levels related to global warming are resulting in beach replenishment programs and efforts to protect the coast with man-made structures. These measures affect not only sea-glass collecting but also the scenic quality of our beaches. The subject of rising water levels is a genuine concern for more than just those who own waterfront property. Without broad, attractive beaches, many coastal states would lose enormous revenues that are now critical to their fiscal obligations. Meanwhile, the cost of beach replenishment programs affects state taxpayers far beyond the immediate coastal counties.

Previous page: San Diego, California

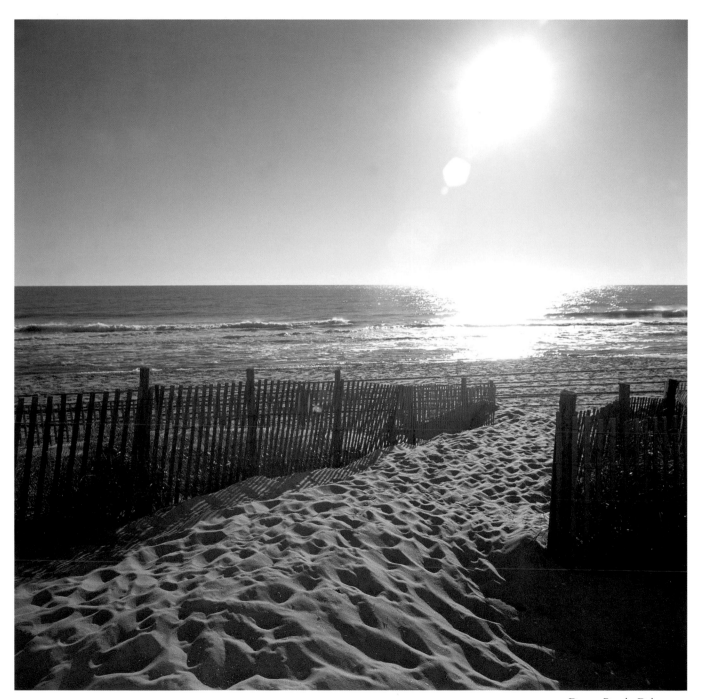

Dewey Beach, Delaware

Some low-lying Eastern states are losing waterfront property at a rapid pace. Along the coast of North Carolina, the majestic Cape Hatteras lighthouse had to be relocated 2,900 feet from its eroding perch in 1999. Scientists from the Woods Hole Oceanographic Institute on Cape Cod, using EPA projections, estimate that by 2025, Massachusetts could lose as much as 10,000 acres of coastline. In 2001, Jim Titus, a project director assessing sea-level rise for the EPA, noted that South Florida, coastal Louisiana, the Pamlico and Albemarle Sounds in North Carolina, and Maryland's Eastern Shore are most vulnerable. This certainly proved true for many residents in North Carolina and Maryland affected by Hurricane Isabel in October of 2003.

Scientists studying climate change expect a full one-meter loss of shoreline during this century. It is important to realize that a small vertical rise in water level creates a much more dramatic effect on a near horizontal shore line. Donald F. Boesch of the University of Maryland Center for Environmental Sciences projects that a millimeter rise in sea level can create a 1.5-meter retreat in shoreline.

There are those who have been devastated by sea level rise in this past century. Most notable are residents of the islands of Tuvalu in the central Pacific. Water levels gradually increased 8 to 12 inches around the island during the 20th century, forcing many to relinquish homes. Their own government has predicted that the islands will be completely underwater by 2050. This has led to threats of litigation against international oil and automobile companies, blaming them for the increased carbon dioxide levels linked to global warming.

Opposite: Martha's Vineyard, Massachusetts

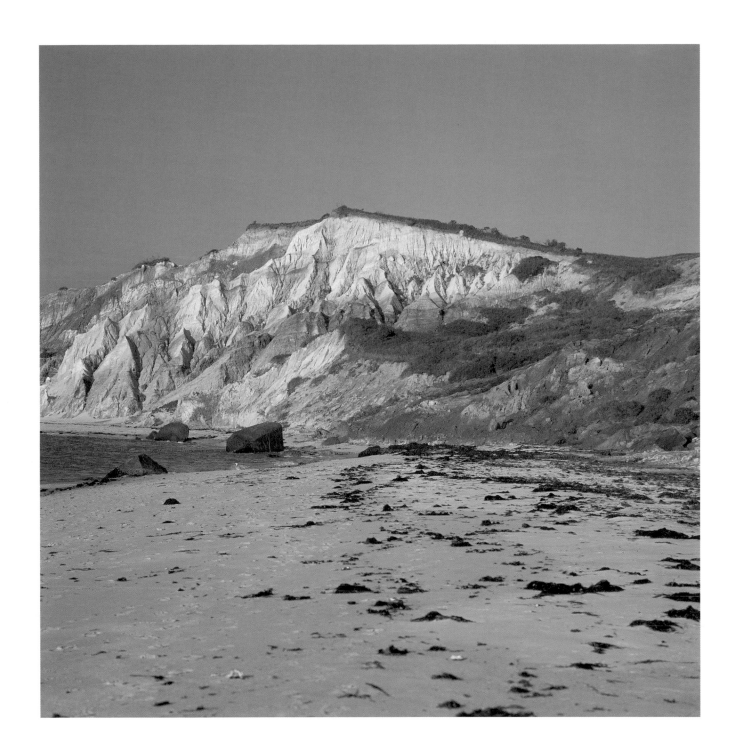

Concerns over rising water levels are important to collectors of sea glass. Not only can water cover up historic natural beaches, but man-made structures placed by landowners and government engineers hoping to protect shoreline property often bury sea-glass supplies. This process is commonly called coastal armoring and includes sea walls, sandbagging, and rock structures such as groins or jetties.

Much of the sand on beaches originates from sediment washed out of rivers and estuaries. Protecting shorelines totally from erosion leaves little sand to feed beaches, virtually starving the littoral drift of sand along the shore. This is evident in some parts of California where dams were built to store precious water and protect against flooding. These actions have prevented much-needed sand from reaching the shores of the Pacific.

Rock Hall, Maryland

Today, a common practice for adding sand to the shores is called beach nourishment. Sand is simply brought to a beach to replenish sand lost due to erosion. This provides short-term relief, but several tons of fresh sand is then routinely washed out toward deeper water. The planting of stabilizing grasses and other hardy vegetation along the dunes and embankments of coastal properties is a much-preferred alternative by environmental experts and coastal geologists. These plantings help solidify property and reduce the amount of sand lost from on-shore winds and tidal surges. Where plants are insufficient, snow fences are frequently added to dunes to help trap the drifting sand. While protecting against erosion, vegetation along coastal tributaries also improves water quality as well as aesthetics.

It is well documented that natural beaches do a far better job of absorbing the wrath of storms than hardened structures. A strong wave melting gently into sand and vegetation does far less damage than one repelled forcefully backward, taking with it sand and a beach. Jetties also create problems since the beach on the side normally receiving sand carried by shoreline drift is then starved and gutted. States like North Carolina deserve great credit for preventing coastal armoring from ruining a great natural resource. Cornelia Dean's book, *Against The Tide*, is an essential read for anyone interested in shoreline preservation.

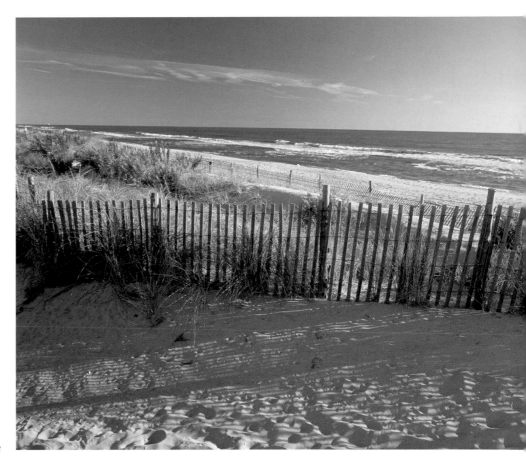

Dewey Beach, Delaware

A National Oceanic and Atmospheric Association (NOAA) report states that over 53 percent of Americans live in coastal counties that border oceans or their coastal watersheds. These numbers appear to be increasing every year, along with tourism totals. In 1990, there were approximately 260 people residing within each square mile of coastal property, and that figure is expected to rise to 310 people by the year 2010. Population increases usually lead to a rising urgency to protect valuable land.

The finest pieces of well-worn sea glass, of peak interest to the collector, are at least 50 to 100 years old. There are yet other factors limiting the ability to find the antique shards. In some instances, the rerouting of major shipping channels further from shore has hindered sea-glass availability. In one case, the desire to straighten an unusual "S" turn in Maryland's portion of the Chesapeake Bay dictated that a new channel be excavated. Large cargo ships that once passed within 300 yards of the shoreline now pass almost a mile offshore. This shift has radically reduced the vigorous lateral water flow generated by the wake of passing ships, thereby reducing the amount of sea glass routinely exposed on a nearby beach. Once an ideal underwater conditioning environment for sea glass, this beach immediately became a less prolific resource for collectible shards. Like many beaches, surpluses of sea glass on this shore are now found mainly after storms.

The Effects Of Vanishing Sea Glass Supplies

A fellow sea-glass hunter once mentioned that collecting is more than just an occasional obsession. It is a wonderful way to spend hours alone with her grandson. When considering a seaside activity that a grandparent and grandchild or parent and child can enthusiastically share together, that list could certainly include hunting for sea glass.

Our growing respect for the environment and propensity to rebuild beaches with borrowed sand will continue to present a less favorable supply of genuine sea glass for our children and grandchildren to collect. In the years ahead, it can be expected that green, brown, and white will remain alone in the grouping of common sea glass colors, while other colors that are simply uncommon today drift quietly into the category of extremely rare.

Author's Note

In my own experience, I recall at the age of 12 spending what felt like an eternity in my grandfather's study listening to his lectures on the questionable future of water quality in the Chesapeake Bay. Meanwhile, my mind raced in two directions, wondering how long it would be until he would offer me a coveted morsel of his delectable chocolate Wilbur Buds, which he had code-named "important business," or when I could escape to Stillpond Creek to catch his favorite lunch. His dissertations on the harmful effects of nitrates and phosphates running off local farm fields and how they would soon impact my fishing success were barely grabbing my attention in 1972. The existing bounty of perch and bass was far beyond the imagination, and so were the abundant grasses that cost me many a Red Devil lure. So like most pre-teens, I paid his theory little attention. But a mere five years later, he was gone, and, as he predicted, so were most of the fish and the underwater grasses.

If only the youth of today could pause long enough to learn from those who have endured the long journey, they would realize the value of the past and share an interest in preserving what was once so extraordinary. In our endless pursuit of highly efficient machines and greater output for more profit, come sacrifices in art and history that we can never recover.

I suspect many of us walk past true gems every day without considering where they came from and what journeys they have endured.

Look deep into nature,
and then you will understand everything better.
Albert Einstein

Glass Museums

There are a tremendous number of glass reference books available in bookstores, local libraries, and in special libraries such as the Barger-Suppes collection in Chevy Chase, Maryland. Books on glass can also be purchased on the internet. In addition, visiting a glass museum is highly recommended for sea-glass collectors. Direct observation of glass containers and tableware at museums, bottle shows, and antique stores will quickly increase the opportunities for proper identification of shards. Equally important is the level of appreciation one will obtain for the fabulous developments made within the American glass industry and abroad.

Four prime locations for studying glass in the United States are **The Museum of American Glass** in New Jersey, **The Corning Museum of Glass** in New York, **The National Bottle Museum** also in New York, and **The Sandwich Glass Museum** in Massachusetts. Note that Ohio and West Virginia also have an abundance of museums, which are a credit to the rich glass history in those states.

The list below includes museums dedicated to glass or ones that provide ongoing glass exhibits.

IN ALPHABETICAL ORDER BY STATE

Arkansas
Museum of Science & History - Little Rock, Arkansas

California
Historical Glass Museum - Redlands, California
Museum of American Treasures - National City, California
Prisbrey's Bottle Village - Simi Valley, California

Delaware
Winterthur Museum - Wilmington, Delaware

Florida
The Glass Museum - Fort Myers, Florida
Lightner Museum of Hobbies - St. Augustine, Florida

Georgia
High Museum of Art - Atlanta, Georgia

Illinois
Illinois State Museum - Springfield, Illinois

Iowa
Brunnier Gallery at Iowa State University - Ames, Iowa

Indiana
The Glass Museum - Dunkirk, Indiana
The Greentown Glass Museum - Greentown, Indiana

Kentucky
Oscar Getz Museum of Whiskey History - Bardstown, Kentucky

Maine
The Portland Museum of Art - Portland, Maine

The Museum of Glass and Ceramics - South Portland, Maine
 (formerly Jones Museum)

Massachusetts
Old Sturbridge Museum - Old Sturbridge, Massachusetts
Sandwich Glass Museum - Sandwich, Massachusetts

Michigan

Kelsey Museum - University of Michigan, Ann Arbor, Michigan
Henry Ford Museum - Dearborn, Michigan

New Jersey

The Museum of American Glass - Wheaton Village in Millville,
 New Jersey
The New Jersey State Museum - Trenton, New Jersey

New York

The Corning Museum of Glass - Corning, New York
Metropolitan Museum of Art - New York, New York
National Bottle Museum - Ballston Spa, New York

North Carolina

Greensboro Historical Museum - Greensboro, North Carolina

Ohio

Baker Glass Museum - Caldwell, Ohio
Cambridge Glass Museum - Cambridge, Ohio
Milan Historical Museum - Milan, Ohio
National Heisey Museum - Newark, Ohio
National Imperial Glass Museum - Bellaire, Ohio
Ohio Glass Museum - Lancaster, Ohio
Tiffin Glass Museum - Tiffin, Ohio
Toledo Museum of Art - Toledo, Ohio

Pennsylvania

Philadelphia Museum of Art - Philadelphia, Pennsylvania
The National Duncan Glass Museum - Washington, Pennsylvania
Dorflinger Glass Museum - White Mills, Pennsylvania

Tennessee

The Soda Museum - Springfield, Tennessee
The Houston Museum - Chattanooga, Tennessee

Texas

Anchor Hocking Glass Museum - China Grove, Texas

Vermont

Bennington Museum - Bennington, Vermont
Shelburne Museum - Shelburne, Vermont

Virginia

Chrysler Museum - Norfolk, Virginia
Reuel B. Pritchett Museum - Bridgewater College, Bridgewater,
 Virginia

West Virginia

Fenton Glass Museum - Williamston, West Virginia
Fostoria Glass Museum of America - Moundsville, West Virginia
Huntington Museum of Art - Huntington, West Virginia
Oglebay Institute Glass Museum - Wheeling, West Virginia
West Virginia Museum of American Glass - Weston, West Virginia

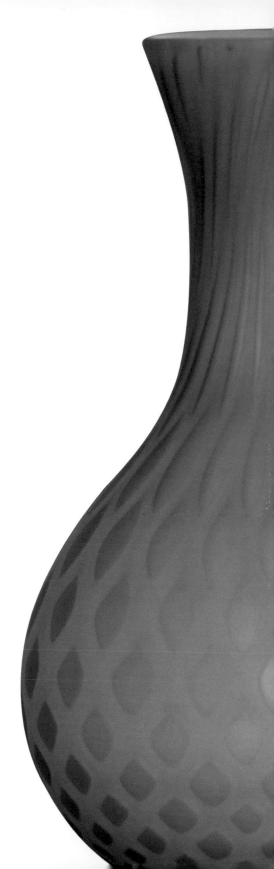

Bibliography

Books

Andersen, William & Baltimore Antique Bottle Club. *Baltimore Bottle Book*. Baltimore, Maryland: 2002.

Biser, Benjamin F. *Elements of Glass and Glass Making*. Pittsburgh: Glass & Pottery Publishing, 1899, reprinted in 1974 by Roy C. Horner.

Burnie, David et.al. *Visual Encyclopedia of Science*. New York: Dorling Kindersley Ltd., 2000.

Clark, D.E. & B.K. Zoitos, *Corrosion of Glass, Ceramics and Ceramic Superconductors*. New Jersey: Noyes Publications, 1992.

Davis, Derek C. and Keith Middlemas. *Colored Glass*. New York: Clarkson Potter Inc., 1968.

Dean, Cornelia. *Against the Tide: The Battle for America's Beaches*. New York: Columbia University Press, 1999.

Drury, Elizabeth. *Antiques*. Garden City, New York: Doubleday & Company Inc., 1986.

Graci, David. *Soda and Beer Bottle Closures 1850-1910*. South Hadley, Massachusetts: Graci, 2003.

Hale, Nathan Cabot. *Abstraction in Art and Nature*. New York: Watson-Guptill Publications, 1972.

Heetderks, Dewey R. MD. *Merchants of Medicine*. Grand Rapids, Michigan: Drukker Press, 2002.

Hume, Ivor Noel. *A Guide to Artifacts of Colonial America*. New York: Alfred A. Knopf, 1978.

Ketchum, William C. *Collecting Bottles For Fun and Profit*. Tucson, Arizona: HPBooks Inc., 1985.

Knittle, Rhea Mansfield. *Early American Glass*. New York: D. Appleton-Century Co., 1935.

Kovel, Ralph and Terry. *Kovels' Bottles Price List*. 12th edition. New York: Crown Publishing, 2002.

McKearin, George S. & Helen. *American Glass*. New York: Crown Publishing, 1965.

McKearin, Helen & Kenneth Wilson. *American Bottles & Flasks And Their Ancestry*. New York: Crown Publishing, 1978.

Middlemas, Keith. *Antique Glass in Color*. New York: Doubleday & Co., 1971.

Munsey, Cecil. *The Illustrated Guide to Collecting Bottles*. New York: Hawthorn Books, Inc., 1970.

Notley, Raymond. *Miller's Popular Glass: A Collectors Guide*. London: Octopus Publishing Group Ltd., 2000.

Oliver, Thomas. *The Real Coke, The Real Story*. New York: Penguin Books, 1986.

Phillips, Phoebe. *The Encyclopedia of Glass*. New York: Crown Publishing, 1981.

Polak, Michael. *Bottles: Identification and Price Guide*. Third edition. New York: HarperCollins Publishers, 2000.

——— *Bottles: Identification and Price Guide*. Fourth edition. Iola, Wisconsin: Krause Publications, 2002.

Porter, Eliot. *In Wildness is the Preservation of the World*. New York: Sierra Club & Ballantine Books, 1967.

Sandon, John. *Antique Glass*. Suffolk, England: Antique Collectors' Club, 1999.

Schroy, Ellen T. *Warman's Depression Glass*. Wisconsin: Krause Publications, 2000.

Sloane, Patricia. *Color: Basic Principles And New Directions*. New York: Reinhold Book Corporation, 1971.

Spillman, Jane. *Glass, Volume 2: Bottles, Lamps & Other Objects*. New York: Alfred A. Knopf, 1983.

Tait, Hugh. *Glass: 5,000 Years*. New York: Harry N. Abrams Inc., 1991.

Taylor, Gay LeCleire. *Museum of American Glass Docent Manual*. Millville, New Jersey: Museum of American Glass (internal publication), 2002.

Toulouse, Julian Harrison. *Bottle Makers and Their Marks*. Camden, New Jersey: Thomas Nelson Inc., 1971.

Zimmerman, Mary J. *Sun-Colored Glass: Its Lure and Lore*. Westport, Connecticut: AVI Publishing Co., 1964.

Periodicals

Bilyeu, Jim. "Collecting Owl Drug Store Stuff." *Bottles and Extras*, Volume 14 No. 1, Winter 2003. Federation Of Historical Bottle Collectors, Johnson City, Tennessee: 36-38.

Brown, Lester R. "Rising Sea Level Forcing Evacuation of Island Country." Earth Policy Institute. November 2001 (on-line).

Cauwels, Don and Diane. "Jack Daniel Distillery." *Bottles and Extras*, Volume 14 No. 2, Spring 2003. Federation Of Historical Bottle Collectors, Johnson City, Tennessee: 24-27.

Coastal Coalition. "Impact Data from the Environmental Protection Agency" testimony of Robert H. Wayland to the Senate Environment and Public Works Committee. July 1998 (on-line).

Culliton, Thomas J. "Population: Distribution, Density and Growth." National Oceanic and Atmospheric Administration (NOAA). *NOAA's State of the Coast Report*. Silver Spring, Maryland: NOAA: 1998 (on-line).

Duffer, Paul F., "How to Prevent Glass Corrosion" *Glass Digest*, Nov. 15, 1986, 76-80.

Faulkner, Ed and Lucy. "Let's Talk About Ink." *Bottles and Extras*, Volume 14 No. 1. Winter 2003. Federation Of Historical Bottle Collectors, Johnson City, Tennessee: 12-14.

Hagenbuch, Jim. "A Brief History of Electrical Insulators and the Hobby of Insulator Collecting." *Antique Bottle & Glass Collector*, East Greenville, Pennsylvania: December 2003: 4.

Morgan, Claude. "Rising Sea-Level Will Swallow Some Coastlines, But Not All." *Environmental News Network*. May 2001(on-line).

Munsey, Cecil. "Lydia's Medicine." *Bottles and Extras*, Volume 14 No. 4, Fall 2003. Federation Of Historical Bottle Collectors, Johnson City,Tennessee: 36-41.

Poch, Glenn. "Cathedral Pickle Bottles." *Glenn Poch's Bottle Collecting Newsletter*, #19, September/October 1997: 1.

Smith, Dr. Michael. "Dr. Daniels and the Story of Witch Hazel." *Bottles and Extras*, Volume 14 No. 4, Fall 2003. Federation Of Historical Bottle Collectors, Johnson City, Tennessee: 64-65.

Time of London, "Earth Summit In Disarray as EU Officials Walk Out." Source: EV World.com, August 30, 2002.

Internet

http://www.antiqibles.com
http://www.apva.org/finding/cullet.html
http://www.akronmarbles.com/marble_production.htm
http://www.akronmarbles.com/elias_greiner_vetter.htm
http://www.antiquebottles.com
http://www.antiquebottles.com/coke
http://www.antiquebottles.com/gingerbeer
http://www.artistictile.net/pages/Info/Info_Porcelain.html
http://www.artistictile.net/pages/Info/Info_pottery.html
http://www.artquotes.net/quotesartists.htm
http://www.brainyquote.com/quotes
http://www.beefeaterlondonradio.co.uk/beefeater.html
http://www.bottlebooks.com/blglssin
http://www.capemaycountybottles.com
http://coastalcoalition.org/facts/statistics/econimpact.html
http://www.thecdi.com/index2.html
http://www.clorox.com/company/bottleguide/cork.html
http://www.cl.utoledo.edu/canaday/quackery/quack3c.html
http://www.colormatters.com/colortheory
http://www.cosberts.com/bottles.html
http://www.dragonventure.com/En/0402/newsletter_4.shtml
http://www.encyclopedia.com/html/section/mirror_HistoryandDevelopment.asp
http://europeforvisitors.com/venice/articles/murano_the_glass_island.htm
http://www.evworld.com/databases/shownews.cfm?pageid=news300802-09
http://www.explorestlouis.com/grouptours/escortNotes.asp
http://www.thegavel.net/grenade.html
http://www.giga-usa.com/gigaweb1/quotes2/quotopa.htm
http://www.glassalchemyarts.com/technical (table 3)

http://www.glasslinks.com/newsinfo/pilk_history.htm
http://www.glasslinks.com/newsinfo/ag_history.htm
http://www.glasstiles.com/lume.html
http://www.glass-time.com/Encyclopedia/custardglass.html
http://www.glassworksservicesltd
http://www.gono.com/vir-mus/painted.htm
http://www.greatantiquebottles.com
http://www.handmade-glass.com/QandA
http://www.history-of-wine.com
http://www.homestead.com/custardsociety/articles.html
http://www.insulators.com
http://www.insulators.com/go-withs/firegren.htm
http://www.jefpat.org/diagnostic/Historic_Ceramic_Web_Page/Historic%20Ware%20Descriptions/Rhenish.HTM
http://www.londoncrownglass.co.uk/History.html
http://www.marblealan.com
http://www.marblemuseum.org/originof game.html
http://www.marblemuseum.org/marblehistory2.html
http://members.tdn.com/nwbhc/refiner/marbles/candystr.htm
http://www.mfa.gov.tr/grupc/cj/cja/Glass.htm
http://www.mii.org/Minerals/photocobalt.html
http://nautarch.tamu.edu/class/anth605/File5.htm*
http://www.nes.coventry.ac.uk/research/cmbe/225che/225che6.htm
http://www.ppg.com/gls_commercial/products/starphire.asp
http://www.press.uchicago.edu/Misc/Chicago/500284.html
http://www.thescarlettrose.com/Vaseline.pdf
http://www.schifferbooks.com/antiques/glass/076431968X.html
http://www.smcm.edu/~jcarr/Color/Ctheo.html
http://www.snodgrass.net/glassory/B%20glossary.htm
http://www.snuffbottle.com/history.htm
http://www.stainedglass.org/main_pages/association_pages/historySG.html
http://www.stainedglasswarehouse.com/glassglossary.html
http://minerals.usgs.gov/minerals/pubs/commodity/selenium/830798.pdf (Roger D. Brown, Jr.)
http://www.ulwaf.com/LA-1900s/02.09.html
http://www.visteon.com/floatglass/about/environmental.shtml
http://www.wiii.org/minerals/photocobalt.html
http://www.winsol.com/550faq.htm
http://womenshistory.about.com/cs/lydiapinkham/index.htm
http://www.worldlynx.net/sodasandbeers/lips.htm
http://www.wramc.amedd.army.mil/education/tobaccohistory.htm
http://www.yoto98.noaa.gov/facts/tourism.htm

*Devitrification - Dr. Donny L. Hamilton, Conservation Research Laboratory, Texas A&M University. Credit is given to the Nautical Archaeology Program,
Texas A&M University.

SEA GLASS COLLECTION LOG OF _____

COLORS	DATE FOUND	LOCATION	COMMENTS
Extremely Rare			
Orange			
Red			
Turquoise			
Yellow			
Black			
Teal			
Gray			
Rare			
Pink			
Aqua			
Cornflower Blue			
Cobalt Blue			
Opaque White			
Citron			
Purple/Amethyst			
Uncommon			
Soft Green			
Soft Blue			
Forest Green			
Lime Green			
Golden Amber			
Amber			
Jade			
Common			
Kelly Green			
Brown			
White (Clear)			

SEA GLASS COLLECTION LOG OF _____

COLORS	DATE FOUND	LOCATION	COMMENTS
Extremely Rare			
Orange			
Red			
Turquoise			
Yellow			
Black			
Teal			
Gray			
Rare			
Pink			
Aqua			
Cornflower Blue			
Cobalt Blue			
Opaque White			
Citron			
Purple/Amethyst			
Uncommon			
Soft Green			
Soft Blue			
Forest Green			
Lime Green			
Golden Amber			
Amber			
Jade			
Common			
Kelly Green			
Brown			
White (Clear)			